broken open

essays by
Martha Gies

trail to table press
an imprint of wandering aengus press
eastsound, wa

First Edition. Published by Trail to Table Press

Nonfiction
ISBN: 9798218382704
Cover Photo: Martin Stabler, https://www.sightings-photography.com
Author Photo: Susan Emmons

Trail to Table Press
an imprint of Wandering Aengus Press
PO Box 334 Eastsound, WA 98245, USA
trailtotablepress.net

In memory of
Parker, Loeta, and Toni Sue
Without words

Contents

THE FUGITIVE YEARS

...remembrance of a particular form is but regret for a particular moment and houses, roads, avenues are as fugitive, alas, as the years.

—*Marcel Proust*

THE SKIN OF THE WORLD

I

As a very small child, I came to associate solitude with revelation. After World War II, after my father was finally separated from the U.S. Army of Occupation and shipped home from Brussels where he had served as Executive Officer of the 70th Fighter Wing, he and my mother resumed their honeymoon. Inebriated and joyous, this honeymoon lasted two years and required finding someone to watch over me. I learned about my essential aloneness, along with its opportunities.

My parents bought a new Lincoln Continental convertible with dark green leather upholstery and christened her Mrs. Buff Orpington after a character on the "Blondie" show, a wealthy matron whose personal fortune was audibly suggested by the *Har-oooohm* of her departure in a Duesenberg. This new car, although not a Duesenberg, was one of only 200 manufactured that year, and identical to one driven by the screen actor Adolphe Menjou except his was powder blue. My parents headed south in Mrs. Buff Orpington, toward Nevada and California, leaving me in the care of my maternal grandmother, who was newly divorced.

I have pictures of her which reveal what I was too young to understand then. In one, she is sad and serious in a dark cloth coat; a later photograph shows her leaning against her polished Buick, laughing, her hair permed and her waist girlish.

Since her divorce, she wanted "modern." She moved off the farm, purchased a phonograph, and embraced synthetics such as margarine, which she purchased white and kneaded yellow. I sat on the table near the mixing bowl, entrusted with the tiny packet of orange dye. Hers was a big house in town with fuzzy burgundy-

colored sofas and cut-glass pedestal candy dishes. In the basement, near the washing machine into which we poured a potent indigo liquid called bluing, she had her own shuffleboard court.

At night she smoothed lotions on her face from the bottles and jars which decked her vanity table's stiff doilies, and at age three I did, too; when we had "done our faces," we climbed into her high soft bed. I loved her, and the only time she ever disappointed me was when she told me, no, she could not marry me when I grew up.

Before my fourth birthday, my parents returned to Oregon and reclaimed me. What I remember of their earliest interest in me was intellectual. My father taught me arithmetic and chess and sometimes I would be summoned from my bed in the middle of the night to find his chessboard set out on the oak coffee table and his friends, elegant, amused, skeptical, waiting for an exhibition of my skill.

Around this time, I had a startling insight about the nature of the world. This was a cerebral adventure more heady than sums or chess. I was contemplating the hugeness of space, filled with wandering, spinning, streaking planets and stars. My mind scanned the edge of the heavens holding all this commotion and I suddenly perceived there, not a border or an end, but yet more space, continuous and forever! This vivid new idea stunned me, and I sat savoring my mental electrification, invisible in a wing chair, as my mother came and went in the room setting up tables for bridge.

II

From my divorced and absent grandfather in photographs, a big man with a cigar and fedora, my mother inherited farmland near the Willamette River. My parents reserved five acres for house and garden, and our tenant farmer, Zack, planted the rest to corn and grain. From there my father drove to law school ten miles away in town, and from there I walked, past Mr. Hardman's Gravenstein orchard, to the two-room schoolhouse painted apple green.

Behind the schoolyard was a sagging barbed wire fence, beyond which trudged Mrs. Chapman's black and white cows, and to the north a creek ran through oak trees, and farther still was a small forest of Douglas fir.

At recess, I stayed at my desk and read fairy tales. Mrs. Carmichael, from her chair near the fire, dunked her tea bag and looked at me over her spectacles and suggested that I get some fresh

air. But she never forced me out of doors, where my classmates, Sara Lauderback and Diana Rule, pummeled a ball tethered to a post.

These tales generally were about a young person who wanders in search of love. Thwarting this one desire was either an ugly woman, a witch, or a peculiarly small man, a dwarf. The young person could rely on the assistance of birds, fishes and horses, and often on the dead. At the end comes Recognition, everlasting love from a prince or princess, as well as silver and gold. But terrible things happen to the dwarfs and witches: they are burned alive, or stuffed naked into a barrel driven through with nails and dragged through the streets. Evil is resisted, and sins never forgiven. Although this contradicted my Sunday school lessons, some primitive part of my mind found it satisfying every time.

Though confined in school at my wooden desk with its cast iron scrollwork, I was free at home on the farm. From wide lawns, on which could be heard Sundays the smack of croquet balls and the tinkle of ice, I passed beyond the border of roses and artichokes, through the *terra incognita* of a small fallow field, plowed faithfully each spring by Zack, and into a compound of abandoned outbuildings.

The centerpiece was the barn itself, a gray classic structure, circa 1915, with stiff leather bridles and heavy yokes still hanging in the stalls and, up the ladder, a loft with a sliding door that gave a wide view of the oak grove, and the creek running into the cement culvert under the county road.

There were three smaller buildings, designated off-limits by my parents, and each with its own mystique: a shed fitted out with an iron cot where hoboes stopped over (I found old wine bottles, cigarette butts, and apple cores); the pump house, a tidy little structure which smelled of grease and throbbed from the inside and had, mounted in the corner, a large poster-board advertisement for Pall Malls, smoked languidly by a music-hall beauty in a long gown and feather boa. But my favorite was a brittle wooden outhouse, unused for a decade. The outhouse blew down during a winter storm, backwards, with the door on top, and in the spring the lush grass which filled the adjacent hole was greener, deeper and richer than any on the farm. The structure looked like a boat lying there on its back, and I climbed in, drew the top hatch over my head and, from the porthole in the bow, had a perfect view of this new miniature Eden.

III

Oak Point School consisted of two classrooms, as well as a kitchen and bathrooms, which had been added later. Above the cloakroom, where we kept our mufflers, boots and lunch pails, was a bell tower and we fifteen children of the Little Room scrambled to be the one to pull the rope. The Little Room had a fireplace, but the Big Room, to which I would soon graduate, had a stage and a precious miniature library.

I have had a great love affair with libraries since age nine, when I reconstructed from these scant resources the entire Rurik and Romanov dynasties. This took me many weeks, and when I was finished, I copied the whole thing out on lined notebook paper, my fountain pen filled with forest green ink. (I was later startled to discover that my research had already been undertaken by someone else, and that in some of the heftier encyclopedias one could simply turn to charts showing the order in which these family members succeeded to the throne.)

The folksy nicknames of the Ruriks—Svyatopolk the Damned, Yaroslav the Wise, Ivan the Terrible, Vsevolod of the Large Nest—forever fixed them in their strengths and weaknesses. But it was the Romanovs whose personal histories first alerted me to the heights and terrors of humankind. I loved Peter the Great, who learned boat building in Holland, the first Russian tsar to travel to Western Europe. When he came home, he installed a huge sail in the palace, a false ceiling which better suggested the low-heavened flat space he knew as a boy on the steppe. I was shocked by cruel Anna, who lived only for her own amusement: she once ordered an entire city recreated in ice and snow, and instructed her servants to occupy it that it might better appear a real little town. They froze to death in those white kitchens and parlors.

Years later, on a visit home, I took Ken, my friend from college, with me on a late afternoon walk to the old schoolyard. The district had long since closed the little school, and I was surprised to see through the windows that the desks were still in neat rows, the chalk and erasers still resting in the wooden gutters beneath the blackboards. I asked Ken to hoist me up to a small, high window and, sure enough, the entire library had been left behind! We went in through an unlocked window, and I rescued the old volume of the Brothers Grimm. Halfway home I remembered something, and we went back, crawled through the window again, and I also saved Sara

Lauderback's favorite book, *Chee and his Pony*, a story about a Navajo boy that I had always regarded as being of doubtful literary value. Nevertheless, I mailed it to her at Stanford.

After I had graduated into the Big Room, Mrs. Carmichael died. Our new teacher got hold of a small yellow bus—a type of vehicle that we saw once a year for field trips to the Oregon State Legislature—and she took Mrs. Carmichael's former Little Room students to her funeral.

It must have been spring, because the country church was full of lilies. There were a few old women scattered throughout the pews, and two neat rows of us children. We sat very still until we were permitted to walk by the coffin. We saw Mrs. Carmichael lying there wearing a navy-blue dress and rouge, but she couldn't hear her own funeral, because she was dead. Or could she now hear everything, conversations all over the world? I worried about her in the "afterlife," imagining it took place in a colorless cirrocumulus, empty of her silver spectacles and porcelain cup, let alone the other wonderful treasures which adorn the surface of the earth.

<h1 style="text-align:center">IV</h1>

In the 1950s we had the Cold War, and fear of the atomic bomb came into our lives. Russia was our enemy. Beautiful Russia, where, according to back issues of *Life Magazine*, they had done away with the gold-smitten tsars and supplied tractors to the farm people. Russia might decide to drop an atomic bomb on our country. Life was subject to a terrible interruption. I drew closer to my divorced grandmother, soft-fleshed, gray-haired and, I now understood, mortal. One day, she announced we were going to see *The Yeoman of the Guard*, just the two of us. I had never been to the theater!

When Friday afternoon finally arrived, I waited for my mother in the schoolyard as other children dispersed on bicycles or swinging their lunch pails through fields. Soon I was alone and the schoolyard was quiet except for the cheep and caw of birds, and I sat in the swing and stared at the hard dirt patch where I lazily dragged my feet.

I thought about time and the impossibility of waiting through it, of how thick and long and interminable it became before the few really good things in life, like Christmas morning or Gilbert and Sullivan. There were weeds coming up through the cement that held

the iron frame of the swing, and a thin film of dust lay on my brown and white saddle shoes. I wondered if my mother had forgotten me.

It was then that I had a revelation about time: I suddenly saw that the theater moment, the moment of sitting next to my grandmother as the music began, was actually adjacent to this swinging, waiting moment, and that I would not register all the unconscious moments in between. Birds flapped and scolded as my mother's turquoise station wagon careened into the schoolyard, scattering gravel.

Four hours later, I sat on a folding chair in the third row of a gymnasium and heard the little orchestra tuning up. My grandmother winked at me and, only moments before the curtain rose on Phoebe spinning on the tower green, I recalled my intuition in the schoolyard. Time, I realized, is compressed into isolated moments of great clarity and registration, appearing contiguous in memory, with all the intervals of waiting removed.

Years later, I readily accepted the relationship, argued by Proust and Stanislavski, between sound and smell and memory. Thinking today of my discovery about time, I can feel the sway of the long swing, and smell the rusty iron and hear the creak of shifting chain.

I have envisioned my own death moment, knowing that it too will be a deeply observed event in which the very light will serve as a fixative for the heart.

V

My parents were having more children. When Michael was a baby, I was permitted to wheel him around the yard in my doll carriage. With the arrival of each child, the tasks assigned me required more dexterity and responsibility. At six, I bathed and changed Julia, and with Toni's arrival I learned to make up a bottle. At nine, I graduated to overseer of the entire upstairs, accountable for all baths, bedtimes and Saturday cleaning chores.

The four of us children regularly held formal councils to analyze tidbits overheard downstairs, to plan campaigns in favor of our least restrictive housekeepers, and to vote on life's saddest problem: which parent we would choose to live with if our household were ever struck by divorce.

Our parents staggered our bedtimes so that the youngest child was sent up first, followed in half an hour by the next. When it

was my turn to go to bed, I would climb to the landing without turning on the light because the others were already asleep. They slept with their doors open, and I could hear their breathing as I passed down the hall, and sometimes, during a bright moon, I could see them in their beds amidst the disarray of rubber dolls and Giant Golden Books. In my room, I would either read illegally in bed with a flashlight or, if there had been a recent parental raid, I would watch the headlights from the road sweep around the dark room.

Often, I would cry! I muffled my sobs so that my parents would not come and demand an explanation. I pulled the sheet over my hot, wet face and touched the wall next to my bed and the sensation of the cool pimpled plaster, associated entirely with the grief of other nights, would bring a fresh storm of tears and trembling.

The sphere of my anguish would enlarge itself, and I cried for my divorced grandmother whose death might come as suddenly as a night at the theater. Then, with a great rush of sobs, for my brother and sisters, who also could be taken from me at any moment. How precarious life appeared for children so small, what with chicken pox and the riverbank and roving ownerless dogs. Finally, as my desolation reached a turning point, I cried for the largest and most abstract of cases—all the children in Russia—and I realized that my sobs had swollen into a keening for what I saw to be the plight of us all, finite creatures, in love with the finite, and stranded too briefly on the skin of the world.

CAMPING PRACTICE

The *Maryanne* arrived in spring. She was a white powerboat with a red canopy that shaded the wheel, and she rode regally atop her trailer which Father towed along our driveway, carefully parking her on the pavement near the dog kennel.

At sixteen, I viewed the arrival of the *Maryanne* with icy adolescent scorn. John Steinbeck's *The Grapes of Wrath* had plunged me into a desperate concern for the poor.

We were eating Sunday dinner, shortly after the new boat arrived, when Father made a startling pronouncement: we would be taking the *Maryanne* up to Diamond Lake for two weeks in August. We were going to *camp*.

We four kids, seated at the table between our parents, were silent. Other families camped—they even hiked and skied—but we did not do these things.

We children went back and forth to school, did our homework without prompting, cleaned our rooms on Saturday morning, and watched what little television was permitted. Our parents went to cocktail parties and to dances at the country club and to football games at Oregon State. Of course, Father sallied forth every weekday to his law office in Salem; on these critical forays all our comings and goings depended.

In September I would start my senior year of high school, and my thoughts already ranged across a choice of colleges. Having come this far without going camping, I really didn't need to start now.

When school let out for summer, the *Maryanne* already a fixture in our driveway, Father made another pronouncement. His forum was again the Sunday dinner table, a meal we typically ate with our parents. "Camping practice will commence two weeks before Diamond Lake," he said.

"And what, pray tell, is camping practice, Parker?" my mother asked, the merriment of two pre-dinner Old Fashioneds in her voice. She had been the youngest girl graduate in the history of Oregon State, taking her bachelor's degree at age nineteen, and I thought her wit and spunk were wasted on her role as housewife.

"We set up the tents and camp overnight in the yard."

We didn't even own tents.

"I can't go in August," I said. "I'm getting a job at the cannery." This was not strictly true. I had left off an application but hadn't yet heard back.

"Too bad if you have to miss it," Father said.

I had not expected this flat reaction.

He turned his attention to Julia, the middle sister, who sat on his far left. "Right, keed?" He grinned at her and winked.

Julia, age ten, did not venture an answer. She looked at him blandly for a moment and carefully sawed off a bite of sirloin with her knife and fork.

Mother generally welcomed any diversion Father might devise and was smiling now. "And the point of camping practice would be?" she asked.

"We find out if we've forgotten anything."

Michael, who was twelve, could not resist. "So what happens if we've forgotten anything?"

"That becomes useful information," my father said, and he looked conspiratorially at Michael, who did not reply but reached for his milk glass.

Over the next week, equipment began filling our basement and garage: sleeping bags, two tents, mess kits with aluminum knives, forks, spoons, cups and plates, all of which fit and snapped together in a cunning way; a two-burner Coleman cook stove and three lanterns.

We began to hear more about Diamond Lake, set high in the wilderness of the south Cascades at the base of three ancient volcanoes. A mile-and-a-half deep, it was stocked with rainbow trout.

Toni, optimistic at age seven, loved the idea, but Michael and Julia remained unconvinced. Michael didn't relish the idea of spending two weeks away from his friends, and who knew Julia's dark thoughts about this wilderness enterprise. Normally I might have sold them on the trip, but since I had weaseled out of it, they were not overly inclined to listen to me.

Father showed off the new gear, reminiscing about the first time he and his friend Oscar Lange ran the Deschutes. Back then, he reminded us, the river was thought to be unapproachable, but in 1949 they had bought an Army Surplus rubber raft which they carried down the canyon and put in at Round Butte. After surviving all that whitewater, they drove their raft down south and ran the Rogue.

In July, Blue Lake Packers phoned and offered me my choice of shifts for bean processing. I signed on for graveyard, where I stood to make an extra nickel per hour.

"My job starts in maybe ten days," I explained at the next Sunday dinner. "It looks like I can make the practice, but not the camping trip itself."

"No camping, no practice," Father said.

Michael and Julia both looked up from their food and stared at Father.

Toni, the youngest, was indignant. "Why can't Martha practice with us?" she demanded.

"We have to replicate camping conditions exactly," Father said, unconcerned that he might be talking over her head. "That's what it's all about. We factor out all personnel and supplies unavailable to us in the field."

My mother glanced at Father, but he was occupied buttering bread. "I'm sorry you can't come, Martha," Toni said softly.

"Hey," I said with a shrug.

No one mentioned my dismissal again.

On the Saturday of camping practice, a schedule was Scotch-taped to the refrigerator:

6:00 p.m.	Assemble, inventory and pack gear and provisions
7:00	Pitch camp on the north side of the house
7:30	Final check and roll call
8:00	Dinner in camp

I caught my mother eyeing this protocol, reflectively inhaling a Winston.

The parklike setting where the camping expedition was headed lay across the driveway, and included a grove of oak trees, flanked by the croquet course. Between 6:00 and 7:00 p.m., my father came and went many times, and so did my brother and two sisters, following his instructions.

"There is no possibility of returning to the house after 7:00 p.m.," I heard him say.

I might as well have been invisible. Even my siblings had pretty much quit speaking to me, except, of course, for little Toni.

Finally, at 7:00 sharp, Mother and Father had a comradely straight shot of Seagram's 7 together in the kitchen. After Father passed the bottle back to her, Mother packed it along with the food to be taken to camp.

All five family members filed out the kitchen door, which Father closed behind them, and marched through the garage and across the driveway, to bivouac on the lawn near their gear.

I busied myself with what I had to do, which wasn't much. I made a tuna fish sandwich and picked up *Of Mice and Men*. I was halfway through it, but now it didn't hold my attention.

I thought of where my life was going. My father hoped I might go to Smith or Vassar and acquire a certain social polish in the company of well-bred East Coast girls, but I was leaning toward staying in Oregon and going to Reed College, which was coed, unswervingly academic, and politically suspect. My decision would cause a family storm, come application time.

Though it grew dark, I did not turn on the house lights. This permitted me to stand at the kitchen sink unseen and gaze across the driveway where two black pyramids hunkered. Three lanterns glowed under the oak trees. Only the occasional rat-a-tat-tat of Mother's laughter broke the silence. I climbed up on the drainboard and sat there, with a good view of camp. I sampled one of Father's Camels (not my first), using the entire kitchen sink as an ashtray.

I peered out the dark window. Between me and the little lights in the oak grove, the *Maryanne* rode a sea of blackness. Across that sea, I saw that the family occupied not an island, but the primary land mass. It was I who was now adrift, in need of whatever craft would keep me afloat, and everyone who meant anything in my life was on that far continental shore.

OLD FASHIONEDS

For Old Fashioneds, my family always used Seagram's 7, an inexpensive blend that served as the house whiskey. Though they kept a fully stocked bar for their friends, from British gin to Grand Marnier, my parents regularly drank Seagram's, even after Father began making money in the law practice. Once, as an amusement, he calculated how much he had saved over the years by not drinking a good bonded bourbon. He sidled up to Mother at the stove, slipped his arm around her waist, and revealed the astonishing sum. Like much of what my father said, his announcement aimed to make her laugh, and she threw back her head and rewarded him a generous throaty yelp.

Old Fashioneds were the first cocktails I ever learned to make, Father having taught me the recipe when I was nine, an age old enough to responsibly lift the short gold-rimmed tumblers down from the kitchen cupboard. These drinks were reserved for Sunday, when the afternoons melted long and shining and no one was in a rush. Once we children were brought home from Sunday school and Mother had started something roasting in the oven, I would get down the glasses, one for each parent and any other adults who may have dropped in.

I made Old Fashioneds most Sundays for eight years, until I moved away to college, where I only stayed two years, then took up living at loose ends in San Francisco. Finally, I came home for Christmas and simply stayed on beyond the holidays. For what purpose I did not know.

One Sunday afternoon found me back at my post in the kitchen, making a first round and now including one for myself. At nineteen, I had learned something of the history of the drink, its 19th-century Louisville origins predating the Kentucky Derby, the

classic mix of whiskey and bitters that earned its name. As I measured Seagram's into a glass jigger, I heard Father speak behind me.

I turned.

He stood in the archway between the kitchen and dining room, handsome at forty-eight, with dark eyes, and a crew cut now turning gray. He wore his usual weekend clothes, a sports shirt loose outside casual slacks. I don't remember what he said. Perhaps he had come to check on the drinks, or maybe another guest had arrived and he'd come to revise the count.

As we stood gazing at each other, one of his knees buckled. He sagged, then caught and steadied himself, recovering instantly. In that moment I knew—in that telepathic way impossible to account for later—that he was dying.

A look of fury came momentarily to his face, and his eyes said, *You didn't see a thing.* He focused on me long enough to make sure I understood. Then he turned, perfectly balanced and perfectly composed, and was gone.

And so I knew why I'd come home.

As winter turned to spring, I watched Father closely, but he never again gave himself away.

In May of that year, he and my mother made a trip to Mazatlán, and I was left in charge of the house and my three siblings—Michael, sixteen, and the girls, fourteen and eleven.

In Mexico, we would later learn, Father had been in so much pain that the manager of the resort courteously provided morphine. Upon his return to Oregon, he was hospitalized in Portland, a candidate for open heart surgery.

Mother spent those last weeks at the hospital in Portland, in constant vigil by his bedside.

I was left at home in the country to provide some regularity in the lives of my siblings, though their lives would never again be regular.

I remember those short summer nights. After I sent the kids to bed, I'd sit chain-smoking Camels and listening to one particular record of Art Farmer playing flugelhorn. His soft swinging rendition of "Embraceable You" brought tears to my eyes, and I played it over and over again.

I'd fall asleep just as the downstairs rooms began to fill with light, and I could make out the border of roses and artichokes along the south side of the house.

Father's heart was found to be riddled with some toxin, possibly a recurrence of the malaria he'd picked up in the Philippines, where he flew fighter planes at the beginning of the War. The heart surgery—a procedure then in its earliest days—was attempted, but he died on the operating table.

It would be months before my mother, then forty-one, could believe her loss. And years before she could accept it.

She changed her drink to vodka. I now understand that the sudden sting of Seagram's on her tongue would have sent a shudder straight to her ambushed heart.

This is my father's Old Fashioneds recipe, simple enough for a child to follow:

Put one teaspoon of granulated sugar in the bottom of a short tumbler and muddle with a little hot water. Add three dashes of Angostura bitters, followed by a double shot of whiskey. Stir with a teaspoon. Add a maraschino cherry speared on a toothpick, and three or four ice cubes.

If you use Seagram's 7, you'll save some money, but that may not matter. Life runs out before the money does anyway.

JUDGMENTS

When I was sixteen, my father and three of his friends bought a huge swath of Willamette River bottomland, and we became, overnight, the largest asparagus growers in the Pacific Northwest. Come summer I worked alongside the Mexican laborers who lived in the migrant camp. I was fascinated by their culture, which was unlike anything I'd known growing up in white-bread Polk County, Oregon. The ranch also finally gave me a topic for conversation with my distant father, though when we discussed the workers' living conditions or wages, we could rarely agree. We regarded each other with suspicion.

Under the influence of John Steinbeck's novel about Depression-era migrant laborers, I began spending every spare moment at the ranch, engaged in long conversations with workers at the cantina.

"What in the hell do you do down there?" Father asked. "You don't want to turn into some kind of do-gooder."

Father was a crackerjack trial lawyer whose boyish good looks and ready wit charmed juries, but I took offence at the nature of his law practice, which consisted of defending big insurance companies against the claims of the little guy—sometimes the paralyzed-for-life little guy.

"He *jokes* about it, for God's sake," I whispered to my three younger siblings as we huddled together on the landing of the stairs, eavesdropping on our parents' conversation. I could never figure out whether he truly believed that justice belonged only to the rich and powerful, or whether he was simply absorbed by the cut and thrust of making money.

For him, the world was populated with three classes of people: idiots, morons and nincompoops. Years ago, I asked my sister Julia to help me sort out the distinctions.

"Well," she said, "idiots were all the other people in the legal profession; morons, I suppose, would be their clients; everyone else was a nincompoop. But you're forgetting one more category: doctors, psychiatrists, and the police were *complete nincompoops*."

<center>ℬↄℭℛ</center>

Father's busy law practice took care of our financial needs and for him that fulfilled his obligations as a parent. He seemed at best mildly amused by his children; mostly he was indifferent. In our large country house, we kids led lives separate from his. My siblings and I were fed at 6 p.m., with paper napkins and stainless-steel flatware laid directly on the chrome-rimmed kitchen table. By the time our parents ate their dinner, two or three cocktails later, we were either sprawled on the carpet in front of the television set or had already retired to our rooms upstairs.

I'm not sure our father ever saw those rooms: not my own balcony view of fields running to the western horizon, nor my brother's nautical-themed wallpaper, nor the pink striped curtains of the little girls' room on the sunny side of the house. Mother, of course, was no stranger to our quarters. She arrived each Saturday morning for cleaning inspection, and every five years or so she would undertake a major project in our midst, such as painting our bathroom or changing the wallpaper in the hall.

Only once do I remember Father ascending the stairs: one December in the late fifties, after considerable begging, we children were allowed to put up and decorate our own Christmas tree. We incorporated all the ornaments that didn't fit Mother's gold-colored motif of the downstairs tree. When the last ornament was in place and the nubby branches were hung with twisted silver garlands, I plugged in the string of colored lights, and the four of us stood in silent admiration, inhaling the perfume of Douglas fir. Proud of our work, we persuaded Father to view it. He trudged up the carpeted stairway as far as the landing, two steps below our floor. "Pretty fancy," he said, and then he glanced at his burning cigarette, which clocked his moments away from the downstairs ashtrays.

<center>ℬↄℭℛ</center>

After Father succumbed to a heart condition, everything about our lives was under revision. Now, so many decades later, I often find myself thinking about him. I am haunted by two particular events that reveal a side I wish I'd better understood. One of life's sorrows is the loss of people about whom we have wrongly or prematurely made up our mind.

Two summers before he died, when I was eighteen, I managed the asparagus packing plant. There were about a dozen workers: eight women at the two conveyor belts, sorting and grading; two men in the back, loading the belts from the big field tubs; a man who hauled the freshly packed crates into the cooler, where they awaited the big refrigerator trucks; and me. My job was to keep an eye on everything, make sure the grading was done correctly, and shut down the machinery for our breaks.

One day a worker named Jesús didn't show. The others told me he was in jail. Jesús was such a shy and serious young man, I could hardly believe it. All the same, María insisted he'd been picked up for public drunkenness by the police in Independence, the first little town you came to after leaving the west end of the ranch. This was even harder to believe, because Jesús didn't drink.

I did something uncharacteristic: I phoned Father at his law office. "All right, all right," he kept saying, as I embellished the facts of the case with my opinions of small towns and racist cops everywhere. He said he'd look into it and hung up. I shrugged at María and gave the signal for the big belts to be started up again. We took our places, and pounds of asparagus began flowing down the line.

Sometime in the middle of the afternoon, Jesús appeared. He had been released (he was not sure why) and had walked the four miles back to camp. He had also put on his good white shirt, normally reserved for Mass or a dance, as though to lift himself above his humiliation.

Later, Father drove down to the asparagus plant in his silver Fairlane 500 and told us the rest of the story: the Independence police had cynically employed a new source of revenue: picking up farmworkers on trumped-up charges of drunk and disorderly behavior and holding them, pending sixty dollars bail. In 1962 this was a steep figure; by contrast, nearby Salem, the state capital, set bail at five dollars for a similar offence.

With a cocky grin, Father assured me it would never happen again. He had made a phone call to the Independence City Council

with this message: if the charges against Jesús were not dropped, he would put a lock on the gate at the south end of our ranch, and the workers would be forced to drive six miles to Salem to do their shopping. To a town of two thousand, like Independence, the money those 700 people spent at the grocery, clothing, and hardware stores was significant. Father hadn't even bothered to phone the police station to make sure they got the message; that would have been unnecessary and, for that matter, inelegant.

The story spread quickly among the workers and, from that day forward, Father became in earnest what they'd always called him: *el Patrón*.

<center>ℰᏟℛ</center>

It was only two years later, when Father died at the age of forty-nine, that our family was automatically bought out of the ranch by the partnership insurance that Green Villa carried.

I was enrolled in classes at a nearby college that summer, and I would drive past the shack of a man named Dave Burrell on my way to and from school. I knew him from the ranch, where he had operated the ramshackle cantina, serving tamales, bacon and eggs, hot sandwiches and soft drinks. One of only two Black people in Independence, Dave had moved to Oregon after World War II. He had learned to make tamales back home in Mississippi, and they were popular with the Mexican women, who bought them by the dozen to feed their families.

That summer I began stopping off to visit Dave, who was then in his fifties. Though no longer at the cantina, he still made tamales, which he sold on the streets of Independence from a handcart. His shack always smelled of cayenne and slow-cooked beef. Many times, I begged Dave to teach me tamales, but he told me the recipe was "top secret." On tamale day he would pull a dingy flowered curtain across the kitchen doorway, and when he went in to check the big pots on the woodstove, he made sure that the curtain fell behind him.

We would sit on his porch in the two rockers and smoke cigarettes and not say much. We both smoked Camel straights. (Dave always kept track of which pack was his by opening them on the wrong end, a trick he'd learned during the Depression.) He'd play some old blues record on his phonograph and we could hear the music through the screen door, and once we listened to a racy

<center>20</center>

recording of Redd Foxx's early nightclub routine. Something about those afternoons—the lazy houseflies, the creaking rockers, the field of red clover across the tracks—was a consolation to me after Father's death.

Dave had known Father, of course, but only once did we talk about him.

"Few years back I was working johnny sweep at the HiHo Tavern," Dave told me, "and there was this one white woman there, worked as a waitress." She had taken up with Dave, who told me about their relationship using the sort of sexual innuendo that Redd Foxx used.

"When people found out about it, some men come to see me one night. They told me I had exactly one day to leave town."

Dave said he had called my father. "Mister Parker, he take care of it," Dave told me, rocking and nodding. "He was a fine man, Mister Parker."

Laughing in disbelief, I stilled my rocker and turned to see Dave's face.

But Dave was serious. "A fine man and a good friend," he insisted.

"So how did he take care of it?" I asked.

Dave shrugged.

"So who the hell were those bastards, anyway?" I asked, jerking a Camel from one of the packs on the orange crate between us.

"You'd be surprised who they was," Dave said, glancing over to see whose pack I was smoking.

"Right. The city council and the police, I suppose."

Dave rocked and hummed a little, but he didn't answer.

"Those damn nincompoops!" I said.

"Yes," Dave said, "they's *complete* nincompoops."

HEART OF WISDOM

Teach us to number our days,
That we may get us a heart of wisdom.
—Psalm 90:12

There was no religion in our family. My parents believed salvation lay in keeping the romance alive in their marriage, and in maintaining a high economic standard of living.

They had four children, each exactly three years apart, which I always took as a sign of my mother's superior sense of organization. I was the oldest, then came my brother, Michael, then a sister, Julia, finally the baby, Toni. I was nine years old when Toni was born. I had special responsibilities as the oldest child: in some ways, I functioned more as a governess or a nanny. Michael, Julia and Toni were like my own kids.

Our father had a successful law practice and Mother had inherited land. We lived in the countryside west of Salem, Oregon, near the Willamette River, with few neighbors to play with. This made the four of us very close as children. Also, our parents were extremely wrapped up in each other. They travelled together—to New Orleans, the Oregon coast, Diamond Lake, Mazatlán—and they enjoyed going to cocktail parties.

Three years after I left for Reed College, Father's death changed the family, violently and irrevocably. My mother was only forty-one at the time, and she thought her own life was over. She did a lot of drinking and driving.

When Michael departed for Antioch University and, two years later, Julia for Bennington, Toni was left at home alone with

Mother, anxious and lonely. At this point, I was living in Montreal, and didn't realize how chaotic the situation had become at home.

This was the sixties, so in addition to the disruptions caused by my father's death, we were also experiencing the aberrations of the age. I was in French Canada with a boyfriend who had decided not to be sent to Vietnam. At Antioch, Michael spent as much time dropping acid as he spent in class. At Bennington, where Julia had been accepted for early entrance, she was already thinking of dropping out.

Then Toni, still at home, became an evangelical Christian. All of us, Mother and the three siblings, were appalled. It would be many years before I had any insight into that period of Toni's life.

Toni was nineteen, and very shortly after her conversion she married a young man who shared her faith. She was taking herself as far as she could get from the pain she felt in her own family. Years later, she told me she had been desperate as a teenager. We were talking about conversion experiences at the time, and about what I had read as the three stages of faith: receptivity, mental assent, total surrender. "Boy," she said, "I moved through all three of those in about a week!"

Toni and Eugene, her husband, lived in the country and were farmers. Two children were born to them, a girl, Hope, in 1975, and a boy, Jess, in 1979. In the winter of 1980, Toni and Eugene signed on with Wycliffe Bible Translators to go to the Peruvian jungle on their guest helper program. Missionaries! Our family grew even more hostile to her religion.

After four-and-a-half months in Peru, Toni and Eugene decided to be missionaries for real. Their plan was to come home, liquidate their few assets, raise the money for their ministry, and sign on for a long-term program.

But instead, Toni ended up in the hospital, in intensive care. Salmonella had invaded her bloodstream. She lived but was stuck with a gigantic hospital bill. God was being unfair. She later said that her illness taught her she had two choices: she could stay stuck in her anger or she could move into acceptance.

At that time, I remember seeing this scripture verse posted on her bathroom mirror: "We are afflicted in every way, but not crushed; perplexed, but not despairing." (II Corinthians 4:8)

It took Toni and Eugene four years to pay off the hospital bill. Finally, in December, 1984, they were free of debt and looking forward to returning to the mission field.

That Christmas, while she was sitting at her kitchen table addressing Christmas cards, she felt a lump in her breast.

The phone rang one Wednesday night just as I walked through the door of my apartment in Seattle. It was Toni telling me the doctors had found a mass which they assumed was fibrocystic breast disease, but that they wanted to do a lumpectomy on her right breast and biopsy it. She said it was nothing to be concerned about, but not to tell Mother because she didn't want to worry her.

Things happened very quickly after that. Toni was told the lumps were cancerous, and she was scheduled for a mastectomy. I said I'd meet her at the hospital in Salem on Monday morning.

I was struck by the number of friends, neighbors, and church members who showed up at the hospital to vigil with her. Toni's earliest instinct was to let others share in her journey, to not keep it a secret. People who couldn't come to the hospital to pray with her wrote letters. One friend sent her a box of nine presents to open, one day at a time. Each was labelled with one of the names of God from the Hebrew scriptures. I remember glancing at them, observing the difference between *Jehovah Raha*, the Lord my shepherd, used in Psalm 23, and *Jehovah Shalom*, the Lord send peace, from Judges 6.

Two days after the mastectomy Toni's tests came back from pathology: she had cancer in the lymph nodes. It was 1985. She was thirty-one years old.

Toni's original interview with the oncologist was tape-recorded, at his suggestion. I still have that tape. "Of course, we don't really ever know for sure, but statistically, we find that if there is cancer involvement in the lymph nodes, we're looking at maybe two years at the outside," the oncologist's deep voice says. "That's if two or three of the lymph nodes are involved."

And then, on the tape, a soft little voice asks, "How many lymph nodes did I have?"

"Sixteen."

With her husband Eugene, Toni prayed about whether or not to take chemotherapy. She, like everyone, had heard that, with cancer, the medicine can be worse than the disease.

Eugene always regarded the cancer as something that had happened to both of them. "You know, you having cancer is really a gift," he told her early on, "because now we will never again have the opportunity for complacency in our lives."

That was to be true for the rest of us, though we did not know it at the time. The family was still very fractured at this point. I was

in Seattle, writing fiction and producing the Motion Picture Seminar of the Northwest. Michael was in Portland, making great career leaps in the TV products division at Tektronix. Julia had gone back to graduate school and was practicing poverty nursing somewhere in Appalachia.

Mother was living in Salem, drinking steadily. We older siblings had pretty much dismissed her as someone whose life wasn't going to show much movement, but Toni took an aggressively hopeful approach to Mother, as though alcohol addiction had to be at least as subject to God's will as she hoped cancer was.

For us, Toni's cancer would become a redemptive catastrophe.

When Toni finally decided she would take the chemo, she made it clear to her oncologist that she had certain concerns about her quality of life that were not negotiable.

First, she wanted to die at home. Her oncologist said he would respect that, but that she would have to do her part not to get into the emergency medical system. He suggested she post "Do not call 911" on all her phones.

She said she didn't ever want to become bedridden. He said that might entail refusing treatment beyond a certain point.

She said, most importantly, she did not want to lose her mind. He said he couldn't make that promise to her. She said, in her wry way, that's what she figured, but she was going to pray for it anyway.

So in April, 1985, she began six months of chemotherapy. The chemicals made her feel nauseated, and it was a record hot summer in the Willamette Valley. She couldn't take the antinausea medication because it gave her *grand mal* seizures. Yet her courage was extraordinary. She began to talk of running a 10K race in July.

"People say to me, You are so strong," she wrote in her journal, "but I am not. I am so weak! My strength is in the Lord. He is my rock, my fortress, my deliverer."

I wrote in my journal that summer, "Toni's faith organizes the experience for her, and gives it meaning."

The Post-it on her bathroom mirror that summer read: "Patience is accepting a difficult situation without giving God a deadline to remove it."

The family began to look at her Christian faith in a new light.

On the fourth of July, Toni and Michael went to the races in the nearby town of Independence. He entered the bicycle race and took first place. Then Toni's foot race began, and he cheered her at

the start. He was there at the finish line, to see her place seventy-third out of seventy-seven runners, and he was still cheering, her victory clearly more stunning than his own.

In the fall, Toni had radiation for six weeks. After that, all of her tests were clean—her bone and blood scans, her mammogram. She'd done it; she'd licked it; the cancer was gone.

But in Tennessee, Julia was reading Toni's letters describing the degree of lymph involvement and was able to stage Toni's cancer from her medical books. Although Toni had gone into remission, Julia foresaw the probable course of the disease, and moved back to the Pacific Northwest, where she had not lived in seventeen years. She joined me in Seattle, took a job at a Skid Road clinic—and waited.

In January 1987, after a full year without cancer, a small nodule was removed from Toni's right breast. She was told the results of the biopsy over the phone. She was angry, anticipating another round of doctors, humiliation, X-rays, being poked at, shuffled around and tested.

She went to see her oncologist, who recommended a stronger chemotherapy this time around. She was against it, because she knew that would mean another round of nausea, vomiting, weakness. She just didn't think she could take it. Adriamycin was one of the chemicals he was recommending, and that meant hair loss. She said no way. She went to Oregon Health Sciences University for a second opinion. That was the first time she ever heard the words "Stage 4 Cancer, Incurable."

This is what Julia had feared all along: now she moved home to Oregon and took a job as a nurse practitioner with Multnomah County.

When I listened to the tape recording of Toni's second interview with the oncologist, I couldn't believe I was hearing so much resistance focused on hair loss. I called her up and exercised an older sister's authority. "Take the damn Adriamycin," I told her.

"That's fine for you to say," she told me. "You're not going to lose your hair."

I went out that day and had my head shaved to about a quarter of an inch of peach fuzz all over it. Then I sent her a photograph. On the back I'd written, "Chemotherapy solidarity."

<center>ဢဢ</center>

Toni's thinking evolved from, *Why is God doing this to me?* to *Why is God letting this happen to me?* and finally to, *What does God want me to do about this?*

When she finally realized she would go ahead with the chemo, she planted four acres of strawberries. We were astonished. The thousands of tiny plants that she put into the ground in May would not be ready for harvest until the following year.

"My feeling is: we go for the long haul," she wrote in her journal. "We learn to live with cancer, we learn to live with chemotherapy. We learn to adjust our lifestyle. We pace ourselves. We draw on the help our friends and family offer, and we are careful that no individual gets burned out—because we will probably need to go through this again. We pray for healing. But whether this is the last time, or only the second in a series, Jesus is still Lord. We will continue to praise Him and give glory to God. We *do* pray for healing, but most of all we pray for the Healer Himself to come and make our lives meaningful."

Her chemotherapy lasted six months. Halfway through, she had a port-a-cath installed to receive the chemicals on a slow drip. She lost her hair completely. Photographs of Toni that summer show her wearing a variety of wigs, turbans and scarves as she hoes the young strawberries.

Toni's case was becoming known. People came to interview her, to photograph her. She'd usually try to have her husband and her children—Hope now eleven, Jess seven—present. Once a young reporter said to her, "I guess something like this makes you rethink your priorities." "Not really," Eugene said. "Ever since we got married, seventeen years ago, we have spent one January weekend, just the two of us, at the beach, praying and writing and talking about what is important to us. When the cancer hit, we were already trying to live the life we wanted."

<center>℘℘℘</center>

Meanwhile, Mother had been available to her for every emergency, even to the point of going one or two whole days in a row without a drink. "This is changing our relationship," Toni wrote in her journal. "Suddenly she has shown me so much compassion and mothering and care."

In the fall of 1987, Toni asked two things of me. She wanted to know if I could be available in June and July of the following year

to help her harvest the strawberries. And she asked me to put my writing skills to use and help her compile a manuscript which she would leave as a testimony for her family and friends.

When I eventually moved back to Portland from Seattle, Toni offered to help me pack and move. "No way," I told her. "This time it will be a professional mover." "Well," she said, "you'll need some help on this end, cleaning and unpacking." And I was thinking, But it's not going to be you, kid.

She came back with one of the most important lessons I learned from her. "When I was sick and my friends came into my house and cleaned the toilets," she told me, "I didn't think I could stand it. And one time I came home from the hospital and looked out my bedroom window and saw an eighty-year-old man from our church weeding my strawberries! Oh, no, I thought. He'll kill himself! But Martha," she said, "sometimes you have to let people help you."

In March 1988, Toni began to experience symptoms of extreme thirst. A CAT scan showed thirty little BB-size tumors in the brain. "They're small," Toni told me on the phone, "but they're trouble." The doctor said she might be looking at a matter of months left in her life.

This was one of many terminal diagnoses which she outlived. After five weeks of radiation to the brain, she had another scan: the tumors were no longer detectable. She would live another two-and-a-half years beyond that prediction.

In June, we began preparing for the first strawberry harvest. A neighbor pulled a trailer into Toni and Eugene's driveway, and I moved into it. Five days before we began the first pick, we learned that the cancer had metastasized to her lungs. "If Jesus Christ is not who He says He is," Toni said, "then now would be a really good time to find out."

Yet we had a wonderful summer, up at 5:00 each morning and starting the crew at 6:00. Toni had about sixty pickers out there, many of them Mexican people. That's a culture we both loved. I had painted the outhouses white and labelled them *Damas* and *Caballeros*.

Every afternoon, after the pickers went home and the buckets were picked up from the field, washed and stacked for the next day, and Eugene had left to drive the berries to the cannery, Toni and I would shower, and lie down, and talk about her manuscript project. We tape-recorded seven interviews that summer and these, along with her letters home from Peru and the journals she had kept for years, became our primary material.

"Toni has made a sacrament of her life," I wrote in my own journal that summer.

And I wrote: "Toni is not in control of her life: God is. She does not try to wrestle that control away from God, but to accept and to praise."

And I wrote: "Toni's only 'victory' is surrender."

And later that fall I wrote: "Toni's hair is growing back!"

The following Easter, in 1989, she was asked to give her testimony in front of her congregation, the McMinnville Covenant Church.

"I wish I could tell you that the cancer has been totally removed," she said that Easter, "but I cannot. God is still working. Since the beginning of this year, we have learned that my lungs are a little worse and they found two small spots of cancer on my bones. What does this mean?

"I think it means, Ask not that it be lifted, but rather ask for God's grace to fulfill the task. Ask for sufficient grace to come closer to God, that you may be lifted above the circumstance."

This was to be the beginning of a public speaking career.

The family began to wake up to something about Toni. Julia mentioned it first. She had been driving Toni around on some errands, and when they stopped to put gas in the car in Sheridan, all the attendants came out of the station and went around to Toni's side of the car, wanting to talk to her, wanting to be in her presence. Julia said it was the same at the post office, and the same at the hospital. All these people were getting something from Toni.

To my mind, the impossible had happened. The sibling order had been reversed: now we were the little ones, and Toni had become our teacher.

ℰℭ

One day in July, when I had been planning to drive out to Toni's to spend the day putting up blueberry jam, she phoned me early in the morning to say she'd had a coughing spell during the night and snapped a rib. "Don't come," she said. "We can't get any jam made with this broken rib." I went out anyway, and we waited together for the doctor to return her call. She had a wrenching cough, along with the broken rib.

"Pain narrows vision," Toni wrote in her journal. "The most private of sensations, it forces us to think of ourselves and little else.

That is why it is so important to me to keep my mind filled with scripture and music, which focus my attention on God."

"God stands within the shadow, behind the dim unknown," I wrote in my journal.

In August, Toni and I put up pickles. She had oxygen then, which she used at night and when she wanted to do something strenuous during the day—like can forty-two quarts of dill pickles. Fifty feet of clear plastic tubing snaked around the kitchen behind her, attached to the oxygen machine which clanged and burbled down the hall.

Later that summer, we borrowed a wheelchair and took Toni to the Polk County Fair. I remember the cool poultry barns, the beauty of the white and polka-dot show chickens.

That summer, Eugene gave a sermon at McMinnville Covenant. "When doubt strikes," he said, "it is time for digging deeper into God's word, rather than closing the Bible and walking away. It is time for more praying and committing our will to Him. Doubt is not the opposite of faith, rather disobedience is. If we are choosing to be obedient to God ... we are able to see how the process of doubt is woven into the process of faith."

That autumn, Toni had a health crisis. In a week she lost five pounds. She was fitted with a morphine infusion pump and needed several lung taps. The family began to take turns staying with her. This is when all the phones in her house were finally labelled: "Do Not Call 911."

During my first shift, I phoned sixteen people and put together a chore network, two hours per week, mainly people from Toni's church. I was on the phone one afternoon when Toni called out for me. She wanted to take a nap, and she asked me to lie beside her and make sure she didn't stop breathing as she dozed.

After Julia took her shift, she told us Toni's metastatic brain cancer had probably returned.

Word was getting around that Toni was failing, and on Sunday night, the elders of McMinnville Covenant visited the house and laid on hands. Then they announced a week-long prayer vigil, in which the whole congregation participated. I phoned the associate pastor and got my name on the list for the 10:00 a.m. slot. I'd never been part of a prayer vigil, and I prayed the nine names of God which Toni's friend had sent her four years before. "*Jehovah Raha*, the Lord my shepherd, who leads me to water and sweet pastures, who counts me at night."

At the end of the week, Toni rose off her bed, got her strength back, and even went the following month to be the keynote speaker at the 1989 Covenant Women's Retreat at Black Lake Bible Camp, in Tumwater, Washington.

I went along with her to push the cart which carried her eleven-pound portable oxygen unit.

There, in front of 300 women, she gave her testimony which said, in part, "I remind myself: Let God be God. Don't demand healing; don't demand death on certain terms; don't demand closure. Be open to His will."

The afternoon was set aside for small workshops, and Toni was giving one called Ministering to the Dying. We were told we'd get fifteen participants.

I walked her to her assigned meeting room after lunch and got her settled on a high stool at the front of the room, with her oxygen tank nearby. Then I scooped up her twenty handouts and went and stood by the door to greet people as they arrived.

One hundred and fifty women walked through that door.

I learned something that day. In any crowd, no matter how unruffled they may look, or how serene they seem, there are always people who harbor deep suffering, people who are ministering to the dying or caring for the sick, or praying about their own diagnosis, or weighing the worth of continuing to live.

One of the scriptures Toni used for that workshop was II Corinthians 1:4: "He comforts us in all our troubles, so that we in turn may be able to comfort others in any trouble of theirs and to share with them the consolation we ourselves receive from God."

After the conference, Toni and I concentrated on finishing her manuscript. It was a book-length effort, which went through five drafts. Now we spent three days together at the Embarcadero in Newport, line editing. Her plan was to print a dozen copies and have me deliver them to the designated recipients on the one-year anniversary of her death.

In December, Toni experienced loss of balance and vision problems. She had a myelogram which showed carcinoma meningitis, cancer of the spinal fluid. A new doctor, this time a neurologist, told her she had three months to live if she did nothing.

Toni was offered the option of a brain operation, a "bubble" implanted in the skull through which chemo could be poured directly. The neurologist said it might extend her life as much as twelve months.

Toni was leaning away from the chemo. She was ready to live out her last quiet, normal three months at home, doing what she could do to be a wife and mom. "Even if I'm just defrosting dinner," as she put it.

Again, Julia read the literature. She determined that the chemo was *not* so much likely to extend her life but might block the progressive cranial nerve deterioration associated with meningitis: water on the brain, coma, death.

Julia had registered for a month-long language course in Nicaragua. Now she cancelled her trip; if Toni refused the chemo, she would need nursing care.

But someone, a nurse I think, talked Toni into the chemo. After a week of research and prayer, Toni told us she was scheduled for brain surgery. An Ommaya reservoir was implanted in her head, and a Groshong Catheter in her chest, so she could take morphine without needles.

After the surgery, Mother drove me to the Greyhound station to catch my bus back to Seattle, then doubled back to the hospital, where she sat and fed Toni chips of ice for two hours.

The next day, they dripped chemo down through the hole in Toni's head, directly into her spinal column. She was doing all right, so they released her from the hospital. Someone said of Toni's remarkable stamina, "It just goes to show, if you have the spiritual resources, how far modern medicine can help you."

On New Year's Day, Toni and Eugene made a resolution to go out on a date once a week.

ᔕᗝᑕᖇ

Toni's great spiritual resources were stubbornness and a sense of humor. Once when her oncologist put her on a new medicine, she was given a long list of signs to watch for, some of which, like vision and balance problems she already experienced from the cancer itself. The last of these symptoms to watch for, was confusion. "So," she asked in a droll voice over the phone, "if you're confused, how in the world do you watch for confusion?"

When she developed double vision, she was told to put a patch over her eye and learn to live with it. Instead, she decided to get help on her own. She called Pacific University's Family Vision Center, and they replaced the eye patch with a prism on the inside of her right lens and started her on vision therapy. She went to the vision clinic

every week for two months and did the prescribed exercises faithfully every day at home. When she was re-evaluated, they found both her vision and her eye coordination had improved. In fact, the ophthalmologist told her he had begun writing an article on her case for a professional journal to show physicians that improvement can be made with vision therapy even in cases of cranial nerve damage from cancer.

In June, 1990, Toni got a call from a television producer, asking her to appear on a local talk show. KATU-TV was planning an episode of Town Hall around the suicide of Janet Adkins. An Oregon woman, she had enlisted Dr. Kevorkian's help in giving herself a lethal injection in a Detroit motel room after learning she had Alzheimer's. The producer was casting about for someone who would be willing to go on the show and say they *would not* use Dr. Kevorkian's suicide machine—someone, that is, who was actually dying. At that point, Toni weighed ninety pounds, and had lost six inches of her height. She walked with a cane and with her neck bent at a ninety-degree angle, her head facing the floor, her eyes peering up to the side to avoid bumping into things. But she went on the air, along with Derek Humphries, who was head of the Hemlock Society, and Ron Adkins, Janet's husband.

The show was staged arena-style, the host whizzing around the center platform on a swivel chair, making quips intended to incite debate. As an invited guest, Toni was seated in the front row of bleachers, frequently in view of the television camera. She didn't say much, but I could see that her frailty and poise affected people. She did not presume to tell anyone else what to do, nor was she interested in the issue of legal rights: she only knew God did not want her to take her life; that God had given this one gift, and that she would wait on Him to take it away.

Carol Remke, the girlfriend who had accompanied Janet Adkins to Detroit, was also on that show, and she came up to Toni and me in the corridor afterwards, as Toni slowly made her way toward the exit. With tears in her eyes, Carol greeted Toni and touched her arm.

Two months later, Mother spent a week at Black Butte Ranch, taking care of Toni while Eugene and the kids rafted and swam. It was a beautiful September. Mother pushed Toni's wheelchair down cinder paths, crushing fragrant pine needles. The rest of us have never entirely known what took place there, but when

they returned both Toni and Mother were calm about Toni's impending death.

After Black Butte, Toni declined radiation, and contacted hospice for in-home nursing care. Then, having made those arrangements, she spent a weekend at the beach with her best girlfriend, writing her own obituary.

A week before she died, Michael and I went to see Toni on a Sunday night. She was so frail then; I remember thinking her head was like a heavy blossom on a broken stem.

At dinner, I cut up her food. She dropped two dosages of medications just trying to get them out of her huge pill holder, and they rolled around the floor beneath the kitchen table like so many ball bearings. It was a mess trying to sort them out.

The following Thursday night, Mother had a dream: she walks into Toni's house to find Jess (Toni's son, then eleven) lying on the couch, Eugene in the kitchen, and Toni dead in the bedroom.

The next day, when Mother drove out to Sheridan, she walked in on a scene that matched her dream, except that Toni lay half-conscious in the bedroom.

Mother phoned me. "I think Toni is dying," she said. "The hospice nurse is here, and she thinks so, too."

I called Michael, who left Tektronix, picked me up, and we drove to Sheridan. In the car, I was praying that Toni would live until we got there.

I went in to her as soon as we arrived. Her skin was hot and dry and, although she was wearing her oxygen, she was inhaling through her mouth and vocalizing each exhalation. She lay on her back and her eyes flickered open from time to time. She was conscious. I talked to her at length, held her hand, and prayed with her. That was Friday.

Julia was in Ann Arbor, where she had just begun a low-residency Ph.D. program in public health policy. We were not able to make contact with her until Saturday, and she began hassling the airlines, trying to get home. By Sunday, Toni was in a light coma, but we kept telling her the exact hour that Julia's plane would arrive.

Late Sunday night, I was home in bed, having already said good-bye to Toni, when Julia called me from the Portland airport. Julia drove two hours to Toni's bedside. At 1:00 in the morning, Toni appeared unconscious, her breathing a shallow gurgle. Julia sat with her and told her everything she needed to say. Then she left the room.

Fifteen minutes later, when Eugene checked the room, Toni was dead.

<center>℥ↄℭ</center>

Toni was granted all of her prayers: she died at home, she never became bedridden, she did not lose her mind.

She went through tremendous pain over a five-and-a-half-year period. Was it worth it to her?

"I would not trade anything that I have gone through or am going through in this battle with cancer," she wrote, "for what it has developed in my relationship with God and in a faith that will not let go of Him."

For me, it was a profound spiritual experience of sustained and unparalleled intensity.

I now think when people refuse illness, dependency, and pain, they may be depriving themselves, and others, of a powerful transformation. "Sickness before death is a very appropriate thing," Flannery O'Connor once wrote to a friend, "and I think those who don't have it miss one of God's miracles."

<center>℥ↄℭ</center>

Toni loved this scripture, and always quoted it whenever she spoke in public:

> Though the fig tree does not bud
> and there are no grapes on the vines,
> Though the olive crop fails
> and the fields produce no food,
> Though there are no sheep in the pen
> and no cattle in the stalls,
> Yet will I rejoice in the Lord,
> I will be joyful in God my Savior.
>
> The sovereign Lord is my strength;
> He makes my feet like the feet of a deer,
> He enables me to go on the heights.
>
> —Habakkuk 3:17-19

OCTOBER SONG

I phoned my brother Michael and asked him to come and see me. I told him I'd been thinking about the sixties, and I wanted to hear him retell one of his stories.

The sixties ravaged our family. After we lost our father in 1964, the rest of it—the drugs, the wandering—seemed inevitable.

It wasn't until after we got off the phone that I realized why I was in this mood. It was nearly October. In 1990, we lost Toni to breast cancer on October 15. We were approaching the fifth anniversary, although I don't know if I'd even acknowledged that yet. I've heard our bodies know the anniversaries of grief before our minds do. Something in me was already responding to the turning of the year, the night's chill, the shorter days, the new stars. Even in the city you could see Vega, so bright now in the west, and Cygnus, the swan constellation, directly overhead.

You'd think that now, what with two of the family gone, Michael and I would be even closer. But what with one thing and another, we were often too busy to get together. I was at home writing and he was at Intel, where he provided technical support for the engineers designing computer boards at their UNIX work stations. Evenings we both had classes. He was taking something called Discrete Structures and teaching two classes in Tai Chi. Weekends he studied at home, as did his wife, Angi, an engineer from Bucharest who was working toward her master's degree. With my friend Geronimo, I talked in cafés about writing, watched films on videotape, or we went dancing. Geronimo grew up dancing with his sisters in the strobe-lit soul clubs of the San Jose Valley, and he was a joyful, tireless dancer. Sometimes, when a get-down blues band played in a club with a big dance floor and good ventilation, I could get Michael and Angi to come with us.

Dancing with Michael took me back to our childhood, when music was our healing balm. In the fifties, the four of us kids would shimmy, two-step, cakewalk and reel around the living room to the deafening sound of the Dixieland records our parents brought us straight from Bourbon Street. Meanwhile some babysitter would stand slumped against a doorframe, her body language an acknowledgement that the situation was way out of control. In the sixties, dancing was how we moved through the pain of our father's death, and dancing was how we staved off our fears for our mother. We lost ourselves in dances full of little hops and long glides, feeling like the Fabulous Flames, who backed James Brown. We did the groove, the mashed potato, and a synchronized line dance called the J Fred, where we spelled out each of our names. We kept Aretha cranked up 125 percent. Our attachment to music was so complete (and our isolation so severe) that we took Sam Cooke's murder harder than JFK's.

Two decades later, when the cancer was killing Toni, Michael tried to get the four of us siblings out dancing. He began to look through the entertainment pages for some ersatz Motown sound. Toni's husband nixed that date, I remember. Then it turned out that the same weekend we were to have gone out, Toni broke a cancer-riddled rib. "Godalmighty, Michael," I said on the phone. "She had a coughing spell during the night and she heard this snap! It's a good thing we weren't out on some dance floor when that happened."

"I'm sorry we *didn't* go," he said. Then we both were silent.

ℰℭ

Anyway, Michael said he'd come over. I can't remember him ever refusing me anything. I said I'd cook dinner.

I was at the stove when he came through the door carrying a six-pack of Rogue River red ale. I stirred a pound of dry rotini into the boiling water as he stashed four of the bottles in the refrigerator. As I brought our dinner to the table, he talked about this great Chinese guy he used to study with. "When we were done, it felt like somebody had poured lighter fluid on my legs and lit them," he said. "I like that in a Tai Chi class."

I checked the table. It's a long table, refectory length, covered with a piece of blue cloth which I bought from the school children who wove it in the Guatemalan highlands. Yellow napkins, white plates, red candles, everything was in place.

"Now what in the hell are discrete structures?" I asked, after we sat down.

"Boy, that's a hard one," Michael said. "If I knew, I wouldn't be taking the class."

"Just give me the twenty-five-word course description."

"It involves notations and techniques that we use in math, in my case, writing the compilers that translate computer programs into machine code."

"Well, that's just perfectly clear."

"It doesn't necessarily condense well," Michael said.

Darkness was at the windows, and a breeze stirred the big maple, heavy now with brown pods.

I wanted that connection to Michael that I had felt all during our childhood. "Tell me again how you got out of the draft."

He looked at me in a certain way he has (our father had it, too): a potent stare that announces the next remark matters. "You carry this guilt for a long time," he said. "Like I should have had to go through that experience." His close-cropped hair and beard are gray now, but he has that same level gaze he had as a kid.

"I remember this one guy, Ron, who was our class clown in high school. He was an artist," Michael said. "He came over to the house to visit me when he got back from Vietnam. He told me about living totally on his own in the jungle. 'I'll give society a try,' he said, 'but if it doesn't work out, I'll just go out to the woods and live on my own.' There was nothing funny about Ron anymore."

"Ron Weaver," I said. I'd known him, too. I tipped Michael's glass forward and emptied the ale into it. We watched the foam subside.

"I left Antioch after the summer of 1967," he began, finally. "My draft notice beat me home. I drove across country, and they mailed it. I was disappointed because Antioch was this big liberal arts college, and I thought that meant something. I thought I'd have a couple of months to clear my head before it hit. But good old Antioch had immediately notified the draft board that I was not a student anymore.

"Well, not a draft notice. It was a letter saying my status had changed, but everybody knew what it was.

"My initial thought was I should make it my experience rather than theirs. Instead of waiting to get drafted, I went down to recruiting and tried to sign up with the Air Force. They sent me to Portland to do their physical.

"But by the time I got to the induction center, I was thinking I could change my strategy: if I marked all these little boxes—the homosexual boxes and the drug boxes—I could get out legitimately, while making it look like I was trying to get in. I could turn this thing around."

"Good thinking," I said.

"I tried it, but it didn't work," he said. "The Air Force rejected me because they consider themselves an elite group. They turned junkies and faggots over to the Army."

I passed Michael the salad, holding the big bowl while he tonged out glossy pieces of romaine lettuce. "Before you get to the part about the Army," I said, "tell me the part about your preinduction physical with the Air Force."

"You are undressed and you are in a long line. You are wearing briefs, and they are wearing full uniforms." Michael swigged the last of the ale in his glass. "It's surprising how much you learn about the features of the service."

"This was October 1967, right?"

"Just before the Tet Offensive," Michael said. "The Army was drafting everyone at that point ..."

"You mean they'd used up all the Brown and Black boys by late 1967." I was thinking of Geronimo, who was Filipino and drafted early, in 1963.

"The game was different now," Michael agreed. "They were stuffing anyone and everyone into the cannons and blowing them out."

I remembered. In 1964 we had 23,000 men in Vietnam; by the end of 1967, it was nearly half a million. I remember being afraid the next one in our family to die would be Michael.

"I went around and said good-bye to everybody," Michael said.

But not to me. In October 1967, I was living in a single rented room in a Montreal lodging house, studying Spanish, Chaucer and Russian history at Sir George Williams University, awkwardly involved in two separate love affairs, and working a 40-hour week at a used and rare bookshop on rue Sainte-Catherine, where I earned sixty-five dollars a week. I didn't get home to say good-bye.

"Strategy number three," Michael said. "I'd read a little bit of William Burroughs and I decided I'd go to Vietnam and be a junkie."

"That sounded good," I said.

"From Burroughs' point of view," Michael said, and we both grinned.

We had finished our dinner now. I took the plates to the sink and brought two fresh bottles of ale back to the table. We leaned in toward each other, elbows planted.

"So, I went back up to Portland, and stayed at the YMCA," he said. "A couple of friends picked me up and got me stoned. I remember they had this late-thirties model Chrysler four-door sedan, with running boards. At 3:00 in the morning they pulled up to the curb in front of the Y and I fell out of the car through the suicide door. I was totally tanked.

"The next moment it was 6:00 a.m., and time to go to the induction center. The room hadn't even stopped spinning for me.

"I thought, I'll get to Fort Lewis and they'll call me a hippie and chop off my hair. So why get into it with these *clerks*? I figured there's no reason to get upset with them. I was just moving through their little ceremony.

"But I had this piece of paperwork that had come out of my preinduction physical, and the Air Force guys had annotated the shit out of it. It had all this writing in the margin.

"I felt myself getting kind of channeled off, away from the mainstream, down a special chute.

"Around this time, Arlo Guthrie had put out *Alice's Restaurant*, which had this song 'Group W Bench.' And it was really like that: there were a few of us who ended up waiting in that line to talk to the shrink."

"The short line," I said.

"Definitely," he said. "I went in to talk to the shrink. He asked me which drugs I'd taken, and when we got to LSD I said, 'Yes,' and he just flipped. He started screaming about how it had been the ruin of our country. That made me laugh. I thought this guy's got a problem; LSD is a trigger for him. He started becoming irrational. The more I laughed the madder he got. He banged his fist on the desk. I thought he was going to hit me. He said, 'We'll get to the bottom of this. I'm going to send you to a civilian shrink!'"

Michael pried the cap off the ale I'd set in front of him and took a pull off the brown bottle. "Like that was going to scare the crap out of me," he said.

"Then they let me put my clothes back on, but I was still in a holding pattern. I started reading magazines. It had become real

obvious that I was not being processed. They were all getting stamped through and I was sitting on this bench."

"You were special."

"Which meant there was something wrong with me. People started staying away from me. They all knew they were going and that I wasn't."

I looked into Michael's brown eyes. That charade in Portland may have saved his life. But for him it's more complex than that.

"They called my name and I went to the front desk. The clerk said, 'You've been permanently rejected from the Armed Services. I bet *that* really hurts your feelings.'

"And I said, 'What happened to the civilian shrink idea?'

"The clerk said, 'I guess they thought that was too much trouble.' He was like, 'What do you want here? You're out!'

"But I was thinking, What happened to the shrink? That sounded like a great idea. I'd always wanted to see one of those guys."

"Tough luck," I said.

"Yeah, right," Michael said. "The desk clerk said they'd issue me a bus ticket, but it would take a while, so I went to over to Fifth Avenue Records, and I bought Arlo Guthrie's *Alice's Restaurant*."

I got up, went into my study, and came back with a stack of Michael's letters. As we leafed through them, my eyes took in the greetings: "Dearest Martha," *"Mi amiga, Marta,"* and even, "Dearest Martha love." There was no letter for October 1967.

I turned the letters face down. Michael finished his ale. There were two more cold ones in the refrigerator, but I sensed he was about to leave.

"Just a minute," I said. I went over to the tall cabinet where my tape deck sat. "I want you to listen to just one cut."

It wasn't Arlo Guthrie. I don't own any Arlo Guthrie. It was Sam and Dave singing "When Something is Wrong with My Baby."

I cranked up the volume, then came back to the table, sat down by Michael, and together we listened to one of the great soul songs that Isaac Hayes wrote with David Porter. The lyrics speak of the pain we feel when a loved one is in trouble. The melancholy singers insist that this pain can never be understood by the listener— *by you*—and this certainty that one suffers alone is exactly what draws us into our own memories of suffering on someone else's behalf.

Michael and I sat and stared across the room at the speakers, his old set of speakers. His old amp and tuner, too. Outside the wind

blew and the big maple rubbed against the west window, while overhead, even the stars tracked their missing loved ones; Cygnus began his slow dive toward the west where his beloved Phaeton had drowned. I didn't need to speak it aloud to Michael; my own thoughts ranged from the kid sister we lost to his friend Ron Weaver, who went to Vietnam, came home wounded, and disappeared into the forest.

We usually skip the slow songs, but Michael turned to me with a look, and we stood at the same moment, pushing our chairs out of the way. He put his right hand against the small of my back and I felt his cotton shirt against my cheek. We danced as we had been dancing together since we were kids, as we might have danced in 1967, the year this song came out, had he not been hassling the draft board in Oregon, and had I not fled to French Canada, sickened by news of the build-up in Vietnam, and the televised images of elderly Black people charged with horses and whipped by their riders.

Sam Moore and Dave Prater. They got together at a Miami nightclub called the King of Hearts in the late fifties. Dave was cooking at the club and jumped up on stage while Sam was singing. I never saw them in person, but I've heard they performed in day-glo green suits.

My brother and I danced slowly around the room, listening to Sam and Dave, as they worked those close harmonies that, one might have thought, only siblings could make.

LOSING THE FARM

From my small urban lot in inner northeast Portland, I sometimes find myself looking back with longing for those fields and gardens on the 240-acre parcel near Independence, Oregon, where my maternal grandfather once raised hops.

There were two identical 1910 houses, set, for privacy, at opposing corners of the farm. When my mother inherited this property, we moved into the house my grandfather had chosen to remodel in the early 1940s. The second house was occupied by the tenant farmer, a dour and silent man whom we might see in the distance, riding the tractor. My parents extended my grandfather's improvements by planting artichokes and roses and wide green lawns on which to play croquet.

Supposedly, we were confined to the five acres immediately around the house that the tenant farmer didn't work, but I trespassed that absurd boundary at the first sign of good weather.

My grandfather had taken out the hop yards in the late forties, and the land lay quiet and lush with wheat and barley. But the old hop barn and dryers still stood, buildings of mystery and substance, and I liked to prowl around there even though I'd been warned repeatedly to stay away. I often found wooden-handled hop knives in the overgrown weeds and, one summer, I climbed the iron track that ran up a long ramp leading to the second floor of the dryer. At the top, I pulled on the two bulging double doors, but they were fastened with rusty wire and wouldn't give. Finally, I broke in through the ground floor and stood tentatively looking around. Dust motes flickered in the pale shafts of sunlight from the open cupola, and I could make out a few old bushel baskets and gunnysacks strewn about the floor. When my eyes grew accustomed to the dimness, I saw the extinguished kilns. Looking up toward the high rafters, I

almost stopped breathing: those upper doors bulged because the old iron hop-hauling car was resting against them from the inside, ready to cut loose and fly down the track. I never went near the hop dryer again.

Between my mother's farm and the Willamette River lay the Horst Ranch, 1,100 acres of river bottomland that had once been the largest hop field in the world. E. Clemens Horst was a German-born New York hop merchant who had moved out to San Francisco in 1902 and, within a few years, started hop ranches in Oregon and British Columbia. In 1934, the Oregon Horst ranch could house 3,000 workers. After the hop boom was over, in the fifties, one of the big produce corporations leased 500 acres to plant asparagus. But with management headquartered in Hawaii, they abandoned the lease after the 1960 asparagus season.

That fall, Dave Kennedy, a neighboring farmer, mentioned to my father that the Horst Company might be willing to sell, now that the lease revenue was gone. My father contrived to act fast, before the property was officially put on the market.

Kennedy also did some nightclub singing on the side, and he happened to be booked for a weekend engagement in the lounge at the Village Green Resort in Cottage Grove. My father invited two friends to spend the weekend at the Village Green, his own law partner and a buddy who sat on the bench of the Marion County Circuit Court. After Kennedy's set was finished, the four men set up a makeshift bar in one of the rooms and talked for hours.

I heard none of the discussion, of course, because I was at home babysitting my siblings. But I heard the announcement when my parents got back on Sunday night: they were buying the Horst Ranch and changing the name to Green Villa, a reference to the resort where they'd made their decision.

This new property was four times larger than my mother's farm and it ran for several miles along the Willamette River, between Salem and Independence. It had a 40-acre lake, three labor camps left over from the hop years, and in one of those camps a cantina and a dance hall.

For me, the real magic of that ranch didn't come from the added acres to explore, but from the community that would soon take up residence. On buying the asparagus operation, the four partners had also bought into a deal with a labor contractor, and he was on his way, the partners soon learned, from Eagle Pass, Texas, with a

caravan of 750 people, due to arrive in April. For the first time, we would have neighbors.

They came as families, two hundred adults and their children of Mexican descent, Catholic, hardworking. They settled into the cabins in Camp One and, within days, had come forward to sign up for a tract of asparagus, its size based on how many men in the family would work the harvest. The women either stayed in camp to mind the children or worked in the asparagus packing plant, which Dole had built in the former Camp Two.

Asparagus was a lucrative crop for these families and would become the means by which many were able to leave the migrant labor stream altogether. Green Villa needed a full crew of reliable workers for the asparagus season—April 15 to June 15—after which there were strawberries, beans and other crops to harvest. With five months of work on the same ranch, there was no need to move. By 1965, sixty-three families had settled permanently in Independence, twenty-five of which were, by then, purchasing their own homes.

That first summer, 1961, I spent sixteen-hour days on the farm, operating the little grocery store I had opened at my father's direction, selling a few staples—like milk, masa, and eggs—in order to save families extra trips to town. It gave me the opportunity to meet everyone in camp, and to train a small boy who was quick and reliable, to make change. Rudi was proud to be my official ayudante and we had a lot of fun together in that little store.

At the end of the season, however, Father was startled to learn that I had actually lost money. I explained that I had set prices to match Safeway's, so that the families would not have to spend extra to shop with me, and that I had extended credit to several families and that one man never actually managed to pay off a rather big bill. My father stood there with a look of astonishment—not the astonishment of admiration. I launched into what I had learned over the summer about the dignity of these men. Every week on payday, after coming in from the field, they lined up to get their money, then went home to get clean clothes, which they took to the showers and then immediately appeared at my store window, in freshly ironed white shirts and proudly paid off their bills. "Jesús always came and paid *something*," I explained. The look on Father's face had not changed. "Well, he has twelve children ..." I'm sure I had more to say about that predicament, but Father had simply turned and walked away.

The following summer, I never opened my store. Instead, I was assigned to run the asparagus plant, where the men got their tonnage weighed when they came in from the field, and the women inspected and sorted the "grass" as it moved down the two conveyor belts. Crates of Number 1, Jumbo, Delicado, and Number 2 grass were stored in the walk-in refrigerated room, awaiting trucks that would take them as far as Chicago. I loved that job, too.

Asparagus season might overlap as much as two weeks with strawberries, so as soon as we finished, I moved outdoors to the berry fields, weighing the workers' flats and loading the truck along with two men.

I came home, but only to sleep.

In their homes, women and girls taught me to make carne asada and laughed at my clumsy tortillas; in the strawberry fields, they pestered me to put on a broad-brimmed hat, to cover up with a long-sleeved shirt; at dances, they pulled me down into their laps, where we sat in one pastel-colored satiny heap, waiting for the men and boys to make their way across the floor.

Then we lost the farm. We lost it in the most unpredictable way possible: Father's death at age forty-nine.

It had been his shrewd lawyerly proviso, designed to protect the cash-shy enterprise in its fledgling years that, in the unlikely event of the death, no widow would inherit. Better to buy partnership insurance, he had reasoned, than to have to buy a widow out.

And so we lost Father and Green Villa on the same day.

Within a year, we four kids had talked our young mother into selling her own farm to Green Villa and moving away from all this *nature*, where birdsong and wild blackberries had the power to break our hearts.

Though I lived an itinerant life after 1964—Montreal, Cape Cod, Seattle, and San Francisco—I made it my business to know what was going on in Oregon. Commercial asparagus shifted to Washington, and Oregon came to lead the nation in Christmas tree and hazelnut production. Hops were still grown, though on only 6,100 acres, a fraction of the 26,000 acres harvested in the peak year of 1935, when my grandfather's hop ranch was in full swing.

At Green Villa, the three remaining partners—the judge, the farmer, the lawyer—grew rich and easy. The amount of the partnership insurance was increased, but they never altered the basic rules of the Russian roulette.

The judge died next.

Then Kennedy, the farmer, was diagnosed with the cancer that would take his life.

In 1978 my father's law partner—the last man standing—sold to a Dutch family for six million dollars.

<center>℘℘℘</center>

Since the late eighties, I've been back in Oregon. Portland, where I now live, has grown into a city, and Mexican people are no longer our only link to the larger world. Here Iranian poets recite Farsi verses into the night; Latin Americans bring energy and style to a dozen tango clubs; in every neighborhood Vietnamese chefs prepare squid salad, lettuce rolls and beef noodle soup.

I welcome the new arrivals. Life in Oregon, in the days before espresso, Chamber Music Northwest, and Powell's Books, could be pretty flat. Forty years ago, the only thing we had much of was each other—and our farms. And that's changed, too, of course: in 1960, when there were only 1,768,900 people in the entire state, we were using twenty million acres as farmland; by 2005, with twice the population, we were farming four million acres less.

Though it's increasingly rare to find someone in Portland who grew up in Oregon, from time to time I do bump into some person who spent their childhood on Green Villa—a lawyer, a film editor—and we share stories. Their Hispanic surnamed families now go back decades in the Pacific Northwest. We may wax nostalgic about the peaceful twilights on the ranch or the lively *paso dobles* of the dance hall, but none of us would return to the long days of labor in the baking sun. Nor would I return to any moment prior to 1964 because I could not bear to once again live through the unexpected and defining moment that was my father's death.

The land, though, is in my blood, as are its distinct and eloquent sounds: the singing of many asparagus-blades being sharpened at once, the switch-switch of the big irrigation sprinklers, and shouts of *¿A dónde vas?* or *¡Ven acá!* floating across the fields.

In the forty-year period since my father's death, I must have attended ten productions of Chekhov's play *The Cherry Orchard* because it speaks to my private loss. After the cherry orchard has been irretrievably sold and Lyuboff Andreevna is forced to leave the estate, she says to her brother, "I'll just sit here one minute more. It's as if I had never seen before what the walls in this house are like,

what kind of ceilings, and now I look at them greedily, with such tender love."

<p style="text-align:center">∮∯</p>

Back in 1998, when my niece got married, I went to the poolside reception afterwards at the home of one of her uncles. Pitched high above the Willamette River, it had a view of plantation Christmas trees and the State Capitol to the east and the lavish homes of neighbors to the south. From that height, sipping from a champagne flute and gazing across the blue pool to the lazy end of a summer day, one owned the world. But, of course, we didn't anymore. My family had dwindled to two grown siblings in urban high-powered jobs and my once beautiful and flamboyant mother, now confined to post-stroke silence in a wheelchair. Landless. Long on memories.

Our host pointed out to me that the man over there, the well-dressed one dancing with his wife, was one of two Dutch brothers who had bought Green Villa twenty years before. My heart jackknifed. I had no need to meet him.

Yet after the sun had gone down, and the first batch of guests had drifted to their cars, someone cranked up the music and I found this man standing next to me. After an abstracted moment watching the dancers dangerously close to the lip of the pool, we quietly introduced ourselves.

When he heard my name, he asked if I were the daughter of Parker Gies.

"You know his name!" My father had been dead for fourteen years when this man's family arrived.

"People still speak of him with respect," he said.

I turned to get a good look at him, a handsome man my age, intelligent, kindly.

I told him I'd heard that the farm was doing well, and we talked about the grass seed and gladiolas that were then commercially grown there.

"Have you seen your old house?" he asked.

I couldn't understand why he was smiling; our old house was a disaster. Mother had no sooner sold it to Green Villa than the partners turned it into a rental. Last I saw it, the gardens were gone and the formerly beautiful yard was weed-infested inside a chain-link fence.

He saw the confusion on my face. "You *have* seen how my brother remodeled it, haven't you?"

I realized he must be talking about the *other* house, the tenant farmer's house.

I always thought your family lived in *that* one," he mused.

"No," I said.

After a moment's silence, he told me he had grown up in the Holland, where his grandparents lived in a 1754 house. As he spoke, we both stared at the diving board on the far end of the swimming pool.

"When my grandfather died, my grandmother hired a famous Dutch garden architect to design a one-acre garden. I lived in that house for twenty years after she died. The garden was famous," he told me. "You can even read about it in a textbook."

"I'm sure it must have been lovely," I said. A young woman, fully dressed, mounted the diving board, evidently searching for one of the guests.

"When I went back to Holland some years later, I visited the house," he said softly. "But they had let the garden go to ruin."

"I'm sorry," I said. We turned and looked at each other, briefly exchanging a look of sympathetic recognition.

And then I excused myself to see about my mother, stranded in her wheelchair, and he went back to stand at the side of his pretty wife.

I can't say I was consoled, but I had met the rare person who so loved the land that he could sense the loss in me.

THE POWER OF HUNGER

I mean that if it is important for us to eat first of all,
it is even more important for us not to waste
in the sole concern for eating
our simple power of being hungry.

—*Antonin Artaud*

DRIVING BLIND

A boyfriend once planted me in a Massachusetts commune, where I lived for two months as our relationship unraveled. There the girls grew vegetables, chopped wood for the stove, baked bread, and cooked the meals, while the boys smoked weed on the front porch and then loitered with visible impatience around the kitchen door. When the summer of 1973 ended, I flew to Oregon.

In Salem, I moved into the guest bedroom of a small house my mother had bought after selling her diamond-shaped home on Basswood with its grand view of the Willamette River. I applied for a taxi permit, had my photograph and fingerprints taken at the jail, and within a few days was driving for Yellow Cab, a temporary fix until I figured out what to do next.

There wasn't much to enjoy about the town, a small state capital of maybe seventy thousand people, almost uniformly white, if you didn't count—and few did—the students at the Chemawa Indian School. The wonderful little shop of used books, discovered in my adolescence on a trip to town, had closed, and cultural events were limited to the Willamette University campus. It was a married town, a place to raise kids. But the job was okay. Compared to clerical work, to which so many women in my generation succumbed, it offered variety and a kind of freedom.

Then, too, driving taxi satisfied an idea I'd picked up years before while reading *Conversations with Nelson Algren*: in order to see the world as a writer, I'd best get *out there*, away from the cocoons of academia and the white-collar class. Algren once wrote that the fiction writer "drives a collision course, lights out, along an untraveled way." Of course, that's a metaphor for writing, not living, though to me it seemed Algren laid claim to both. Algren himself had waited tables, mowed lawns, sold bogus appointments for Marcel

waves, picked cotton and black-eyed peas, run a service station, worked for the Illinois WPA, and peddled black-market cigarettes in Marseilles while soldiering in France. That's the *short* list.

By age twenty-nine, I'd been reading Algren's stories of seamen and hookers, bartenders and junkies, boxers and floozies for half my life, and by the time I started driving cab, I'd accumulated a pretty good resume of my own: I'd been a drugstore soda jerk, run an asparagus packing plant, served food and cocktails at a Chinese café, programmed huge IBM computers for Georgia-Pacific, sold used books in Montreal, painted stage sets on the wharf at the old Eugene O'Neill playhouse in Provincetown, and worked several other short gigs.

That first week driving, I discovered it was the poor and the elderly who regularly used cabs during the day. They called a cab to take them to the bank when their government check arrived, and from there to the grocery store, oftentimes the liquor store, and then back home. We had so many calls from five clinics, two rest homes, and the penitentiary, that the dispatcher never bothered to give the full address. Sixteen-twenty-five was the United Methodist Home, from which the elderly needed an occasional respite; twenty-six-o-five, the Oregon State pen, where single mothers often took kids to build fragile bonds with locked-up dads.

One of the day drivers was a talkative New Yorker with an Irish surname. Doolin was vice president of the local chess club, which explained the portable magnetic chess set on his dashboard. He spent his downtime parked in one of the slots at the bus station cabstand, working out chess problems. It was Doolin who clued me in on a number of things.

The company had eight owners, and those guys drove days and hired night drivers to keep their cars on the road 24/7. Hired drivers, assigned to one of those privately-owned cabs or one of the five company-owned spares, earned forty-five percent of what we booked on the meter, though after federal and state taxes, FICA, and a nickel for some accident program, it worked out to be more like a third.

Doolin described one of those owners as a prince. "Jim will give anyone a fair chance, and he's gone to bat for a couple of the younger guys who have a talent for trouble."

Ely, for example, was a wild kid in his mid-twenties, always into something. "If there is a fight or a wreck or a robbery, he's on the scene," is how Doolin described him. Separated from his wife and

seven kids, Ely had a sixteen-year-old girlfriend who worked as a waitress.

"Sometimes he'll take five breaks a night, six nights in a row, then he'll turn around and drive one hundred hours the next week." Doolin shook his head at the thought of pulling fourteen-hour days for an entire week. "They've got him on probation, and it's probably only this owner, Jim, who stands between him and unemployment."

The big fat guy who always wore a uniform of his own devising, that was Andy. He had driven nights for six years, a company record, before he finally got on days. "I've no doubt he knows the town better than anyone," Doolin assured me, "but he doesn't always take kindly to his fares. They say he'll let a ninety-year-old cripple put her own luggage in the trunk without raising a hand to help her."

Doolin's briefing included a couple of the more dire episodes to befall our drivers: Number 38 had been held up at knife point, and Number 23 had been hijacked just one year earlier. "A fare out of Greyhound forced him to get into his own trunk at the point of a gun, then drove the cab twenty-three miles out of town and abandoned it. Wally lost his nerve after that," Doolin said, by way of explaining why I would encounter him dispatching on night shift.

"You're saying I'll be moved to nights?"

"It's where they usually start the new drivers. They previously had two other women, and I heard the first one drove for about a year, day shift. That was six years ago, Miss, so I never met her.

"But the second one, you see, was just last year, this young one named Diane. She's the one went downtown to protest the city ordinance against women driving cab at night."

That tidbit seemed worth filing away, and I later made a note in my journal.

"So she wins her case, and the company puts her on night shift. But then she can't handle all the lousy drunks, so she quits."

"And I pick up where she left off."

"That would be my guess, Miss."

The day after that conversation, Doolin pulled his car into the cabstand in front of the Stagecoach, the bar adjacent to the Greyhound depot. He came up alongside my car window and knocked.

I set aside the volume of Richard Hugo poems and rolled down the window. "What I was saying yesterday about Andy not

treating his fares so good? I should have told you whenever a dispatcher needs help, Andy is Johnny-on-the-spot."

"I'll remember that," I said. In truth, I didn't know if that meant Andy worked the dispatchers in order to get the best calls, or if he would heroically come to the rescue if a dispatcher, alone in the office at night, were in any kind of trouble. In any case, it would soon be clear to me that Doolin was one of the few friendly drivers.

I smiled and went back to my book.

Some of those Hugo poems written about Montana towns could have been speaking for Salem, Oregon: *"Only churches are kept up … / One good restaurant / and bars can't wipe the boredom out."*

<div align="center">℘℧℩</div>

About me going to night shift, Doolin had that right: I got reassigned after I had driven exactly one week.

Before I left days, he showed me how to extricate a heavy drunk if one ever passed out in my cab: open the door nearest your passenger, then go around and get in the driver's seat with your back against the door, extend your legs across the seat, and *push*. Fortunately, I had to use this technique only once, and the man woke up at the last moment and righted himself before I toppled him to the curb.

"By the way, Miss, I heard we have a Zen Buddhist driving nights. Maybe you can figure out who that is."

I gave a little wave good-bye and told Doolin I'd keep him posted, though I figured we'd rarely cross paths once we were on separate shifts.

<div align="center">℘℧℩</div>

As the newest driver on nights, my shift always went right up until 5:00 a.m., when the first of the day drivers came on. I drove a seventy-and-a-half-hour week, writing notes in my journal during the slowest hours, after I'd safely conveyed the drunks home.

Socially, night shift was a whole different affair. I was the only woman driver, as I had been on days, but the night drivers, if we passed on the yard, never met my eyes. If I pulled my car into the Stagecoach cabstand, no parked driver so much as looked over his shoulder, let alone nodded. And if our cars met on the roadway, they drove on as if oblivious.

It made for a lonely shift.

I was a warmhearted blonde, wicked smart, and not much accustomed to having men ignore me.

The night drivers were, on the whole, a group of young or middle-aged white men, unhealthy from late-night chain smoking. Several were also overweight from too many hours at the donut shop, one of the few establishments in that tidy little town that stayed open twenty-four hours. It was a hangout for cabbies and cops, particularly after the bars closed and the town took on a dreamless silence.

One might have thought that not one of these drivers was conscious of me, though I didn't read it that way. To a man, their ability to ignore me could only have been intentional or born from the hope that what they don't acknowledge, a broken screen door, say, will eventually go away.

Still, out of sight did not mean out of mind. The dispatcher's voice was heard in all cabs; every other driver could hear him ask me, "Number 15, are you about to clear?" We heard the address to which each cab was sent on a call, though we could not hear what the cabbie answered, whether they asked a question or turned down a call.

It took me a few weeks to figure out why anyone would turn down a call: there were a couple of bartenders who had the sleazy habit of cleaning out customers, confiscating their car keys, then calling a cab. One night, I took a call that I'd already heard the dispatcher try to give away twice. I walked into a dingy bar on State Street at 2:30 a.m. to find that my fare was a big man who looked more likely to fall off the barstool than stand and walk. This was my first time in the bar already well-known to other cabbies for sending drunks home with an empty wallet.

But it turned out that I knew this guy. Tom M. had done time for felony income tax evasion, and my parents loved to tell the story of his lavish going-away party, where many of the guests thought his pending "trip to the island" meant Hawaii and not McNeil Island Federal Penitentiary. I drove Tom home and left a note on the kitchen table, telling him how much he owed me, along with my mother's address. As I figured it would, the money came in the mail. But I, too, quit taking calls at that bar.

A few drunks never even realized their driver was a woman, not sensing in their impaired condition that there were breasts zipped up in that loose jacket, and long blond hair tucked into the suede newsboy's cap. In that extra polite way of some drunks, at least once

a week a man would exit my cab bidding me a formal, "Good night, sir."

While my coworkers never addressed me, I did have some great conversations with fares, about everything from Filipino psychic surgeons to the history of Oregon's death penalty. I was often asked for advice. People are lonely, and lonely people will talk to a sympathetic stranger, particularly if it is likely they will never see that person again.

An elderly fare told me she'd been married to a driver who worked for another cab company, back in the 1950s, and that he had wanted to buy in. (Doolin had explained to me how hard it was to become an owner because it only made the split smaller for those who already owned.) Her husband took his application for an owner's license to the city, but when it looked as though he was actually going to be issued a license, the cab company accused him of stealing an eighty-five-cent fare. According to this lady, a witness paid to perjure himself made the ploy work: with a record, her husband was no longer eligible for the license.

"But he wouldn't let them get away with that," she assured me.

We had reached her house: mowed lawn, swept walkway, hydrangeas. She fished in her wallet and handed me a five. "My husband sued them for twenty grand, and when he won, the cab company went bankrupt," she said, holding out her hand for the change.

"Now there is only one cab company in town," she said with a sweet smile.

<center>ᔓᘎ</center>

Occasionally a customer—usually a woman—would lecture me for an entire ride on how my life was in danger. I'd be reminded that a woman could expect to be murdered, or at least raped. Once, when this line of reasoning was followed by a demand to admit I was afraid, I waited until I had parked and collected my fare before saying, "The only thing I'm afraid of, madam, is the kind of hysterical talk to which you have just subjected me for the last ten minutes. It ruins an otherwise lovely evening."

There was real risk, of course. Every intersection presented an opportunity to be T-boned by some idiot who only took the car out once or twice a month, unlike cabbies, whose long shifts required

us to be watchful even when exhausted. I learned how frequently people prepare to make a turn by signaling the opposite direction than they intend to go. I learned to drive with both feet, right foot on the gas and left on the brake—exactly what we've all been taught in driver's training never to do—because there will be times when the split second saved is crucial.

A cop once turned fast and wide onto Summer Street and would have sideswiped me had I not yanked the wheel to the curb. He pulled over in front of me and jogged back to apologize, but I was hyperventilating and could only wave him off.

One foggy November night—the foggiest night I can remember in the valley, and I had grown up out there—I was dispatched to an address on one of those obscure streets west of Salem that run straight up into Eola Hills. Of course, we didn't have GPS, and my map was of little use in those conditions. The dispatcher told me to drive west along the Salem-Dallas Highway and take a right up the hill. (No kidding; a left would have put the car in the Willamette River.)

Once I got across the Marion Street Bridge and out past the little West Salem community, I could see nothing but the centerline, and that for only a few feet in my headlights. After the road became rural and the streetlights disappeared, I realized I'd never spot any landmark, let alone a street sign in the cottony fog.

I began a long dialogue with the dispatcher, who repeatedly asked me, "What can you see?"

"Nothing. I can see the white line marking the right edge of the road, but I can't see the gravel shoulder itself." I slowed to twenty, then ten, now beginning to worry I'd be rear-ended by some local driver racing home drunk.

I wasn't even sure how I could turn around and get back to town, since I was driving blind, trying to keep my wheels next to that yellow strip running alongside my car on the left.

This was a bit too literally Algren's "lights out, along an untraveled way."

"But what *can* you see?" the dispatcher kept demanding.

Since he appeared to be my only way out of this, I tried to keep the annoyance out of my voice: "Nothing." "I cannot see anything." "Nothing."

Here I was, maybe eight miles from where I grew up, on a road I'd traveled countless times both as a child and as a driver, and I now felt my fear rising to claustrophobic terror.

"Number 15, *now* what can you see?" The panic in his voice almost matched my own.

Then, for the first time in fifteen minutes, I did actually spot something in front of me: an eerie white light floated above the roadway at the height of a man's head. And then, before I could make sense of that light, I saw a second one, right behind me.

"I think maybe there's another taxi out here," I told the dispatcher. "Come in, Number 38," he said.

Of course, I couldn't hear 38's reply, nor did I even know the name of that driver.

"Number 18, come in," the dispatcher said. "You do see her?"

"Number 14, do you see her too?"

"Come in, 49."

"Okay, gentlemen, then can you get her turned around?" The dispatcher sounded like a happy kid.

Two of these white lights pulled into a driveway or roadway, I couldn't tell which, but left room for me to pull in. We couldn't communicate, cab to cab, but when I started to back out, to head the other way, a third and a fourth white light hovered above the highway, on either side of where I backed out my cab.

Leaving the dispatcher to deal with whoever had called for a cab, the five of us caravanned back to Salem, top lights glowing in the silver haze.

<p style="text-align:center">ℝ℞</p>

Eventually the owner for whom I'd been driving decided to rehire an ex-driver who needed the job to support his family. That left me to drive company spares, and, since nobody took responsibility for those cars, they tended to be unreliable. Several times I had to return to the yard to change cars.

One evening, just as I was beginning my shift, the rearview mirror fell onto my lap during rush hour. I got my fare to his house, then drove out to Broadway and Gaines Northeast and returned the car for good.

I quit.

<p style="text-align:center">ℝ℞</p>

Right after Christmas I joined a stage magician and his wife, Miss Nevada World. My job, which required me to dress like a showgirl,

was to be cut in half in high-school auditoriums from Butte to Nogales.

Like Algren himself, I was on the road.

Nelson Algren. One of my favorite quotations from that book of conversations is when Algren says to H.E.F. Donohue:

"Well, you asked me what's the matter with American literature and I think the trouble with American literature is it doesn't know who it is. It thinks it's Henry Miller writing to Lawrence Durrell and then again it thinks it's James Baldwin telephoning Norman Mailer, and then it thinks it's Jack Kerouac, subsisting on Coca-Colas on a cross-country ride to nowhere.

"Actually American literature isn't anybody phoning to anybody or anybody writing about anybody. American literature is the woman in the courtroom who, finding herself undefended on a charge, asked, 'Isn't anybody on my side?'"

Algren might have pointed out that those night drivers, so many years ago, were never my enemies. They may have been only a paycheck away from the fares I drove to the state pen on visiting days, or to the liquor store for a fifth.

<p style="text-align:center">℘)℘</p>

I never figured out which cabbie was the Buddhist, but I did know that four of those guys drove out west of town to search for me, unprompted. Since they couldn't talk between cabs, and since we had no cell phones back then, each must have had the same idea independently. Hearing the dispatcher frantically trying to talk me through the fog, each driver had set out on his own to rescue me.

Yet after that night little changed. I tested that fact by walking into the donut shop a few nights later. I stood at the counter, and while the waitress was getting my black coffee to go, I glanced over at the clutch of half a dozen cabbies at their usual table by the front window. Were my four guys in that group of drivers? One or two of them? I studied their faces as they leaned on their elbows, caressing coffee mugs, but I had no way of knowing.

As usual, I got no nods and no smiles, but a couple of them did look up.

Briefly.

SUBSTITUTION TRUNK

He needed a stage assistant for a traveling magic show, someone available to spend three months out of town.

I sat in the beige-on-beige living room of the magician's ranch-style home and listened to him reminisce about his most recent assistant. The Great Kramien was a portly man, around fifty, whose thick, dark hair crested in romantic waves above his face, in the style of old-time matinee idols.

"This kid was gorgeous," he said. "You know, Chinese." His beefy right hand dipped into a can of peanuts by his chair and he popped a handful in his mouth.

She had deserted him, inexplicably, for a job as a bookkeeper.

From the next room came the coo and caw of a large aviary.

A woman came into the room, bringing us coffee, its surface a soapy white swirl.

"Thanks, doll," Kramien said. "This is my wife, Miss Kathleen."

Miss Kathleen, who had showgirl stretch legs and a sculpted bubble hairdo, already an anachronism in 1974, was considerably younger than the magician.

"Miss Nevada World, 1969," he called after her. "Right, babe?"

Miss Kathleen didn't answer and we proceeded with the interview.

Kramien had seven elaborate satin costumes, custom made for the Chinese girl, and now he was looking for someone who wore size five. They would fit me without alteration, which I took as a sign: here was my opportunity to learn the secrets passed down through the ages by sorcerers.

Kramien did allude to the salary, but that was not my main concern. (I might have felt differently had I understood that all my own road expenses came out of this modest amount.) We shook hands. From his itinerary (the expired mining towns of the Continental Divide) and his venues (public school gymnasiums), I understood Kramien was third-rate. It only enhanced the fascination. At twenty-nine, I still believed that authenticity sprang only from the lower depths, an idea I would hold dear right up until I took a job as a sheriff's deputy. But that was later.

I left in early January. My single suitcase held jeans, T-shirts, guidebooks for six states, and a paperback biography of Houdini. Mildew freckled its pages, but it had cost me only thirty-five cents.

My mother drove me to a Portland freeway exit off I-84, where I was to meet up with the Great Kramien. At 5 a.m. the magician pulled up in a white Cadillac, Miss Kathleen in the passenger seat beside him. My mother, whose emotional support looked more like bravado when extended to some of her children's dubious pursuits, said simply, "Write if you get work." It was an old gag between us. I climbed into the Cadillac's commodious leather-upholstered backseat, and waved good-bye to her through the tinted window.

The entire show followed us in an eighteen-foot truck: prop storage, animal pens, aviary, and living quarters for the young driver and his wife, Roy and Iris. With a leer, Kramien advised me they were newlyweds. The truck was painted red, with the magician's name on either side above a top hat and two wands; it represented Kramien's entire fortune. I noticed that whenever he lost sight of it in the rearview mirror, his breathing changed.

Riding east through Oregon and Idaho, Kramien talked me through the show.

"We're talking fifty-six cues in an hour-and-a-half," he said, looking at me sharply in the rearview mirror. I also had the seven costume changes, and when I was not on stage, I was supposed to be loading animals into props.

"We do the whole show to taped music, hon," Miss Kathleen said, "so everyone's timing has to be perfect."

Kramien interrupted her. "We absolutely never tell anyone how the illusions are done." He shifted his bulk around and looked me in the eye with a stern pronouncement. "Remember that, kiddo."

"As we go through these illusions, just write down the names and your cues," Miss Kathleen said. "The magic will all make sense when you have a chance to see the props and study the gaffs."

A "gaff," she explained, was the unseen mechanism that made the magic work, an ingenious device, such as a black velvet pocket or clear plastic inner lining, a false door, ceiling or wall, a secret lock, or a hidden blade.

When Miss Kathleen finally described the Substitution Trunk, the sensational first act finale, she said, "It's probably the closest thing to magic you'll ever see."

The audience sees a solid, heavy trunk. On stage there's also a cabinet, which she described as standard magician's equipment: drapes hanging on four sides of lightweight aluminum poles. The magician reaches into the trunk, lifts out a large scarlet bag, and holds it open while a girl steps inside. "That will be you," Miss Kathleen advised me. Men are invited up from the audience to tie the bag shut, you sit down, and they put on the lid with you inside, then padlock the trunk and wind it around with heavy rope. Kramien and Miss Kathleen pull the cabinet around the trunk, and Miss Kathleen steps inside the cabinet, holding the front drapes closed so that only her face is visible. The magician counts to three. At that moment, my face appears between the drapes and Miss Kathleen has vanished. I fling open the drapes. The trunk is there, but Miss Kathleen is gone. The men will examine the knots and testify that they are the very same, and undisturbed. Then they will unwind sixty feet of rope, unlock the trunk, and lift the heavy cover. The satin bag is intact. They untie it and find inside—Miss Kathleen! All this happens in less than two minutes.

"That trunk is a tiny dark space," Miss Kathleen told me, "and you've got to be fast. I hope you're not claustrophobic."

"Elevators don't bother me," I said, "if that's what you mean."

"One thing you'll learn," she said, "the tricks that people think are dangerous, like being sawed in half or run through with swords, usually aren't dangerous at all."

Kramien turned a scowling glance on her, which she chose not to notice, and a heavy silence filled the big car.

Half an hour later, I broke that silence by reminding the magician that I had committed to staying with the show only through Nogales, the southernmost booking.

We sped on toward Montana, no one saying a word.

Having read that the infamous Copper Trust hadn't left enough money in the town to buy uniforms for the police, I was happy to find that Butte did have public schools. Our first appearance was at the elementary school gym.

Backstage in Butte, I sat at a makeshift dressing table in the school lavatory, brushing on green eye shadow. My first costume was gorgeous, a sort of satin corset, iridescent green, with a long train of green and gold ostrich feathers which swept the ground. I could see the whole effect in the mirror only by standing on a toilet seat and holding open the cubicle door.

Without knocking, Kramien charged into the girls' lavatory, dressed in his tux and carrying his shoes.

I stepped down off the toilet seat.

He dipped a dirty rag into my jar of cleansing cream, leaving it streaked with shoe polish and grime. "Here's what I was looking for," he said, and he proceeded to shine his patent leather shoes with my cleansing cream, then slipped them on his feet. He shook a couple of red capsules from a prescription bottle and popped them into his mouth. "Five minutes," he barked, then turned and walked back out the door.

When my music cue began, I whipped on stage, too disgusted with Kramien to be nervous. The matinee was full of children and parents.

The Guillotine, a sinister machine with vermilion uprights and a heavy, diagonal cutting blade, required a willing child. Kramien invited a boy to come up on stage. No older than six, the boy hitched up his corduroy pants, grinned at his sisters in the second row, and climbed the little steps up to the stage.

Kramien placed a bunch of carrots on the neck piece of the guillotine and slammed the blade down, sending carrot slices rolling around the floor. The little boy looked on and, remarkably, did not scream or flee.

"And now, ladies and gentlemen, for the first time since the violent days of the French Revolution ..."

Kramien indicated the boy should kneel, with his head across the neck piece. Then, interrupting his own patter, Kramien turned away from the mic and muttered to the boy, "Okay, you little bastard, ready to get your head cut off?" The boy's face made a jump cut from

shy self-congratulation to primal terror. I looked at the audience, but they were still smiling; obviously they had not heard the remark.

When Kramien slammed the blade down once again, I held my breath—it felt as though the crowd did, too. After a moment, the boy lifted his head, stood, looking a little dazed, and then scrambled back to his seat amidst loud applause. Afterwards, he sat with his face pressed into his mother's breast; I don't think he saw the rest of the show.

Meanwhile, Miss Kathleen and I flanked the magician, moving in unison, handing him props, mugging astonishment, and encouraging applause. Every ten or twelve minutes, we'd go offstage and return in dazzling new costumes—violet, indigo, burgundy—all worn with net opera hose and silver high heels.

After my fourth costume change, I came back on stage with a small socket wrench hidden in my bodice. We were approaching the end of the first act: Substitution Trunk.

What made the trunk unique was the requirement that I labor to get out of it. The other illusions required little or nothing on my part; usually it was enough to lie still (as when I was cut in half) or make myself as small as possible (as in the Doll House). Getting out of the trunk was a struggle because I had so little time to work. The first night that I performed the trunk I was clumsy and hyperventilating, as frantic seconds ticked by in the dark.

After the show, I walked alone through the center of Butte, wondering if the show was beautiful enough, the little towns interesting enough, the magic promising enough to make up for travelling with this deranged magician.

I climbed the Granite Street hill which commands a view of the town. I had read that the "richest hill on earth" was now hollow to depths of more than a mile underground. The frail and shattered crust on which the city rests was like an eggshell from which the viper had sucked the egg. After the gold and silver were exhausted, the Copper Trust had moved in. By 1900, the fumes from the big smelters had killed all the grass and trees in town. Valuable ore was the gaff that made a big illusion out of Butte.

I went back for the 8 p.m. show, knowing I'd have to keep some distance between myself and the magician. He was swaggering around backstage wearing only his jockey shorts—not an inspiring sight. When he turned around, I saw he had huge raised white scars across his back.

Afterwards, Kramien told me we were going out for a drink with "our sponsors," two local men who belonged to the Lions Club. "No thanks," I said.

In a moment, Miss Kathleen appeared, pleading with me. "They like to meet the people in the show, hon. It's a thrill for them." She had changed into a red sweater and a leather skirt, but still had on her stage makeup.

"How did he get those scars on his back?" I asked.

She stopped fishing in her shoulder bag and looked at me. "He had a chimp act in the circus," she said. "One of the chimpanzees went crazy on him."

"Was that the end of the act?"

"Ask him."

"I'll have one drink, that's it." I slowly peeled off an eyelash the size of a butterfly. "Did you ever see him work with the chimps?"

"Don't take off your makeup," she said. "They like us the way we look on stage."

"I'm not getting paid to wear makeup to a bar," I said. I took off the two-inch rhinestone dangle earrings, tissued off the makeup, and slipped my trench coat over my jeans.

"Look," she said. "I grew up in Oklahoma. My folks were so poor that when we came to California, we had our mattress strapped to the hood of our car." She gave me a moment for this to sink in, then told me what I could have guessed. "I'm never going to be poor like that again."

"Kathleen, do you think there might be worse things than no money?"

She gave me a look, but no reply.

On the dark street, Kramien grabbed my arm. "They're going to want to know how the magic works," he said, in his gravelly, side-of-the-mouth voice. "Don't tell them anything."

We were met at a cocktail lounge by the two Lions. Without asking whether the rest of us wanted to eat, Kramien ordered for himself: fried eggs and bacon, fried potatoes, and toast which came slathered with yellow oil. Then he pulled out a deck of cards.

One of the Lions, a ruddy-faced man named Mr. O'Connor, spoke up. "The Doll House. I don't suppose you'd tell us how that was done. Or the Sword Box?"

"Those are just big showy illusions," Kramien said. "This is where the real skill lies. Just watch." He asked Mr. O'Connor to select a card from a spread deck, show it to the other Lion, and then hand

it back to him, taking care to keep it face down. Kramien placed it back in the deck, covered the deck with a dinner napkin, then produced the very card by stabbing it with a fork. This was a close-up version of the Card Stab, which he did on stage with a large needle. He was good: even at close range, I could never catch him palming the card.

O'Connor kept looking over at me. When I smiled at him, he told me he had twenty-two years as a produce man for Safeway.

"I guess the union is pretty strong here?" I asked.

"You bet," Mr. O'Connor said.

I rattled the last of my bourbon and water. I was interested in hearing about Butte, which Anaconda Copper had dominated for nearly a century, and how the union had fared with them.

"Say, can I buy you another drink?" Mr. O'Connor asked.

"Put your money away," Kramien said.

Mr. O'Connor hesitated, then put his wallet back in his pocket.

I stared at Kramien.

"She'll pay for her own," he said, and he returned my stare with a snort.

I finished my drink, untangled my trench coat from the back of my chair, and said goodnight to Miss Kathleen and the Lions, as Kramien gazed off in another direction. I walked back to the Travelers Rest Motel and winged my suitcase open on the second double bed. Nothing in the room suggested the city of Butte; the orange shag carpet, triangulated toilet paper and bolted-down TV belonged to the larger kingdom of Motel Land. There was no stopper for the tub, so I took a hot shower, then folded back the tightly made bed and began reading the Houdini biography, hoping to recapture some enthusiasm for my new profession.

I learned that Erich Weisz had been born in 1874, at a time when the world was fascinated with spiritualism, seances, and psychics. At twenty, he changed his name to Houdini (after the great French stage illusionist, Robert Houdin) and took his young wife, Bess, to Coney Island to perform as his partner.

I was startled to read that their very first act was the Substitution Trunk. Perhaps I really was in the Great Tradition, I thought, as I put the book aside and turned out the light.

కారా

At 11 p.m. the next morning, I was sitting outdoors on the motel steps, blowing on a Styrofoam cup of coffee and waiting for Kramien. Iris, the truck driver's wife, her long red hair in pigtails, joined me.

Roy and Iris had a tough job: responsible for the truck, they were always in the path of Kramien's anxiety. At each new town, they set up the show, which took two-and-a-half hours, and they were responsible for the strike, which required another hour after the show. They fed, watered and cleaned up after the ducks, doves, rabbit and rooster. Before the show and at intermission, they sold programs, cotton candy, and a cheap book of magic tricks.

Iris was eating a donut that oozed jelly. "I think you do a real nice job," she said.

"Thanks." I sipped the watery coffee. "That trunk is something else."

"That's the best part of the show!" Iris said. She wiped a glob of jelly off her jeans and licked her finger. "Do you believe in magic?" she asked.

"You mean entertainment-magic, or miracle-magic?" Across the parking lot, I watched Kramien come out of his room, unlock the dusty white Cadillac, and start the engine.

"I guess I mean both," she said.

"I'm working on it," I said.

Kramien's car began rolling towards us.

"But do you believe it?" she asked. In bib overalls and a pink T-shirt, she looked about fourteen.

I knew she was going somewhere with this question, but I couldn't tell where. "I guess believing is what makes it work," I said.

Iris stood and turned her back on Kramien's approaching car. "They said Roy and I couldn't have a baby," she said in a whisper, "but we're trying anyway."

"That's great," I said, and I reached up to touch her arm.

The Cadillac stopped; Kramien stayed at the wheel.

Iris reached for my empty coffee cup. "Here, let me take this," she said.

"Hey, I'll see you in the next town," I said.

From Dillon, we dropped down into Idaho, playing school auditoriums and Grange halls in Idaho Falls, Pocatello, Burley, and Twin Falls. Kramien's red pills came out before every curtain. My guess was he'd been an alcoholic, but pharmaceuticals were his habit now. His face told it all: baby fat cheeks, eyes alternately glazed and inattentive, then excited and watchful.

He guarded the itinerary as though it were the secret of sword swallowing itself. Roy had somehow discovered that the show had another employee, a promoter, who worked ahead of us on the road. The promoter usually called the magician late at night, Roy insisted, and these phone calls confirmed our engagements.

"So, when do we play Nogales?" I asked Kramien.

We were coming into Elko, Nevada, and he signaled to turn in front of the Stampede Motel.

I repeated my question.

"Who wants to know?" he asked.

"Look, I said I'd stay with the show through Nogales. So when is that?"

Miss Kathleen pulled down her visor and got busy refreshing her lipstick in the little mirror.

"When I know anything, I'll tell you," Kramien said. He laughed and I caught his wink in the rearview mirror. Miss Kathleen refused to meet his eyes.

After I registered at the motel, I put my bags in my room and told Kramien I'd walk to the high school for the afternoon setup. I couldn't spend another minute with him in the car.

On my way across town, I passed the bus station where I saw a family of four carrying hand luggage and four fishing poles. The woman was a heavy dishwater blonde in baggy blue jeans, the right side of her face reddened and erupted with pimples. The two little boys, maybe five and two, had pimples on the same side, as though they were all facing the same direction when a filthy sandstorm blew through. The little ones carried their belongings, stuffed into pillowcases, which they dragged along the sidewalk.

The father, a thin wispy-haired fellow with a pencil mustache, went across the street to purchase a little Styrofoam plate of toast and when he came back, the two boys hurried to his side, clearly very hungry. They waited in silence as he spread margarine, and then they each received a toast triangle. Right away, the smallest boy set his toast on the ground while he rearranged his pillowcase. The father elbowed his wife, and together they stared at the piece of toast on the sidewalk. Then the father bent down, picked it up, and walked it to a sidewalk trash basket. "It's garbage now, buddy," he said. The child stared in disbelief, and then began to cry.

I realized that family could be right out of Miss Kathleen's childhood. Easy for me to think she should leave Kramien.

The next day, riding south on U.S. 95, through Fallon and Hawthorne, alfalfa and cantaloupe country, I sat in the Caddy's wide backseat, mending opera hose. The elasticized fishnet lay shriveled in my lap, the big hole I was looking for now hard to see. It was the size of a silver dollar when I was wearing it, but the size of a dime when I took it off to mend. I separated the longest of the busted strands and carefully knotted them together.

Kramien paid me $125 a week, motels cost at least $15 a night, and I was eating out of the grocery store—apples, canned fish, and saltines. I began to envy Kramien's fat-laced diet.

In Tonopah, Nevada, our next town, I told Kramien I wasn't registering at the Best Western.

"What the hell are you talking about?" He was watching Roy back the truck into a parking space.

"We passed an old hotel as we came through town. That's where I'm staying."

"I'm not driving you anywhere."

"You don't have to. I can walk there."

"We're leaving at 9 a.m. in the morning, whether you're here or not."

"Whatever," I said.

After the evening show, I got a ride with a Rotarian and his wife, who dropped me at the old Mizpah Hotel, a garish relic of the silver boom, and half the price of the Best Western. Built in 1907, it had high ceilings, a small casino, and a wide, dramatic staircase.

I pushed through the swinging saloon doors, made straight for the bar, and ordered a whiskey. Five local cowboys were playing poker at a round table; otherwise the big room was empty. The bartender poured me a shot and I asked him to spin the keno cage, just once. I won eight bucks, slugged back the whiskey, and picked up my money.

"Night Ma'am," the bartender said, and as I left, two of the cardplayers lifted their Stetsons. I floated up the stairs to my clean but shabby quarters, climbed up on the old iron bed, and resumed reading about Houdini.

According to his biographer, after Houdini broke into the theater circuit, a man named Jim Collins regularly traveled with him. A jack-of-all-trades, Collins designed the gaffs, then built, loaded, and rigged them. Houdini always insisted on 24-hour exclusive access to the theater before a show and absolute privacy backstage. The indispensable Jim Collins would set up his control room

somewhere out of sight. Eventually they played the most mammoth theater in the world, the New York Hippodrome, where a huge tank sat beneath the stage.

So here was the answer to what I'd myself been wondering: were there any magicians who didn't rely on elaborately pre-built effects? And the answer turned out to be no. Even Houdini traveled with his own designer and carpenter. I smiled to think that I'd gone to such trouble to learn what most of the world already knew—that magic was a beautiful hoax.

<center>ഇരു</center>

The next day we were back in the Cadillac, flying past sage brush, old miners' shacks, and weathered, collapsing pole barns. Kramien's dreadful gaze was frozen in the rearview mirror whenever I looked up to meet it. Since my rebellion in Tonopah he looked as though he expected me to tell the first filling station attendant how the whole show worked.

When we stopped for lunch in Goldfield, Kramien and Miss Kathleen went into the café. I took my dinner roll and carton of milk and knocked on the door of the red truck. It was a bright February day; Iris set the rooster's cage out on the ground so he could feel the sun. As we ate lunch, Roy and Iris and I talked about what a good performer the rooster was—he waited quietly in his elegant gold enameled prop, never crowing until he'd been "materialized" by the magician.

"Keep the goddamn show in the goddamn truck," Kramien yelled. He stood in the doorway of the café, wearing reflective sunglasses. He spit a toothpick out of his mouth and let the screen door slam on Miss Kathleen. "What are you, crazy?"

Iris put the rooster back in the truck, and I climbed into the Cadillac without a word. I noticed Miss Kathleen's mascara was smudgy and her eyes red.

When we pulled onto the highway, Kramien bubbled effusively about Las Vegas, somewhere down the line. "First thing, I'm going to chow down on a hot pastrami sandwich, a real one. How does that sound?"

Miss Kathleen said nothing.

"Caesar's Palace," he persisted. "How about that?"

She lowered the visor, pulled out a manila folder and, without a word, handed it over the seat to me. It was the first itinerary I'd seen: a typed list of towns, dates, and sponsors.

Beatty, Nevada, I read. *Jaycees, February 27.* I scanned down the page and read, at the very bottom, *Nogales, Arizona, Fraternal Order of the Police, March 21.*

"Thank you," I said. I handed it back. Kramien glared at Miss Kathleen in disbelief. But twenty miles later, he cheerfully began to reminisce about his dancing poodle act.

"Was that before or after the chimps?" I asked.

"The chimps, hell," he said, and he grinned at me for the first time in two states. "That was just a sideline. The big money was smuggling birds from South America."

I saw signs for Beatty, Nevada, but we sailed right through it.

"Wait a minute," I said. "What happened to our engagement in the Gateway to Death Valley?"

"The dogs bark, but the caravan moves on," was Kramien's only comment. "Ancient Arab proverb."

That gave us a four-day break with no show. I was cloistered in a sprawling concrete block motel on State Route 93, not far from the magnesium plant at Henderson, Nevada.

I wrote a hasty note to my mother, admitting that the job was not all I might have hoped for: the magician was a jerk and, on what I was paid, I couldn't save up enough to leave the show. I asked her to write me General Delivery, Green Valley, Arizona.

By the second day of our impromptu vacation, I had less than a dollar, felt woozy from my diet of coffee and soda crackers, and was running a fever. That night, after a semi rumbled by, I darted across the highway—three lanes of traffic, a ravine, and three more lanes—to the Outpost Bar.

Inside the door, a blackboard advertised *Noodle Beef Soup, 45¢ bowl.* A red and yellow linoleum floor rose up to meet lurid green walls. Two aged little people shot pool in the back, standing on chairs to sight down their cues. The woman behind the bar, one arm in a sling, sold me an order of soup in an oversized Styrofoam coffee cup.

In bed later that night, I heard a crunching sound. When I sat up and turned on the lamp, a sand-colored rat froze for a moment, then relaxed and nosed deeper into my box of soda crackers. I switched off the light. In my delirium, I saw a second rat walk off the desert and through my motel room wall.

My fever broke two days later, leaving me weak but anxious to get back to work. We climbed back into the Cadillac and continued rolling south, playing Boulder City and Kingman. After so much down time, I was glad to hear the theme song for the Substitution Trunk start up and feel the return of that adrenaline rush. We took the show to Flagstaff, set in an exalted landscape of ponderosa pine, then turned south through a lush valley and played Sedona, Cottonwood, and Prescott.

<div align="center">ഗ‍ദ</div>

At Coolidge, Arizona, I got up early and walked north of town to the ruins of a Hohokam Indian village which had been deserted over 500 years ago. At this site, which Spanish discoverers named Casa Grande, I visited the excavated remains of a tremendous four-story temple/observatory. Interesting to think that magicians had governed entire cultures.

A Zuni girl, employed by the U.S. Forest Service, pointed out a curious thing: when the inhabitants abandoned the village, they removed the observatory's interior floors, so that no enemy tribe could gain access to the upper reaches.

After her talk, I sat in the still landscape of white sand and soft green cactus, eating an orange and trying to solve this mystery. Why was it important that no one ascend to the top floor of the tower? What was the gaff?

At Green Valley, I had a letter waiting from my mother, who began with a reference to my old cabdriver job, where my assigned number had been 15. Alluding to my current employment under the magician's saw blade, she began, "Dear 7-1/2." It was a great letter: she made me laugh and she sent cash. Now I would have a way out.

Back on the road, Kramien talked about the show promoter. "Dick will be in Nogales." he told Miss Kathleen.

"Why is he sticking around?" Miss Kathleen asked.

"Nogales is hot. The Mexicans eat this up. He's got 3,000 tickets out in Nogales. Now he wants to do El Paso."

I leaned over the backseat of the Cadillac and tapped his shoulder. "Nogales is my last show."

He turned on the radio.

In Nogales, I had just paid for a room when the bell tinkled, the door opened, and Kramien burst into the tiny motel office. A Chihuahua dashed out from under the counter and danced, yipping,

about his trouser cuff. Without looking down, Kramien raised one foot, as though to plant it squarely on the animal's back. The little dog retreated to a corner brochure rack, where he furiously scratched his neck with a hind leg.

"You're fired," Kramien said.

"What are you talking about?"

He unwrapped two pieces of gum and folded them into his mouth. "You're fired as of right now."

"You owe me for three days," I said.

"Then you're fired retroactive to Wednesday," he said. He dropped the gum wrappers on the rug and smiled. "I hope you haven't already paid for your room." He went out through the tinkling door, leaving me standing in the office of the Pasatiempo Motel, holding my battered Samsonite, my fingers tightening around the handle where the plastic was splitting away from the metal.

Instead of asking the owner for my $17 back, I went to my room and stretched out on the bed. From my purse I pulled the Houdini biography, which I'd been reading slowly, trying to make it last.

Houdini began a war against spiritualism, which put him constantly in the headlines: HOUDINI EXPOSES TABLE TURNING (or spirit rapping, automatic writing, crystal gazing, the Ouija board). From famous séance parlors he confiscated wires, tubes, telescopic rods, hooks, coils, rubber hoses, and extension poles—all the gaffs of the trade. But the world wouldn't give up the idea that Houdini's own illusions were supernatural, and Houdini himself a reluctant psychic.

I lay back and closed my eyes. Kramien, I knew, had the same disdain for spiritualists. But then his cynicism made him disdainful of almost everyone.

Someone knocked on the door. I opened it to find Roy and Iris standing in the gravel parking lot.

"She's been throwing up," Roy said.

"Does this mean you're pregnant?" I asked Iris.

She stared at her sandals and shook her head.

"It means Kramien is putting her in the show," Roy said.

Tentatively, she asked, "Maybe if we could go over the Substitution Trunk?"

"I can't be away from the truck," Roy said. "I'll come back and get you in an hour." He kissed her hair.

My room had no chairs, so we sat on the pink chenille bedspread. "Okay," I said. "So you and Miss Kathleen bring the trunk on stage, and Kramien invites two men up to examine it. It's solid."

"I know it's solid," Iris said. "I put that thing away every night."

"Then Kramien unfolds the huge red satin bag, which is in the bottom of the trunk."

"I know all about the bag," she said. It was Iris's job to re-stitch the bottom of the bag each night with a single long thread. It had a breakaway bottom; it was the top they tied with those extravagant knots.

"So this audience sees you step into the red bag and sit down in the trunk. The two men on stage help Kramien tie the bag closed, put the lid on the trunk, then all six padlocks, then the ropes. Finally, Miss Kathleen and Kramien pull the cabinet around the trunk, so that when you climb out the top, you can't be seen.

"The important thing for you to remember is, as soon as the lid is on that trunk, you slit open the bottom of the bag with your fingernail and crawl out. Make sure you roll the bag and leave it in the correct position at the foot of the trunk.

"I forgot to say you have a tiny socket wrench down the front of your costume. You can't forget that, or it's all finished. There's a concealed trapdoor on the top of the trunk."

Iris gave me a look of surprise. "There is?" Even she and Roy, who packed this object every night, had never detected the elegantly concealed trap.

"So you need the wrench to remove four bolts in the trap. You have to work very fast!

"Once that trap is loose, you hold it in place until you get the signal. When it's time for you to get out, she'll kick the trunk. You've got to drop the trap and move. Make sure you have left the wrench and the bolts in the upper corner of the trunk where Miss Kathleen can find them in the dark."

"How long do I have?"

"You'll hear Kramien yelling at the men to hurry up and rip off those ropes and remove the locks, but don't worry about it. They've got sixty feet of rope to unwind."

"So how long do I have?"

I put my arm around Iris's shoulder. "About ninety seconds."

"I don't know how I got into this," she said.

I walked her to the door. "I'll come down to the gym later and see how you're doing."

I still had two chapters left.

On his deathbed, I read, Houdini had warned Bess that the psychics would swarm all over her after he died. He gave her a secret password that only the two of them knew. Never believe it's me, he told her, unless you hear this word.

In 1926 Houdini died. Sure enough, Bess was set upon by mediums, and every one of them claimed to be in touch with the great magician.

But none of them knew Houdini's secret word. And Bess held out, waiting for his signal.

At 3 p.m., I walked down to the gymnasium. Roy was setting the show amphitheater style, on a tarp covering the gym floor, facing one wall of bleachers. Kramien was rattling a prescription bottle and shouting instructions. Two black velvet wings, hung from aluminum break-apart poles, were used to frame in a stage on the occasions we worked without a proscenium. Miss Kathleen and Iris were walking through the umbrella routine, which opened the second act. I scanned bleacher capacity: if even half the tickets turned up, Kramien would have to put on two shows.

"Hey! Get her out of here. The public is not allowed backstage," Kramien yelled when he saw me. "Kathleen, look alive."

Miss Kathleen walked me toward the big double doors. I gave her a piece of paper on which I'd written my mother's address. "Kramien owes me for three days," I said. "Here's an address just in case."

"I'm sorry," Miss Kathleen said.

"Kathleen, there really are worse things than no money."

Miss Kathleen gave me that skeptical look of hers, but this time I saw affection, as well.

I turned and nearly walked over a little guy who looked like a squaredance caller, in a brown doubleknit suit with yellow piping around the lapel and wearing a toupee.

"Have you met Dick?" Miss Kathleen asked.

"Hey, Doll," the man said. "How's it going?"

Kramien yelled at Miss Kathleen to get back to work. The promoter followed me outside.

"So you're the man responsible for moving us around the West," I said. "What happened to Beatty, Nevada?"

He opened a monogrammed cigarette case and took out an oval Delicado. "The Jaycees figured out only 15% of the ticket sales were going to their Underprivileged Children's Fund. For a minute there, they wanted to have me arrested." He lit his cigarette with a matching Ronson lighter. "I don't know what the big deal was. Hell, some charities lose money on fundraisers."

"I hear you've done very well here."

"Got a great sponsor here," he said. "The Fraternal Order of the Police." He grinned. "Stick around, Doll, and I'll buy you a drink." He strolled off toward the stage.

"Right," I muttered to myself.

I checked out of the Pasatiempo, and carried my Samsonite to the bus station, where I stashed it in a locker. At a cigar stand, I bought a copy of the *Santa Fe New Mexican*, for old time's sake. Four years before, I had worked a season at the Santa Fe Opera, constructing fountains, gold-leafing chandeliers, and covering Louis XV divans with brocade, while the orchestra in the pit rehearsed Verdi, Menotti, Donizetti, Stravinsky, and Mozart.

I bought a ticket north. The night bus didn't leave until 10 p.m. I still had time.

This was my chance to see The Great Kramien perform. I stood in line with an excited, talkative crowd. Hundreds had shown up; in this poor border town, every merchant who bought a ticket book saw that the tickets got used. Children of all sizes, clinging and bold, scrubbed and scruffy, chattered in Spanish and English. "Would the *mágico* have a real *elefante?*' one child asked.

When the line began to move inside, I could see the velvet drapes and the shining brass dove perches. From the crowd there were cries of *¡Ay, qué hermosa!*

I had figured the gym would take 800, but 1,000 people must have crammed in for the first show. Girls sat on the laps of their sisters, and children rode their father's shoulders.

At 7 p.m. sharp, the music blared and Miss Kathleen and Iris strutted rapidly in from either wing, decked in glittering headdresses and trailing green ostrich plumes. They raised their arms in a welcoming gesture to The Great Kramien, portly and commanding in tuxedo, cummerbund, and top hat. He skinned off his white gloves, slammed them into a drawer, yanked the drawer back open, and a live dove rose into the spotlights.

He stuffed a rainbow of silks into a tube, and another dove fluttered up to join the first, and together they circled the gymnasium's high rafters.

He chopped the air with a butterfly net and produced a third dove, then a fourth. From a flaming platter bloomed two quacking ducks; from an oriental screen, the rabbit. Kramien was exquisite with the huge Chinese linking rings: his big hands handled seven at a time.

The stage blazed with color and music and light and motion, and the bleachers trembled under the applause.

When the Guillotine fell, and a red-shirted boy still had his head, Iris whisked him into her arms and carried him back to his family in the front row. I wished I had thought of that!

It was the Substitution Trunk, of course, that I wanted to see, but Iris blew it. She never made it out of the trunk. When Kramien took the lid off, she was still half in the bag, sitting there frightened and exposed, like someone caught in the bath. Kramien shot her a killing look, then signaled for Roy to hustle the trunk offstage.

Yet the audience clapped and shouted their delight, as though Iris's failure only proved the difficulty of doing magic and the nobility of anyone who might even attempt it. Their cheers resounded as the trunk and Iris were dragged across the gymnasium floor.

Kramien let loose a few more doves, got back in synch with the tape, and finished the show with a flourish. Applause boomed around him as his final doves fluttered upwards, and it echoed around me as I was swept by the crowd into the dark street.

The enthusiastic applause of the audience still filled my ears as I boarded the Citizen Auto Stage and stashed my suitcase on the overhead rack. Kramien would have been the first to tell me the world contained no magic, but those people in the bleachers, with their joy and willing belief, knew where magic truly lay.

TEACHER: A MEMOIR OF RAYMOND CARVER

I met Raymond Carver in 1980 when I took a two-week summer workshop which he taught in Port Townsend, Washington. In fact, I wrote my first story to get into that class. Before that, I had written only journalism, but Carver's story, "So Much Water So Close to Home," got me writing fiction, converted me, I should say, because reading that story was a revelation.

In this story a man goes fishing for the weekend up on the Naches River. The first night out he and his buddies find the body of a young woman floating in the water, and rather than pack up and notify the authorities, they tie her to the bank, and fish for the rest of the weekend. Carver says, "They pleaded fatigue, the late hour, the fact that the girl wasn't going anywhere."

The story is told from the point of view of a woman, the wife of the man who goes fishing with his friends. It is told with an uncanny and exact sense of her fear, curiosity, revulsion, and desire. The psychological home truths in that story knocked my socks off.

Within a matter of weeks, and with the synchronicity I have come to expect once an idea becomes lodged in the unconscious, a brochure came across my desk announcing that Carver would be teaching writing at Centrum in July. He could take up to sixteen students, and you had to submit a short story along with your application.

At that time, I was in Portland, Oregon, running a center for film and video makers. The difficulty of keeping a nonprofit arts organization viable didn't even leave me time to crack the spine of a time management manual. Yet somehow, I cancelled my life for the next eight weekends and wrote my first short story. I shut myself in my apartment, never changed out of my bathrobe, and didn't answer the phone.

First, I reread what short fiction I had on hand—Katherine Mansfield, Ernest Hemingway, and that fat, red paperback of John Cheever's stories, which had just come out in March.

From these examples, I tried to figure out what a short story actually was; how dialogue, narrative, description, transitions, and scene worked. Now, so many years later, I understand this process would have been easier had I limited myself to contemporary work. As it was, I gave equal attention to Jane Bowles and Stephen Crane.

At the same time, I was sifting through memory and idea to find a story of my own, a small starter story, one that might rise above personal chronicle and speak meaning to another person. Told from what angle, I wondered, and at what remove? Where does an action properly start, and when has enough been told?

One Saturday morning, I set up a folding card table in the sunny back bedroom and, banishing the ghosts of spiritually wounded soldiers, disheartened commuters, promiscuous spinsters, and of brides ushered into Yellow Sky, I wrote for twelve hours straight. From time to time, I paced down the hall to the coffee pot in the kitchen.

My story was about a married man who plans to leave his girlfriend. He has taken her to a small Spanish restaurant, where he hopes to get past the difficult announcement quickly so they can enjoy their last dinner together.

Was it successful? My assessment was that either it was a shoo-in for a place in *Best American Short Stories 1980*, or it was something far less than a story, a quirky glimpse of two mean-spirited people, having neither meaning nor form nor grace. I vacillated wildly between these two judgments even as I dropped it into the blue mailbox on the corner.

&)G3

When I first saw Raymond Carver, a big, solid man, over six feet, he was wearing a plaid shirt and khaki slacks. He was seated in one of those chairs with a wraparound writing surface, his long legs jutting into the middle of our circle of chairs.

"Here's the way we'll do it," he suggested, his low voice almost a mumble. We had eight working days, and he proposed the class meet at two in the afternoon, using mornings to write and work with him privately. "If that's okay with you," he added, and looked around the room with a questioning glance.

Manuscripts were circulated in advance so we could read them and prepare for critique. In class each writer was asked to read his or her story aloud and, if there were time, Carver might have a second person read it so the writer could hear it in someone else's voice. As the group discussed the story, the writer was to remain silent, so as not to be put on the defensive and to better attend to and transcribe what was said. I have since heard that this is the Iowa method, that is, the type of workshop Ray would have taken at the Iowa Writers' Workshop in 1963. A decade later he taught there.

Ray generally began the critique by asking, "Is this a story?" He would ask this of even the most ill-formed, hopeless narrative and, with a dogged seriousness, help us to discern why or why not.

If someone asked a jokey question he never responded in-kind. He always answered carefully, as though understanding that jokes often come from nervousness or self-consciousness. If someone made an ironic, self-deprecating aside, or—God forbid—a cruel remark, he stared off quietly for a moment, often smoking, patiently waiting for us to recall ourselves to generosity.

Our work was to identify the story's intentions and set about helping the author better achieve them. We were, meanwhile, vigilant about passive voice, awkward inversions, inconsistencies in point of view, and so forth. Carver told us to make our remarks specific, and to be constructive.

He offered encouragement to everyone, no matter how unpromising a story might appear to the class. Not every teacher does, I learned. One woman in our workshop had studied with Robert Stone the year before and he had advised her to quit writing altogether. Of course, she was crushed. I have since read William Styron's *Paris Review* interview, where he says, "The professor should weed out the good from the bad, cull them like a farmer, and not encourage the ones who haven't got something."

Raymond Carver encouraged us all and left the weeding to God.

Along with kindness and respect, Ray had a wonderful sense of humor, as evidenced in almost all his writing. He told us how he had sat in on a trial in California where a girl on the witness stand kept saying, "and then he goes," "and then I go." He coveted these cozy usages, and this particular one shows up in "Gazebo." He likewise loved an uncommon word, and I remember how he was charmed by Ellie Scott's use of the word "undercarriage." He asked her if he could borrow it.

"Short stories are closer to poetry than to the novel," he said. "They are built like poetry, line by line."

Without turning them into rules, he offered suggestions for making the writing easier. "Short story writers have enough going against them without trying the omniscient voice. Third person limited gives us plenty to try to deal with," he told beginners.

Mostly, he told us what worked for him. "I try to write fast, in longhand. I never spend more than two days on a first draft, and I like to do it in one day, if possible.

"Put everything into that first draft," he insisted. "The first draft is the most important you'll ever write—besides the last draft." Ray called these clumsy, overwritten first drafts "money in the bank." They are what we work with over the next weeks and months. He expected us to rewrite a story two or three dozen times if that's what it took. His story "Neighbors" started out at ten times the length, he said. Writing, he constantly reminded us, was a laborious and exacting process. We should learn to take joy in rewriting.

I was always amazed to see how he could reach down into one of our paragraphs, pull up a single awkward sentence, and carefully refashion it until it became perfect and shining under his hand.

Carver assured us that we were engaged in a very serious enterprise. He said John Gardner taught him that at Chico State College in the late fifties, and he talked about Gardner's fastidiousness and patience, both as writer and teacher. If we meant to be writers, we should expect a prolonged and arduous development; Ray told us we should expect to work.

For the most part, he steered the discussion away from publishing, though he did tell us the story of his own "red letter day," in 1960 when he received his first letters of acceptance. Two came on the same day. One was from *Western Humanities Review,* for his short story "Pastoral," and they paid in contributor's copies; the other was from *Targets* [now defunct], who sent a dollar for his poem "The Brass Ring."

"One dollar!" one of the students groaned.

"But then nobody ever asked you to write," Carver said, with a smile of amusement.

In 1980, Carver's only published book of fiction was *Will You Please Be Quiet, Please?*, though he had three small-press volumes of poetry. Most of his work appeared in literary quarterlies. He passed around copies of *TriQuarterly* and *Antæus* to show us what a literary quarterly looked like.

Outside class, we only occasionally got a glimpse of Ray, walking alone across the wide lawns of Fort Worden, where Centrum is housed. He didn't hang out. I remember reading somewhere in Norman Mailer that men walk with a bear-like walk from the shoulders or a cat-like walk from the hips. (The preposterousness of this distinction has kept it alive in my mind for decades.) Yet, Carver's was a bear-like shoulder walk. He would come alone into the Washington State Park Service cafeteria and take his orange plastic food tray to a small table along the wall, never joining the long table where we usually ate. He did not mean to be a pal and he was certainly not on the make.

I was curious about him, of course, and managed to piece together a sketchy biography. Ray's dad had originally come to the Pacific Northwest from Arkansas in 1934, looking for steady work. After a construction job on the Grand Coulee Dam, he moved his family to Clatskanie, Oregon, where Ray was born, and then to Yakima, Washington, where he went to work as a saw filer at the Boise Cascade mill. Carver was raised there in Yakima, a small town built around the sawmill and apple orchards.

I knew this landscape, where people drink straight shots, sitting around waiting for the next thing to happen. I had been raised in Independence, Oregon, which also had a sawmill, plus bean and strawberry fields. In my high school, the sons of millworkers got Cs in English—or worse. Good ballplayers but bad writers. Carver has said that he finished high school very near the bottom of his class.

I remember he named the day he had quit drinking: June 2, 1977.

And there had been a long marriage, whose ruin smoldered in all of his works.

If booze was the gasoline, his kids were the lit match, and for years his life was in danger of burning right down to the ground. He and his first wife, Maryann Burk, ended up with two babies before Ray was twenty, and in the essay "Fires," he would later say they were the biggest influence on his writing, a "heavy and baleful influence." He used those words.

Booze and kids, no time and no money. These were Ray's demons, all well-documented in his writing.

Carver had years of money trouble. In his stories, men are out of work, and people have to sell their car in a hurry. He knew the dreadful sound of the bill collector's footsteps creaking across the loose floorboards of the front porch. He worked at the mill. He also

cut tulips, pumped gas, and swabbed hospital floors. At the end of his shift, he would return to a household made chaotic by poverty. He sometimes went out and sat in the car and tried to write his stories there.

In the evenings at Centrum, the writing faculty read their work in the little military chapel. The night Ray read, I was in the front pew. From *Will You Please Be Quiet, Please?* he read "Fat," the story about the waitress who is mesmerized by an obese customer. Then he read "Gazebo" from his second collection, which Knopf had just bought. This is the story where a couple troubleshoots their damaged marriage holed up in a motel room with a bottle of Scotch, and where the narrator says "then I go," "then Holly goes." It is hilarious; he had to stop several times and wait for the laughter to die down.

In the front pew, I was laughing as hard as anyone. Then I remember—it was the line where Duane says, "When I look back on it, all of our important decisions have been figured out when we were drinking."—my throat did a sudden clutch, and I found myself sobbing openly. Like other Carver stories, "Gazebo" has a smooth surface and a fatal undertow.

It's to Centrum's credit that the writing program consists of daily workshops, and nightly readings, and not much else goes on. This is all you need. I once saw a brochure for a Berkeley workshop that offered movies, cocktail parties, and appointments with agents and psychotherapists.

Yet I do remember one twilight reception for the Centrum writing students. Ray did not come to that, and I imagined it was because a jug of red wine was set out. The purpose of the reception was to integrate the several writing sections but, predictably, the detective story writers clotted together, as did children's fiction, the novel, and the short story. In our particular huddle, we sipped wine from plastic glasses and confessed our thrill at being accepted to study with Carver. One woman said she was attending on a $1,000 inheritance from an elderly aunt; another had hitchhiked from Tucson, riding in a carful of Pima people who were, maddeningly, taking their time; a young man said he'd received his acceptance on June 23, his birthday. We tried to guess at how many applied who didn't get in.

Then a woman who helped out in the office spoke up and said there'd been no screening process whatsoever.

Our group fell silent.

"Only sixteen people applied," she said.

The cheese looked cracked and the carrots were beginning to curl and, what the hell, Ray wasn't going to show. We began drifting back to our dorms.

Yet there were some fine writers in our group, among them, Craig Lesley, who came with chapters of what would later be published as *Winterkill*; Alex Hancock, already working on *Into the Light*; and Ellie Scott, whose stories later appeared in several of the quarterlies.

<div align="center">છ૭ભ</div>

I worked hard over the next two years, meanwhile trying not to worry about publishing. Ray had said that we must simply learn to write.

By that time, I had resigned as director of the Northwest Media Project and moved to Seattle. I had a contract to produce the Motion Picture Seminar of the Northwest at the Seattle Center Playhouse. For six months of the year I did that work, and for six months of the year I wrote stories.

In 1982, Ray was scheduled to teach again at Centrum and I went back.

The first thing I noticed was that he looked tired, and he seemed to be smoking more. *What We Talk About When We Talk About Love* had been published, and *The New Yorker* had run "Chef's House" and "Where I'm Calling From," two stories about drinkers struggling to quit. This, astonishingly, in the magazine which then identified the good life with cocktails—in cartoons, in fiction, and in legends of the Algonquin Hotel round table of Dorothy Parker's era. Later that same month, July of 1982, they would print Carver's "The Bridle," where a man gets boozed up and dives into the pool from the roof of a cabana—and misses the pool. Their full-page Tanqueray ads, precipitation dripping from icy green bottles, would never look the same to me.

When we asked him, Ray agreed that success made things easier. "I don't waste as much time," he said. "Usually when I sit down I know what I'm going to do."

My strongest memory of that summer is of a private conference I had with Ray. I had been working steadily in the two years since I'd seen him, and I attached considerable importance to this conference.

He had my manuscript in advance, and I went to his little Centrum cottage at the appointed time. He invited me to sit down. I sat on the sofa, but he remained standing and he shifted around the room as he spoke. He asked me what I did for a living. "Writers have to do something to buy time; there's no money in it."

I explained briefly about my work, though I remember thinking, this isn't computing for him. For the Motion Picture Seminar, I booked speakers, arranged flights and hotels, worked with printers, caterers, projectionists, and film equipment manufacturers.

"We need stories about how people cope with their work," Carver had said in class. But my work seemed vague and abstract to him, I think. At any rate, he didn't pursue it. After a moment, he picked up my story from the table and stared at it. When he looked back up at me, he said, "You're a writer." From him, that meant a lot.

In the late 80s, it was common for critics and editors to bemoan the numbers of Carver clones, but Ray never inflicted his own style on a student. If there were imitators they must have, on their own, found much to admire in the clean, spare, nuanced storytelling, and tried to reproduce it.

Gordon Lish, who was also teaching at Centrum that year, was another matter: a Knopf editor and former fiction editor at *Esquire*, Lish presented himself as the arbiter of East Coast literary chic.

Lish met his class in the morning, outdoors on the grass. Those of us in Ray's workshop regarded this as an open invitation to seat ourselves around the periphery and listen to what he had to say. Lish was much given to rules. "The first two sentences comprise the attack," he explained. "The three essentials of the attack are stance, authority and news."

Craig Lesley was also back at Centrum and had given Lish a story about Indians at the Pendleton Round-Up, who were in the back of a pickup, passing around a brown-bagged bottle of rosé. "That's not news," Lish said. "We've all seen Indians drinking wine before. Show me Indians in the back of a pickup drinking martinis. That's news!" (I crib this story from Craig, who is too kind and forgiving to ever tell it in print.)

For himself, Ray liked all kinds of writing, including the lush prose of Faulkner, the darkness of Dostoievski, and Conrad's romances. He said he'd learned to prune adjectives and adverbs from reading Hemingway, but warned us, "you can't trust what Hemingway says about writing." His taste in writers was catholic.

He said he was once so moved after hearing Joseph Brodsky read that he went home and stayed up all night writing poems, determined to never lapse from poetry again. With great enthusiasm he delivered to us the names of writers he loved—not just Tolstoi, Joyce, Babel, and Flannery O'Connor, but also his contemporaries: Joan Didion, Larry Woiwode, Geoffrey and Tobias Wolff, Leslie Marmon Silko, Barry Hannah, Ann Beattie, and James Purdy, a master craftsman whom he'd read with admiration for years.

Mainly, he looked for feeling. Here's a Carver quote from my notebook: "A short story or a novel or a poem should deliver a certain number of emotional punches, and you can judge that work by how strong these punches are and how many are thrown."

He was especially strong on his colleagues here in the Pacific Northwest. They were his pride and joy. "The literature of the West is in its infancy," he said. He told us to read Richard Hugo, who was living in Montana at the time, his poems, of course, and also his essays on writing, collected in *The Triggering Town*. Ray was rooting for Bill Kittredge, Ursula K. Le Guin, John Keeble, Marilynne Robinson, and Jim Welch. He rooted for Tess Gallagher, then his partner of four years, and for Richard Ford, who was also his close friend.

Ford, Ray told us, belonged to the great brotherhood of rewriters. "He wrote his novel, *A Piece of My Heart*, in the first person. It didn't work. It had taken him three years to write, yet he rewrote it in the third person. That took a year and a half." Ford's books were then out of print, but I wrote down his name, too.

Ray had this vision that there was a renaissance of West Coast writing afoot, not unlike Paris in the 20s, or the American South of any decade we might name. Ten years later, when I saw Howard Junker's map of everyone he had published in *Zyzzyva* (limited to West Coast writers), I could almost believe.

In 1983, something wonderful happened to Carver: he received the Harold and Mildred Strauss Living Award, $35,000 a year for five years, tax free. In my selfish heart, I begrudged its one condition: he was expected to not teach, but to work full-time on his writing.

He quit his position at Syracuse and quit giving workshops. I was never to study with him again.

When next I saw him, at a party in Seattle following his reading at the University of Washington, I asked him, wistfully, if he missed the teaching and he said, "Not really. No."

"Well, you may not be my teacher any longer," I said, "but I'm still your student."

And he said, "Why, bless your heart," which was a favorite expression of his.

I sent him a note when my first story was accepted. "Crossing the publication line is important," Ray wrote back, "and helps a lot to validate what one has been doing so long and so seriously. I'm glad for you."

I saw him again at the University of Washington where we gathered in the autumn of 1986, remembering Richard Hugo. This might have been the end of my direct involvement with him but for something that happened in the spring of 1987, when an old friendship from the film world brought my life full circle.

I had given up my contract with the Motion Picture Seminar two years before and was almost out of touch with the many filmmakers I had brought to the Pacific Northwest over the years. But that spring Jill Godmilow phoned me as she passed through Seattle promoting her first feature, *Waiting for the Moon*, a film about Gertrude Stein in Paris.

Over drinks at the Pink Door in Pike Place Market, Godmilow told me that she had read Carver's collection *What We Talk About When We Talk About Love* on the flight home from Paris. She remembered I knew Carver. "I just have this feeling," she said, "that the stories actually happened. Do you know if they are true?"

"True" can be a disconcerting word for a fiction writer, and I remember giving a noncommittal shrug.

Never mind the answer to that question, she was excited about their possibilities for film. "I have this idea," she said, "that by careful sequencing, the stories could be told about one man's life; I'd make it all one protagonist. Otherwise, I would want to be as faithful to the original as possible. I'd even have the screen go to black between each story. What do you think?"

"It's a very literary idea," I said, "a purist's Carver film."

But when she asked me if I would help her write the screenplay, I was floored, not only because of my great respect for her as a filmmaker, but because I'd never written a screenplay. Clearly, she needed a real screenwriter. I ordered another gin.

But, she argued, I knew Raymond Carver and knew the territory, that is, the locations— Yakima, Chico, Eureka, Cupertino. I knew the alcohol culture. (She had just handed her empty chardonnay glass to our waiter and told him to bring her a Perrier.)

I was not a union writer and, therefore, affordable. She knew I admired her work, and that meant a lot to her; it would be critical in a long collaboration. She counted on me having a ferocious loyalty to Carver's work, more than any "real" screenwriter would have. Besides, I had written her an enthusiastic letter about Carver from the Centrum workshop back in 1980. Apparently, she had just come across this letter in an old shoe box and took it as a sign.

Her proposition flattered me. I quickly calculated the opportunity to make an end run around that nasty codicil in the Harold and Mildred Strauss Living Award, that he shouldn't teach. Well, yes, I thought, trading stem glasses with the waiter, but he might mentor ...

In October of 1987, we flew to Syracuse with a forty-page treatment to show to Ray. That was the beginning of the cancer, I remember. He had just had two-thirds of a lung removed. "It's okay now," Ray insisted. "I'm okay."

Tess served Alaska salmon, a West Coast sign of warm welcome, and I tried to send Jill a silent reassurance down the length of the table.

After we ate, Ray took the treatment upstairs to his study. As Jill and Tess sprawled chatting on the living room rug, I sat distracted on the couch, wondering what was going through his mind upstairs. In stringing the stories together the way Jill envisioned, I had presumed a single protagonist. But I also had insinuated so much biographical information into the script that the protagonist was, implicitly, Ray. Would he sense that I had eliminated the distance between art and artist (already a slim margin in his work)? Would he feel his privacy invaded? I worried about it.

After a time—about an hour, I think—Ray returned. I heard each thunking footfall on the wooden stairs. As he stepped into the living room, Jill and Tess fell silent. Looking at me, he said in his soft mumble, "Great. I think it's great."

I wanted to throw my arms around Jill and shriek, but I stayed put. Ray came and sat with me on the couch, and we discussed the treatment for an hour or so, turning the pages slowly, reviewing his margin notes.

In May of 1988, when I saw him at Elliott Bay Books in Seattle for his last reading there, he had just that day received the fourteen-page option agreement. I'd gotten my copy, too, and I confessed I'd filed it without reading it.

"I signed it without reading it," Ray said, and he laughed.

That night he read "Elephant," about the man who is hounded for money by every member of his family, one of those stories that starts out hilarious and by the end you can hear your own heartbeat. He didn't seem to have enough wind for reading it, but he made it through. His face was puffy, bloated. There were rumors flying around that his lung cancer had metastasized to the brain, but Ray continued to insist he was okay. "I'm going to make it," he told me.

At that time, my kid sister was also fighting cancer. She desperately wished for just one conversation that did not lead off with that ponderous question, "How are you, *really*?" but her decision was never to conceal the truth: she had been told she was terminal.

A month later, when Ray and Tess went through a marriage ceremony, I still didn't read the signs.

Meanwhile, a Writers Guild strike was underway, and the entire film industry had gone into a stall. Because of this, Jill negotiated to postpone the effective date of her option.

On August 1, the strike still unsettled, our option went into effect.

On August 2, Ray died in Port Angeles of metastatic lung cancer.

On August 3, the Writers Guild strike was settled.

On August 4, 1988, Tess Gallagher buried Raymond Carver in Port Angeles.

I could not go to the graveside service because I had contracted to spend the week typing for Perkins Coie, and I sat in the law firm's 25th-floor Portland office feeling miserable. During my coffee break, a secretary for one of the litigators darted through the lunchroom, in mid-conversation about why some girlfriend was leaving her husband. She lit a cigarette, took two desperate drags and stubbed it out, then grabbed a Diet Coke from the ice box and rushed toward the door, leaving this line floating in the air behind her: "He just never made her skirts fly."

I wrote that down and felt a moment of private communion with Ray.

<div align="center">ℰℭℜ</div>

By this time, I had moved back to Oregon. I kept writing, published some more stories, won a couple of prizes and, in 1989, was asked to teach a writing class at Marylhurst College.

We never made our Carver film. Jill came up $250,000 short of her bottom-line budget. With four years of her life into the project and no film to show for it, she accepted a teaching position at Notre Dame in the fall of 1992.

<p style="text-align:center">∽◌◞</p>

People die to us by degrees. When I quit working on the screenplay, I lost Ray a second time. Now his poems and stories are what is left. In these he remains my teacher.

Once in a while, a student will interrupt my class to ask about Raymond Carver. "I mean, what was he like as a person and a teacher?"

"How many have read Raymond Carver?" When I ask for a show of hands, usually half the class responds.

You must, I insist, read the work. Get *Where I'm Calling From*, the volume of Carver's collected fiction. Start at the beginning and read the book straight through. Read "Fat," which is haunting and elliptical, read "Cathedral," a pivotal story for Carver, where his language becomes fuller, read "Errand," his last published story, which illuminates a moment in the death of Chekhov, a writer he loved.

If you read these stories in order, I tell my students, you will see that, without sacrificing precision, Ray began putting more experience, more emotional charge into the work. And that is what all of us—Richard Ford and Gordon Lish, Jill Godmilow and Tess Gallagher, and each one of us in this room—strive so hard to do.

THE MISSION AT NIGHT

Raymond Carver's classes inspired me to focus on short stories, and a decade later I had won a couple of literary prizes. I was invited to teach at Marylhurst, a liberal arts college near Portland, and I stayed there, teaching one upper-division creative writing class each term, for twenty years. I had pretty much given up freelance journalism altogether, save for the occasional denunciation of the City's indifference to the growing numbers of homeless and the thoughtless destruction of low-income rental housing.

Then, toward the end of the nineties, I began writing a book based on interviews with graveyard-shift workers. The idea had been percolating since a trip to Maui some years before, when my host had knocked on my door in the middle of the night insisting that I slip on my sandals and follow him outside to the edge of a nearby cliff where night-blooming jasmine clung. Although I could not see much below, not even under the beam of Jim's flashlight, the fragrance wafting up was magical. The surprise of that tropical shrub set me wondering. What else occurred while I slept?

Midway through my research, I spent two months spanning the millennial new year in Chile. There in a Santiago restaurant, over a long lunch with a local journalist, as I sat listening to his stories about all the international celebrities he'd met in the course of his work, I had a new thought about my book-in-progress.

"I had the privilege of interviewing two dozen strangers," I told him. "Most of these people had never dreamed of ever being asked for an interview." I fell silent for a moment as the privilege of those encounters washed over me.

Mike McCoy was one of those people. Here follows Mike's chapter from my 2004 book, *Up All Night*. I include it because his story continued to haunt me long after the book came out.

At six o'clock on a Friday night in June they begin lining up on the sidewalk, men of all races and ages, waiting to get into the mission at 526 SE Grand. Many wear multiple shirts and sweaters, even though it's a warm night. The mood of the group is relaxed because it's easy to eyeball the cluster of forty-some people and know that everyone will get in. On nights when more than fifty-five people are in line, the beds are given out by lottery.

Inside, Mike McCoy prepares to greet the homeless when the door opens at 6:30. A year ago, Mike was on the other side of the door, hungry, dirty, and looking for a place to crash. Today, he is one of ten men going through the mission's Recovery Program. He lives in a small hotel room upstairs and shares the work of running the mission at night.

At the end of the day, only one staff person is still around, and he himself is about to go home, leaving Mike and the other "program guys" in charge. According to Mark Duhrkoop, who works as a counselor at the mission, there is more at stake here than a clean, safe place to sleep. As he puts it, "We are ambassadors to the homeless, helping them to make a choice to change."

In his deep, gravelly voice, Mike McCoy agrees. "We treat the guys as family, with dignity and respect. Because they don't get it anyplace else. And I know they don't," he says, "'cause I didn't get it in the street."

Weather-beaten at age forty-seven, Mike has been clean now for eleven months; he'll graduate from the Recovery Program in two weeks. "Some of these guys out here knew me on the street," he says.

At 6:30 p.m., the door is opened and the men start streaming through it, each stopping to show a current valid TB card to the man at the door with a clipboard. The cards, required by the larger shelters in town, are proof that the bearer has been screened for tuberculosis within the last year.

The men take seats on folding chairs set up on the "chapel" side of the mission, that is, to the right of a partition which runs down the center of the room. Most have been here many times before. They know the routine and they know this room: the linoleum floor in a brick design and the propeller fans hanging from the ten-foot ceiling. A simple wooden cross is all there is to look at on the rear wall.

By 6:40 p.m. all forty-five men are seated and David, one of the men on program, steps up to the podium. "Any new guys here?" he asks. Even though no one raises a hand, he goes through the rules just the same:

"Please don't line up before 6 p.m. We have to cooperate with our neighbors. They're not homeless-friendly. We've already been taken to court about it. So, please, don't come before 6 p.m.

"Once you sign your name here, you're not to leave the building. Stay in front of the building. We call 'Last cigarette' about 9 p.m.

"If I smell alcohol, or if you're high, I'll ask you to leave. If you have a problem with that, you're out for thirty days. We're all alcoholics or addicts on the program. We know. You can't play a player.

"Leave hate, all that street mentality outside. This is the house of the Lord.

"When you go outside to have a cigarette, put your butts in the little can there.

"In the morning, you can have as much coffee as you want, but please bring the cups back inside."

David announces the names of seven men who have mail, but only one person comes forward to claim an envelope.

"Showers for a buck," he says. "There will be no laundry tonight. Please line up."

Eleven men go forward to pay their shower fee. Meanwhile, there are low grumbles of disappointment that they can't get their clothes washed.

When shower sign-up is over, the worship service begins. Tonight's ministry is provided by Pastor Leary and his wife, Judy, from the Tri-city Baptist Temple in nearby town of Gladstone. A guitar player has come with them, a heavyset man wearing a short-sleeved tropical-print shirt, and very white tennis shoes. Without introduction, he begins the service by singing "Jesus Put a Yodel in My Heart."

"Who plays guitar?" the musician asks in his Southern drawl. Three hands go up. "When you play for yourself, that's one thing," he says. "When you start playing for the Lord, I tell you, that's awesome." He gets the men singing "Amazing Grace." In the back row, an old man in black jeans and two wool shirts, his silver hair in a crew cut, knows all the verses. He sings in a bass voice, his hands

shaking. The last verse is simply a low chant "Praise God, Praise God, Praise God, Praise God ..."

His music ministry ended, the guitar player gives a two-minute sermon. "If you can learn to praise God, you'll be okay," he says.

Pastor Leary preaches for five minutes on John 6:40: *"For it is my Father's will that everyone who looks upon the Son and puts his faith in him shall possess eternal life; and I will raise him up on the last day.*

"God wants to have first place in your heart," the pastor adds. He asks the men to bow their heads and invites anyone who wants Jesus in his life to raise his hand.

"Come on," the guitar player coaches. "There's somebody right here that's got their heart broke."

One man comes swiftly forward and, after a moment, two more follow. Pastor Leary kneels with each one privately, praying in a low voice.

And then the service is over. The last staff person has already gone home. Mike, David, and the other program guys pick up the chairs—the floor will be needed for mattresses—and the homeless men make their way to the other side of the partition to eat.

"We need to go through the rules each and every night because guys have different issues," Mike explains. "Kind of a short-term memory thing." Coming in drunk would be an issue. "Normally what we'll do is we'll ask the gentleman to leave and then come back the next day when he sobers up. If he gets feisty about it, if he gets violent, if he's got a knife on him, we're not to get in fights." Mike figures he's had to call the police maybe half a dozen times in the eleven months he's been here.

The men on program have assigned jobs, running the mission and keeping it clean. "There are two areas that are the backbone—the laundry and the kitchen," Mike points out.

"They're the ones that constantly need attention. The sheets and pillowcases are laundered every day, the blankets on a cycle basis. There's quite a bit to do."

He explains that it's not this washing machine that's on the fritz, but the one used for personal laundry. "Everything's donation here, and it's not a commercial-grade machine," he says. "You got to make do with what you got." That old unreliable washer? He's pretty sure that Julie Stephenson, the mission staff director, will figure out a way to get it replaced.

Tonight, the menu is minestrone soup; the big meal of the day was served at noon. The mission's day program, five days a week from 11:00 a.m. to 2:30 p.m., offers showers, food, television, and a place to get out of the rain.

By 8 p.m. the men have finished eating, and everyone is given a mattress and foam pad. "Everybody kind of settles in."

"At nine o'clock, the night supervisor will go upstairs, and the graveyard man will come down. He works till 4:30 in the morning when I relieve him." Mike is technically exempt from taking any shift now that he is this close to graduation and already employed full-time outside the mission, but he elects to take the early morning shift because he wants to stay close to the lives of the homeless.

"It gets pretty quiet at night," Mike says, recalling his own nights on graveyard. "What the guys will do, what at least Dave and I used to do, is we'd bring down all our Bible studies and do our homework. And we'd fold their laundry, get it prepared for them."

Currently, six of the ten men on program share graveyard rotation. "It's tough on recovery," Mike concedes. "There is a certain wear and tear on you doing it.

"But there always needs to be somebody awake down here," he says. "We've had epileptic seizures, we've had people just wake up having a bad nightmare, maybe get violent or whatever—we get different things. It can be as simple as wanting water. Usually when I was on graveyard, I'd put out a couple pitchers of water for them. We may have guys who are working late. They're on a reserve list and we have to let them in, but they may not come in till say eleven o'clock at night. We normally tell them, 'Just press the buzzer real quick.' If the guy's awake back here, he can still hear it," Mike says with a dry laugh. "The major problem for the night guy is the tendency is to get tired and fall asleep."

Mike believes that working the night watch put him in touch with the heart of the mission. "I can walk down these aisles and pretty much tell you, probably by name, what's with these guys. We share in their personal lives, their joys, their sorrows, their frustrations, their anger. I actually learn a whole lot more from them than they have any inkling of knowing. A lot of them don't understand what a blessing they are to us. There's nothing that we could possibly do that's too good for any of these guys out here."

At the same time, Mike has learned not to expect too much of these encounters, unless the man is ready to change. "I can give them the tools, I can show them the road, but I can't take them down that

road. And nobody could do it for me either," he says, referring to the five-year period of his life when he was camping out in southeast Portland and using drugs.

He had gone once to Narcotics Anonymous, but he wasn't willing to stop using. "That's the key," Mike says. "My desire wasn't there yet. I needed to go out and do more research, as they say."

Like any other street person, Mike was aware of the Peniel Mission, which had a 94-year history in Portland, but he didn't consider himself someone who went to missions. By preference, he camped out and considered himself a loner.

"But I'd seen a guy that was on this program, that was back out on the street. I got to talking to him, and he said, 'Did you know that there is a program there?' I told him, 'Okay, I'll keep that in mind.'"

It wasn't until four or five months later, when Mike had gotten to the point where he was feeling hopeless, that he gave the Peniel program some thought. "It's like one day it dawned on me: I knew I needed to change."

Every mission in Portland has its partisans. Though he'd had no experience of other mission programs, Mike guesses that the success rate at Peniel, Union Gospel, the Salvation Army, or Portland Rescue is "about the same." Some men believe that being located away from the drug dealing on Portland's Skid Road gave Peniel Mission a bit of an advantage during the last twenty years that it's been on the east side of the Willamette River. "It is a little easier to stay clean over here," mission counselor Mark Duhrkoop says cautiously. "The river becomes a barrier."

Now in its sixth location, the Peniel Mission opened at 247 Northwest Couch Street, in 1904, as a branch of the head mission in Los Angeles. Founders Theodore Ferguson and his wife Manie had begun preaching on the corner of First and Spring Streets in Los Angeles in 1884 and went on to found the first mission in the city. By the end of 1907, Peniel was in thirty-five locations, including sixteen other towns in California, as well as Portland, Seattle, Alaska, and several cities, most of them seaports, outside the country.

It was Mrs. Ferguson who named it Peniel, a Hebrew word meaning "the face of God," the same word Jacob used to name that place east of the Jordan River, where he wrestled with the angel (Genesis 32:24-32).

Mike believes he was led to Peniel by that man he ran into on the street. "My greatest need at that point was my spiritual need, and

I understood that. Not that the others don't have a spiritual program, but I was led here," Mike says. "There is a plan and a purpose. I believe that."

He took a risk when he came in off the street because he was a wanted felon and could have been sent directly to jail. "I'd been running, I'd been on probation but I wasn't doing my probation reporting. I had two assault charges against me, I had a theft charge, criminal activity and drugs, and I was absconding. I knew that if I came here, I would have to turn myself in. My probation officer said, 'Hey, it's admirable that you went and put yourself into this program. But, you know, you still have to deal with all these issues.' I said, 'Fair enough.'

"So while I was going through this program, my probation officer sanctioned me to this Day Reporting Center for absconding felons downtown, and I was required to go through the six-month outpatient drug-treatment program at Providence. I had a full plate, doing all three at the same time. There were times where I'd leave here in the morning and I wouldn't be back till midnight."

Shortly after Mike entered the program, in 1998, Peniel folded, and CityTeam Ministries of San Jose took over the five remaining Peniel missions, all of them on the West Coast. CityTeam's recovery program, like Peniel's, is Bible-based.

The mission classes are held four mornings a week, but Mike wasn't able to attend until he'd finished the Multnomah County program. Every weekday for 120 days, he reported in at the Day Reporting Center at 9 a.m. and stayed for three hours of classes. "You call in every night and if your number comes up then you better be prepared," by which Mike means, you better be clean. "They do UA you.

"They want to try and turn people around. Why are people addicted? Why do we have criminal behaviors? It's more or less a secular way of dealing with the issues that those guys have, myself or whoever. We had prostitutes down there, drug addicts. We would cover criminal thinking distortions, that's what they called it. Why a person would think the way that they do. They would ask questions like, 'When was the last time you committed a crime?' (The last time I needed drugs.) 'When did your crime stop?' (When I quit doing drugs. Silly me.) That kind of thing. But see it's very basic. It seems so black and white to what they call the normies, the normal people, but after living years and years and years of it, it's a comfort zone. Misery can be a comfort zone.

"I was comfortable being miserable, but nobody enjoys it. It's just we don't know anything else, we're so used to it. We can become like that. And that's what's sad about these guys out here," Mike says, waving a hand toward the mats lined up along the mission floor. "I know that they're comfortable being in that state of mind, because I was there."

Mike began in a group of twenty-five offenders at the county's Day Reporting Center, mixed men and women, and was one of only two who finished. "That's the percentage. They just run.

"Anyway, I'd come back here, do some chores, do the things I needed to do here, then go back to Providence by six that night. Up there you don't fool anybody," Mike says with his distinctive laugh. "Some of the counselors sit there and say, 'I heard something in your conversation that tells me that you might want to go use again.' And I'd be, what's that mean?

"But you'd pick up after a while, kind of get an inkling. You don't want to learn other people's programs, but you kind of know when somebody's going to go use."

In addition to group therapy, which was required at Providence, Mike was invited to choose which classes he wanted to take. He took Anger Management, Communication Skills, How to Be Assertive, and a general education course about drugs, how they affected the spiritual, mental, emotional, physical, and social areas of his life. In that class, he came to an important understanding: "The addiction when I was homeless ran my whole life. So therefore, my recovery had to be the same. It had to be holistic in the sense that I need to take care of every area of life again.

"I'm at the beginning of my journey," Mike says. After a pause, he chuckles. "You know, by no means is there an arrival."

<p style="text-align:center">∞⟩⟨≻</p>

David, who is about to go off duty, announces "LAST CALL FOR CIGARETTE!" Many men are already asleep, but a few lumber up off their mattresses and trudge outside.

At ten, the lights go out, though there are some smaller reading lights in the rear that the graveyard man can leave on. "At my age now, I can't see very well at night," Mike says, "so I usually used these." But, since he was accustomed to reading a little every night in bed, to read in the dim light in the rear of the mission would

put him to sleep. "I would have coffee or go out and stand in the cold to wake up."

Before he got clean, Mike had been in and out of jail many times. "I mean I'd been abusing drugs for over thirty years," he says. "I had little stints of going to different jails, but never actually convicted of anything. So till about 1995, 1996, I'd basically gotten away with all my crimes that I'd perpetrated for twenty-some years. I used to say I'm either very good or very lucky. And I'd probably figure it's a little of both. But there were times, you know, the drugs will get you thrown in jail, number one."

Mike also lost his marriage on account of drugs. "I moved out of there in about '94," he recalls. "She didn't like me using drugs, and I wasn't going to give in. I said, '*This* is my sweetheart. See ya.' I was stupid. Using the drug, that's the only thing that counted in my life. And so eventually that became a divorce, and I moved on.

"I had an apartment for a while and then lost that, and then I started basically living in a car, dealing dope, running chemicals. I had biker affiliations, and that's how I hooked up with a lot of the heavy methamphetamine users. It's a very violent drug and they don't mess around, they don't play with it. They're very different from all the other drug addicts. *Very* different. And that's how I ended up on the street.

"Meth will take you down. As a matter of fact, I was just reading an article in *U. S. News* about methamphetamine. It's cheaper than cocaine, gives you more of a rush, and it's also more dangerous than heroin and cocaine because it mirrors schizophrenia so well. And it can cause permanent brain damage in a person so quickly it's unreal.

"I used to buy from different dealers, I'd make my own. I've done my reactions in hotel rooms, in places where they'd have to send in hazmat afterward if they found out. Because they use about seven different carcinogens mixed in to get the rush.

"I would shoot it. You can eat it, you can snort it, but shooting it is the way. Minimum, I would buy twenty-dollars' worth. Usually I'd buy about fifty-dollars' worth and shoot it all at once. Half a gram's about fifty bucks. I was up to that, anyway. From fifty to a hundred dollars a day.

"I shared with prostitutes, people I didn't even know. I picked up needles and just used them on the street. I would draw water out of mud puddles to mix it up. I've done all kinds of stupid stuff.

"Self-destruction," he says now. "There was a time where I just felt there was no direction. I didn't care about me, so obviously I didn't care about you or anybody. And that's what leads into crime."

One of the things Mike has learned at the mission is personal accountability. The Bible class uses the *Gospel Echoes* series, which was developed in Saskatchewan for inmates. They take actual life situations and solve them from a scriptural basis. As Mike describes it, "It would be the 'What would Jesus do?' in a sense. When's the right time to get angry? When we come in, we all deal with basic issues of low self-esteem, addiction, emotional problems, working together as team members. They teach you Bible studies from a practical standpoint."

Mike found a job ten months into the program, and now spends his days as a warehouseman at Portland Fasteners. "That's basically a nice term for industrial nuts and bolts," he says. "Say somebody's building a high-rise downtown: they'll order nuts and bolts for all the girders and stuff. And that's what we do.

"My boss is a great guy to work for. I said, 'Tom, this is where I've been, this is what I've done.' And I was just honest with him. And he says, 'That doesn't even matter.' He says, 'All that counts now is where you're going and what your friends are like now.'"

<center>഼ഽ</center>

For the time being, Mike's friends are the homeless guys he helps care for.

"I get the guys up in the morning. We hit the radio, hit the lights. 'Good morning, guys,' we tell them. 'Coffee's up there.' We usually have sweet rolls out for them. Then we'll go around picking up mattresses. They're usually pretty good about getting out around 5:30 a.m. In winter we let them stay till six. But we just can't leave them here all day because we've got to get things going." And Mike, of course, has got to start work at 7:30 a.m. at Portland Fasteners.

Mike and his friend Gary will be the first to graduate since CityTeam assumed the management of the mission, and a graduation ceremony is planned for the 29th of June.

"Basically, I'll get up and talk about this place, give these guys out here the encouragement that they need on a daily basis— sometimes on a minute-to-minute basis." He welcomes the opportunity to stand up and speak to the men who are still living on the streets. "I know that if I can do it, they can do it," Mike says.

"I want to offer that hope for them. I'm just one beggar showing another beggar where the bread is, and that's a fact."

A FATHER'S STORY

On October 4, 2002, Attorney General John Ashcroft went on national television announcing the synchronized arrests of "terrorists" in Portland, Detroit, Seattle and Lackawanna, New York. "Today is a defining day in America's war against terrorism," he announced.

Here in Portland, that very morning, we had been stunned by the spectacular arrests of four people who would eventually be connected to a case the media dubbed the Portland Seven.

It did not escape me that these arrests conveniently coincided with the administration's political needs: they preceded by six days the Senate vote allowing President Bush to invade Iraq. The publicity machine for the new "war on terror" required "dangerous terrorists."

At the time, I had a passing acquaintance with Kent Ford, who was a long-term employee at the neighborhood gym where I worked out. Fifty years before, Kent had started the Portland chapter of the Black Panther Party and led it for a decade. He also happened to be the father of one of the four men just arrested. In the weight room, I overheard a chilling remark: "They could never get Kent Ford, so they finally got his son." This was delivered by an older Black man, and I was struck by the murmurs of agreement around the room.

I asked Kent if I could interview him about the situation with his son, whom I heard was not only brilliant, but fluent in Mandarin. A former intern in the mayor's office, he had often been asked to escort visitors from China to the Lan Su gardens downtown.

Kent was cordial but declined the interview, explaining that the defense team had gagged the families of the accused, and that he could talk to me only after the trial. Meanwhile, *The Oregonian* made

much of this local "terrorism" in headlines, column inches, and papers sold. All their "facts" came from the federal prosecutor's office.

There was no trial.

In the way that the majority of criminal cases are now decided in the U.S., prosecution threatened each defendant separately until one of them finally agreed to "confess" in exchange for a light sentence. One by one, all were sentenced by federal judge Robert E. Jones according to the prosecution's recommendations. The defendant they rolled got seven years; Lumumba, who said he would never accuse a brother Muslim, was given eighteen. At that point, Kent phoned me.

The piece sold to *Portland Monthly*, one of those flashy city magazines that rarely run in-depth content. However, Russ Rymer had recently taken over as editor, and was working to bring serious reporting to the magazine. He may have been one of the first editors in America to publish work that questioned any of the ongoing cases of domestic "terrorism."

I began this piece in fall 2004, and it ran in the March 2005 issue. Within a couple of years, the *New York Times*, along with other newspapers across the nation, had begun to question the ethics of these FBI-concocted sting operations.

<center>ഌൟ</center>

The weather report for Portland says the temperature will hit the high 80s today, but at 8:30 a.m. on Tuesday, August 31, 2004, the sun brightens without warming the chill walls of the Mark O. Hatfield Federal Courthouse. Prominently etched in the green marble is an Alexander Hamilton quote—THE FIRST DUTY OF SOCIETY IS JUSTICE—and on a bench below it sits a solitary man, dwarfed by the spacious lobby. At sixty-one, Kent Ford is a stocky figure, his hair graying and shorn of the Afro he wore "back in the day."

Today federal judge Robert E. Jones will decide whether Ford's son, Patrice Lumumba Ford, was in contempt of court for having refused to answer questions when he appeared before the grand jury several months ago.

Wearing a T-shirt imprinted with his son's mugshot, Kent Ford is here to greet friends and family as they arrive for the hearing and to hand out leaflets protesting his son's sentencing, in November 2003, to eighteen years in a maximum-security federal prison on

conspiracy charges as one of the "Portland Seven." The United States government regards today's contempt hearing as yet another chapter in its war against terrorism; according to Ford's leaflets, it's another chapter in its war against Islam.

Three dozen people—half of them white, including a few dressed in the loose flowing gowns and white embroidered caps of traditional Muslim garb—take a leaflet, then ride the elevator upstairs to gather outside Jones's tenth-floor courtroom. But the doors are locked, and a court officer appears to announce that the hearing is closed. A murmur of discontent courses through the group, but no one leaves. The people stand or sit cross-legged in small circles until 10:25 a.m., when the doors are finally opened.

Inside the courtroom, defense and prosecution lawyers are seated, looking up at a small, balding white man in his late seventies wearing glasses, his yellow tie peeking from beneath his judicial robe. For Ford, it's an unhappy irony that he knows this judge from thirty-four years ago, when Robert E. Jones was sitting on the Circuit Court bench and Ford appeared before him at a hearing.

When all are seated, Judge Jones explains what transpired today in private: the government and the defense argued over whether or not Patrice Lumumba Ford should be held in contempt under Section 1826, the recalcitrant witness statute.

A tall man with shaved head, Lumumba, now thirty-three, is seated with his back to the door. He turns a guileless, full-bearded face to see the spectators and acknowledge his family.

On seeing his son in prison blues, Kent Ford suffers a terrible pang. "I never wanted the American dream for him," he says of Lumumba, "but I sure as hell wanted him to stay out of jail."

NIGHTMARE

For Kent Ford the nightmare began on Friday, October 4, 2002.

"I'd been painting all day, came home, and there were all these voice mails up there on the machine," he recalls. "God, I was getting calls from everywhere, all the way from upstate New York, from Hawaii, Oakland, South Carolina, Louisiana. What in the hell would all these people want with me?"

The one call he returned was from his stepson, James Britt, an attorney in private practice. "'They picked up Lumumba,' Jimmy

said. 'I don't know what for.'" Ford showered and changed clothes and hurried down to the federal courthouse to meet him at 3 p.m.

"There wasn't enough seats and Jimmy asked someone, 'This is the father, could you let him sit down?' And then, to see them bring him in, with his hands behind him in handcuffs. Oh, my God."

That's how Kent Ford found out that his firstborn son had been arrested for conspiracy to levy war against the United States.

The barrage of phone calls to his answering machine had followed an afternoon television appearance by United States Attorney General John Ashcroft, who declared the arrest of Lumumba Ford and four of his friends "a defining day in America's war against terrorism."

The following morning, Eric Lichtblau, writing in the *The New York Times*, noted that the Portland arrests followed closely upon other Patriot Act arrests in Detroit, Seattle, and Lackawanna, New York, and that the "developments may help the Bush administration respond to critics who say that plans for an attack on Iraq are diverting resources from the war on terror."

The arrests of Lumumba and co-defendants, along with Muslims in three other American cities, coincided with the administration's political needs: this "defining day" was just six days before the Senate resolution permitting President Bush to order U.S. troops to invade Iraq.

Factoring the "terrorism" and "conspiracy" language out of the newspaper reports, Kent Ford could pinpoint two accusations: that on September 29, 2001, a deputy sheriff had spotted Lumumba and three other men engaged in target practice at a gravel pit in Skamania County; and that in October 2001, Lumumba had gone to China to meet up with four other Portland-area Muslims and, allegedly, to cross the border into Afghanistan in order to fight with the Taliban. One of his group, a Jordanian named Habis Al-Saoub, was never seen again; the other four ended up back in Portland without ever setting foot in Afghanistan.

Lumumba Ford would explain that they had been in China attempting to get visas for Pakistan, where millions of desperate Afghanis were living as refugees.

Kent Ford learned about Lumumba's China trip the day Sandra Ford, Kent's ex-wife, asked him to come out to their son's apartment, where she was staying with Lumumba's young wife and their ten-month-old son. Sandra said she had something to tell him.

"As soon as I hit the door, she says, 'Lumumba went to Pakistan.'

"So I said, 'Dammit! Why did you let him go?'

"She says, 'He went to help with the relief effort.'

What Sandra Ford didn't mention was that she had tried to talk Lumumba out of this trip. "I did not want him to go because it was dangerous and I was scared," she would tell me later.

"And he said, 'Mom, you and Daddy Kent have always taught me to take care of other people.' And I said, 'This time the other people are your wife and baby.' We had a big struggle about it. He just couldn't stand the thought of Muslim children being murdered. Without help. He had learned how to do first aid, and he thought that would be helpful.

"In some ways he's kind of naive," Sandra says of her son. "He just thought, well, I'll just tell them I need to go and help people, and they'll let me do it."

The entire family pulled together to help Lumumba's wife, a native of China who had not been long in the U.S. "So I go out every day and check on my daughter-in-law to see if they have plenty of groceries," Kent Ford says. "Babies need things, and the mother's not from here, you know. One day after about two or three weeks, we're just sitting there on the couch, and she said, 'Lumumba called.' I said, 'Where's he at now?' She says, 'He's still in China.' I said, 'Huh? Didn't he get to Pakistan yet?'

"Something just didn't sit right with me."

Ford was hurt and confused that his son, who was thirty when he made the trip, had not told his father he was going. "It just wasn't like him to leave without touching base with me." He decided to go out to the mosque to see what he could find out.

Lumumba Ford had converted when he was studying in Beijing as an undergraduate, a decision Kent Ford says he respects, though he personally never had much use for Islam. "I used to know lots of Black Muslims back in the sixties, but I could never forgive them for the death of Malcolm X," he says.

The Masjed As-Saber mosque, where Ford went to inquire, is not Nation of Islam, the American Muslim group with which Malcolm X was affiliated, but a worship community predominately composed of Arab or Somali people. One of the guys at the weight room of the Matt Dishman Community Center, where Ford has worked out for forty years, told him that he should "ask for the imam."

"So I go around to the mosque and I say, 'Is the imam here?'

"The imam's sitting in a room with a computer and a chair, and I said, 'My son Lumumba. He went to Pakistan to help with the relief effort. Do you know what agency is he with? How do I contact him? He left a wife and baby here.'

"The guy didn't give me any answer. This was that Sunday. And that Tuesday Lumumba was home! He must have been already on his way back when I went around there."

Lumumba was home, but not out of harm's way. In Portland, FBI informants tailed and taped the China travelers, now officially suspects, initiating conversations with them about how far they would go and what they would do in the name of Islam.

Jeffrey Battle said some inflammatory things, even boasting that he had once thought of attacking a Portland-area synagogue. However, from reports the U.S. attorneys received from the FBI, they evidently assessed Battle as something of a blowhard; they decided it was safe to wait until they felt they had built a case on all the defendants. It was eleven months after Lumumba's return from China that they pounced.

<div align="center">₧₨</div>

After the arrest, Kent Ford took a copy of the indictment over to show a lawyer friend who works out at the Dishman gym.

On October 17, 2001, the Jordanian national Habis Al-Saoub had fled with Jeffrey Battle to Hong Kong. On October 20, Lumumba Ford followed, along with Ahmed and Muhammad Bilal, the two American brothers. Together the group entered mainland China, applied for visas to Pakistan, but were refused.

"Paul read it, and he said, 'Kent, your son is in a lot of trouble. They're going to try to split them all up. The main thing the guys got to do is just stick together.'"

"'You know you ain't done nothing,'" Kent recalls telling Lumumba when he visited his son at the Justice Center. "It was pretty much my turn to do some lecturing then. I said, 'You got three squares and a cot. Just stay here 'til the cows come home and it will pan out.'"

Four other defendants were also in jail awaiting adjudication, though not in communication with each other. Then, in March, 2003, five months after Ford's arrest, Maher "Mike" Hawash was taken into custody; five weeks later, he was named a co-defendant in the

same case, now dubbed "The Portland Seven" in headlines. Hawash, also recruited by the Jordanian, pleaded guilty to having planned to help the Taliban and, in exchange for this guilty plea and for promising to help prosecute other individuals, got a seven-year sentence and a dismissal of all other charges.

"After Mike rolled over," Ford recalls, shock and disgust still in his voice, "then they took the brothers." Ahmed and Muhammad Bilal also cut a deal. In late September, the single female defendant, the ex-wife of Jeffrey Battle, pleaded guilty to wiring Battle money in China (she had not gone along on the trip) and also promised to cooperate with the prosecution in exchange for a light sentence.

What Ford's friend Paul had said must not happen had happened.

That left the last three defendants.

The mysterious Jordanian, Habis Abdulla Al-Saoub, never returned to the U.S.

Lumumba Ford and Jeffrey Battle had refused all along to testify against any of the others, and Kent Ford felt they should stand their ground. "They had a trip to China." Ford groans. "That's all they had! I said take this cheap shit to trial." But in the end, the two pleaded guilty of conspiracy to levy war against the United States— in exchange for eighteen-year sentences.

There was no trial.

"When the government came and offered this deal," Sandra Ford explains, "Lumumba wasn't going to accept any favors. But I was telling him, 'Please, please, please accept this. You don't have a chance in a courtroom.' There'd been a jury poll, and most of the people in the Tri-County area think if you're a Muslim, you're a terrorist."

"This plea bargain just hung me out," Kent Ford says, disagreeing. And then, to make matters worse, Lumumba Ford had been set up by a snitch. "I said to Lumumba, 'You mean to tell me you had an informant on your tail for six months and you couldn't sniff it out?'"

Ford didn't push the issue further with his son, but he remains incredulous. "In our day, we wouldn't make a mistake like that. We would have had his head swimming so much he wouldn't have known whether he was coming or going."

"Our day" was the decade that began in 1968, when J. Edgar Hoover declared the Black Panthers to be "the greatest threat to the

internal security of the country." The following year, Kent Ford started a chapter of the Black Panther Party in Portland.

JESUS, MALCOLM AND MAO

Born in Jim Crow Louisiana in 1943, Kent Ford spent the happiest years of his childhood at a fishing camp operated by his maternal grandfather on the Maringuoin lobe of the Mississippi delta, near Baton Rouge. In a wooded area between the levee and the river, his grandfather kept a dozen boats he rented out to sportsmen from town. As a child, Kent learned how to cut up bait, string the lines, and run the boats. With his own canoe and shotgun, both gifts from his grandfather, he delighted in a wilderness rich with channel cat and crawfish, opossum and raccoon, whooping crane, ducks and heron.

At age twelve, Kent Ford and his three siblings followed their mother and her new husband to Richmond, California. There he became deeply involved with Easter Hill United Methodist Church, joining the Youth Fellowship, going on camping trips, and singing in the choir. "I didn't miss a Sunday," he recalls. Rev. Booker Anderson, by way of encouraging Ford to go into the ministry, got him a scholarship at the University of the Pacific in Stockton.

"But to me the church just wasn't answering the social ills," Ford says today. "I would see on the front page the Klan was outright killing people." In 1961, the year he graduated from Harry Ells High School, he began drifting away from the church. That same summer, he got a speeding ticket, his first run-in with the police. "For doing sixty in a forty-five on the lower deck of the Bay Bridge," he recalls. "I went to jail for three days on that one. I had just turned eighteen and little did I know then that it would set the stage for the rest of my life."

He never went to college. "I had brothers and sisters," Ford insists. "I had to get out and go to work." He moved to Portland and set himself up in a candy business, buying the merchandise wholesale and recruiting adolescents to sell it door-to-door. "I called it a group dedicated to keeping young men out of jail," he says today with a laugh. His half-dozen young followers were making money, and he was able to support himself and send money back home.

At the same time, he was reading insatiably, looking for the answers to the questions that he felt the church had avoided. In

January, 1967, Ford took a job working as a computer operator at Safeway, running price and order lists for their 104 stores. "Once the programs got running, I would read at work," he recalls. "I read *The Autobiography of Malcolm X*, then *Malcolm X Speaks*, and then *Malcolm X on Afro-American History*. Me and the whole candy crew read them.

"Malcolm was strictly getting down," Ford says today. "When Fannie Lou Hamer was beaten with a blackjack in 1963, Malcolm X had said, 'If any of this happens again, we've got the force to come down and deal with it.' He talked about the slaughter in the Congo, about the death of [Congo's leader] Patrice Lumumba. He moved the local struggle to the international level."

Ford, too, began to look at America's race problems in international terms. He studied the colonial periods in Africa and Latin America, pored over Mao's writings on the class struggle, and came to sympathize with independence movements, especially in the Congo, Guinea and Puerto Rico. Eventually, his interests attracted the attention of the police.

In December, 1967, Ford was living in an apartment on NE San Rafael Street. "When I got home one evening the side door was broken," he remembers. He and a neighbor found they'd been robbed. Ford was missing $1,000 cash, so he called the police. The two officers who answered the call noted the material lying about Ford's apartment—large maps of Vietnam and Cambodia, pictures of Ho Chi Minh and Mao Tse-tung—and wrote a report not about "burglary" or "reported break-in" but about "possible subversive subject."

"I had bought the posters and pamphlets from the Reed College bookstore," Ford says. "If they'd asked me about them, I probably would have told them." The incident, he thinks, got him pegged as a problem. "You had this war going on," Ford says of the late sixties, "and you got poor Blacks hung up between the devil and the deep blue sea, with their bellies empty, and the government's spending $60,000 to train each and every one of them and send them to Vietnam."

Ford himself had been granted a hardship deferment: when his mother separated from his stepfather, she declared Kent to be the family's sole support. But he was constantly meeting other Black men who weren't so lucky. One of his good friends, Tommy Mills, had served two deployments in Vietnam. Mills had earned the Silver Star for gallantry in action as a tank gunner, along with the Air Medal with three oak leaf clusters. "Tommy and I, we were organizing on

Vietnam," Ford says. "We found a place—God, the rent was like $100 a month—and we would have political education classes." These classes later became a Panther program.

Ford had twice visited Panther leaders in Oakland, but he didn't make his move into the party until after a brutal baptism into the ways of local law enforcement.

"I was coming down Union Avenue—which is MLK now—and right there at Shaver used to be an Italian fast-food place called Lidio's," he remembers. "I guess some of the kids was back in the alleyway shooting dice, and about nine at night the police run in and broke it up. We seen all these police cars over there and I looked over and said, 'What's going on here?'

"The police had arrested this kid that I knew. He was in the back of the police car, so I reached over and opened the door and let him out. The police jumped me. They figured out who I was: 'Here's Ford, let's take him now.' I didn't want to go, so we start fighting, and we had a hell of a fight." Telling this today, Ford laughs sheepishly. "I wouldn't do that today, you know, but I was twenty-four, twenty-five years old.

"They roughed me up pretty good. There was a whole parking lot full of policemen and when they get me in the car, one of them says, 'He's swallowing something.' So they kindly opened the back door, reached in and grabbed me by my feet, yanked me out. I landed on my back and they was hitting me in the stomach and everything. They put me back in the car, and an older policeman got in and he said, 'Kent, you're charged with Inciting to Riot.'

A friend came up with the bail that same night, and within days, Ford was back on the street, "agitating some more," as he puts it. "I didn't have the sense to stay home."

About a week later, he and a friend were on Union Avenue and saw a big mass of people coming up the road. "All Black. They're coming up from the Rose Festival Fun Center and they're being chased by the police. I said to Jeff, 'What's going on?' He said, 'Man, they shot somebody over there at Lloyd Center.'" Over the next few days, as northeast Portland erupted, the two men distributed "pocket lawyers," that is, guides to phone numbers, rights and procedures for people under arrest.

"For ten days there was firebombing and burning and shooting," Ford recalls, during which time the DA's office was trying to identify possible ringleaders. "It took about a week for them to pick me up again."

This time, with the Inciting to Riot charge still hanging over him, they charged Ford with Riot. "My lawyer argued before the judge: 'You got to choose either one or the other.' So they dropped "Inciting to Riot" and left "Riot." They went back to the Lidio's thing. They were saying that I gave the order and a guy kicked a policeman, but it was before I even got there.

"We went to the bail hearing, and I'll never forget: the prosecuting attorney got up and told the judge—these riots were still going on, you know—and he said, 'All he's going to do is get out and aggravate an already tense situation.'"

This time the bail was set much higher, at $80,000, and the court wanted it either half in cash or the entire amount in unencumbered property. Ford spent thirteen days in jail before anti-war friends Don and Susan Hammerquist arranged for radiologist Dr. Melbourne and heiress Penny Sabin to put up the property bonds to bail him out.

"After I got out of jail, I just said, 'Let's do it.'"

THE BLACK PANTHER PARTY FOR SELF-DEFENSE

Kent Ford officially launched Portland's Black Panther Party for Self-Defense in summer 1969 with a press conference on the steps of Portland Central Precinct, then at SW 2nd and Oak. "I said, 'If they keep coming in with these fascist tactics, we're going to defend ourselves.'

"I can count on one hand the people we actually recruited," Ford says without irony. "In those days, the police did most of our outreach." At top, he estimates Portland Panthers, half of whom were women, numbered fifty.

By December, the Panthers had started a free breakfast program at Highland United Church of Christ on NE 9th and Going, feeding up to 125 kids weekday mornings before school. Across the country each day, Panther chapters were feeding about 10,000 children. As Jesse Andrews, then Treasurer of the State of California, said, they were feeding more children than the U.S. Government. "But because it had been initiated and implemented by the Panthers, the FBI was constantly trying to discredit it," Ford says. "But the people in the Black community, who knew kids was going to school hungry, they admired it."

Around this time, Ford met Sandra Britt (née Trigg), who would be the love of his life, the mother of his children, and his comrade in the Black Panther Party. Ford had first spotted her at a northeast branch of First National Bank. "She was one of the few Blacks that worked for those guys. I used to see her when I'd go in the bank there, and she was the prettiest woman I ever saw."

Before he had a chance to ask her for a date, she came by his apartment with two friends. She had noticed him, too. As Sandra recalls, "Kent had just gotten out of jail. And he was living like a monk in this little apartment."

"She hugged me and kissed me," Ford says, "and I invited them in. And that was pretty much it."

In getting together with Sandra, Ford took on the role of stepfather. "I think Jimmy was going on six," Sandra says, "and I think Cindy was about 12 months."

"It was beautiful," Ford says. "They were well-mannered kids, and we did a lot of things together. I always tried to find time to go down walking the waterfront, or take the kids to a movie or fishing, stuff like that.

"In those days, it was just like electric, you know, in the height of the civil rights movement. Everything was clicking and there was so much going on. Sandra would always take the kids to all these meetings. Those days," he says with nostalgia, "were just incredible days."

Yet Ford was still dogged by the Riot charge. In 1970, having turned down several plea bargains over the last year-and-a-half, he finally went to trial. He was defended by Nick Chaivoe, a native New Yorker who had ridden the rails to California and in 1935 moved to Portland, where he attended law school at Lewis & Clark. Ford figures Chaivoe eventually helped him on maybe twenty different criminal matters, the result of constant hassling by the police.

Ford's trial lasted two weeks. "I beat the case," he declares. The court found that the incident that allegedly started the riot had happened before Ford even arrived on the scene. "They subpoenaed the guys involved in it and they said they didn't know me."

Chaivoe didn't stop there; he sued on behalf of his client in federal court. "The basis of it was I was handcuffed when they dragged me feet first out the car, and I landed on my back. I'll never forget, my lawyer asked, 'What was it he was swallowing?' And the policeman said, 'I don't know.' And so the judge heard this and then they awarded me $5,000."

Chaivoe got $2,800, Ford recalls, "and I ended up with something like $2,200," a fair amount of money in those days. What did he do with the settlement? "Well, Sandra was having Lumumba and I gave her some money for the baby. And then we took the rest of it and we got some guns."

"We never did openly display our weapons," says Percy Hampton, who considered himself "the kid" in the Portland party back then. "We kind of kept that out of the limelight 'cause that could frighten our own folks. We tried to keep our issues focused and the violence and the rhetoric down. We didn't want anyone to perceive us as being out-of-control, gun-toting radicals." Years later, Percy served as president of Laborer's Local 296, a 1,100-member union.

But at the same time, J. Edgar Hoover's war against the Panthers was in full swing. The FBI was engaged in its infamous COINTELPRO (counterintelligence program) tactics against sixties radicals, a program deemed unconstitutional in the seventies by the Senate's Church Committee, and subsequently dismantled. Under COINTELPRO, the FBI used wiretaps, informers, and plants to gather information about the Panthers, as well as extralegal means of intimidation, such as "brown mail," phony hate letters and death threats sent to Panther members, carrying the forged signatures of other Panthers. Party members were framed for crimes they hadn't committed, and several leaders were assassinated. Nineteen sixty-nine was a bloodbath for the party: 700 Panthers were arrested and forty-three killed that year, according to Lee Lew Lee's 1996 documentary film on the party. Casualties included Los Angeles leaders Bunchy Carter and John Huggins, both shot, and in Chicago, young Fred Hampton, killed by police as he lay sleeping in his bed. (The Portland Panther Percy Hampton and the martyred Chicago Panther Fred Hampton are unrelated.)

"We put guns in a special place for safekeeping," Ford explains, "so when the stuff was to come down, we'd have access to them and we could defend ourselves."

As it turned out, the local chapter never suffered a police siege. The Panthers' success in Portland, Ford believes, was partly due to the strong coalitions it made with the white community. The party collaborated with many progressive groups whose white members helped it establish the Fred Hampton People's Health Clinic.

In late 1969, the Panthers invited members of the Multnomah County Dental Society to attend a meeting at Geneva's, a popular

Black nightclub, to talk about the possibility of starting a dental clinic as well. According to Gerald Morrell, DMD, then on the Dental Society board of directors, about twenty of the city's leading dentists showed up. "The Panthers had an empty office on Williams Avenue," Morrell recalls, "and we got some pretty archaic equipment donated. My own dental assistant came down and washed instruments."

That was the beginning of the Malcolm X People's Dental Clinic, which lasted ten years. "But there were a lot of people we couldn't get to come down to Albina at night," says Morrell, who served on the board and recruited other dentists to help. "The clinic had a big picture of Malcolm X in the window, so that freaked a lot of people out.

"In those days, all you were hearing about were Panther shootings in Oakland. But local Panthers weren't interested in creating a national Black uprising; they just wanted to create in their own community—Portland—a better life for Black people, especially in terms of health and dental care.

"We didn't check race or income," Morrell says. "Essentially a white or a purple person could come down. The thing that was really neat was that Kent and Sandra, in their interactions with people, always stressed you can like or dislike people but do so on the basis of who they are, not on the basis of their race.

"I'd never had an experience with a Black person," says Morrell, who grew up in small towns in Washington. "I went to Oregon State in the fifties and they never even had a Black basketball player until the sixties. At night after dental clinic, Kent and I would go out to have a beer and shoot pool. I came to love him for who he is."

DADDY KENT

Ford married Sandra Britt in the summer of 1970, and on March 9, 1971, their first son was born. "Kent was a very kind partner," Sandra Ford says today in her soft voice. "He was just the most solicitous husband when I was pregnant. He indulged my cravings and my temperament and all of that.

"Lumumba was like a gift for him. He was so amazed. And so grateful. He would stand over his crib, I can remember that. Especially at night, he'd get up 'cause he wanted to make sure he was breathing. 'Do you think he's all right?' 'Yeah, he's all right.'"

In naming the baby, the Fords summoned all the qualities that Patrice Lumumba represented for them: ardor, idealism and endurance. "We are going to show the world what the Black man can do when he works in freedom," Lumumba had said in his 1960 Independence Day speech, "and we are going to make the Congo the center of the sun's radiance for all of Africa." Kent Ford bought his young son a biography of the martyred Congolese leader, and he framed a magazine photo and hung it above the child's bed.

Sixteen months after Patrice Lumumba Ford was born, the couple had their second son, and Kent named him Sekou, after Ahmed Sékou Touré, under whom Guinea had gained its independence from France in 1958.

"Kent was a very hands-on parent from the beginning," Sandra recalls, "even when the boys were babies. He never was afraid of them like lots of men are. He helped take baths, comb hair, feed them, cook their food, help them make their bed, dress them."

"What did I like about being a dad?" Ford says, "God, something real simple. Just having the kids calling me Daddy Kent."

When Cindy was ready for second grade, the Fords transferred her from Humboldt Elementary to the Black Education Center, which had been founded in 1970. In turn, they enrolled Lumumba and then Sekou in the school, and all three thrived in the environment of small classes and devoted teachers.

"Lumumba is an extremely smart kid," Percy Hampton says. "All of Kent and Sandra's kids were, to us lay people, like geniuses as far as books and schooling and education. They had really produced a very fine batch of kids."

In the late seventies, the Fords' marriage began to crack, and they were divorced in 1979. Today, neither of them is very articulate about how or why their breakup happened. They agreed on joint custody. Although Jimmy and Cindy were never to live with him again, Kent Ford kept Lumumba and Sekou two weekends a month and visited all the kids every day at Sandra's, if only to make sure they were doing their homework.

Lumumba's favorite subject, Sandra Ford relates, was Chinese. He first got interested in it so he could read martial arts texts in their original language, and he applied to Lincoln High School because it was the only high school where Chinese was offered. The boy loved his adopted language. "His first set of grades, he got a D in English and an A in Chinese," Sandra recalls. "And Kent

looked at it and he said, 'There's something wrong with this picture here.'"

Only once does Kent Ford remember having to crack down on Lumumba: in his senior year of high school, he started chasing skinheads. "He and his friend cornered some skinheads down in the Pioneer Square bathroom," Ford says. "They walked in and Lumumba said, 'Skinheads?' And this one said, 'Yeah, but we're not racist.' That defused it," Ford recalls. But he told Sandra to send the boy to live with him. "I told her I'd nip that shit in the bud," Ford recalls, the exasperation returning to him after all these years. Lumumba Ford came to live the remainder of his senior year with his dad, and he would live with him again after he came back from doing undergraduate work in China. By that time, he had graduated from Portland State University and was serving an internship in the mayor's office.

Through all these years, Kent Ford continued to help financially, making no distinction between children and stepchildren.

At one time, maybe twenty-five years ago, Sandra Ford was convinced that Kent should go to law school. "I just couldn't do it," he says. "I saw it as crossing over, and I couldn't, not with so many of my friends gone to prison."

Kent Ford's prominence in the Black Panther movement continued to invite the attention of the police, and he used to get regularly picked up twice a month. "No license plate light or not signaling within 100 feet of a turn," Ford recalls, the annoyance still in his voice. Each time, the police would tow his car in and take him down to the station. "Every time I'd go to Chaivoe's office, I'd say, 'Man, I'm sick of this shit.'"

The Panthers' charitable efforts also made Ford a target. In August 1970, Al Laviske, general manager of a firm with six McDonald's franchises, went on local television and, as Kent Ford recalls, accused the Panthers of being extortionists. Kent and Sandra Ford were shocked: only a few days before, at Laviske's request, Kent had escorted him on a tour of Panther clinics and the breakfast program.

The Panthers decided to picket the Union Avenue McDonald's. Their leaflets cited McDonald's for its failure—locally and nationally—to award franchises to Blacks, for racist hiring and promotion policies in Portland, and for disinterest in contributing to the children's free breakfast program. Laviske filed for an injunction, and Judge Robert E. Jones, then on the Circuit Court, offered to hear

the matter. It wasn't a good sign. The Panthers used to circulate a list of judges they deemed so unsympathetic you never wanted to meet them in court. The name at the very top of the list was Robert E. Jones. Jones's decision, though, was moderate. He permitted the picketing to continue but told the Panthers to reduce their numbers on the line in front of McDonald's to ten.

Nearly a week later, the same McDonald's was dynamited in the middle of the night. Damage was not extensive. The Panthers pointed out that they'd had no motive to take their dispute to that level because the picket line was working: about ninety percent of the franchise's business had fallen off.

Before it opened back up, Ford recounts, Laviske sent word to the Panthers through the Office of Economic Opportunity's Neighborhood Service Center that he wanted a meeting. When they got together, Ford reminded Laviske that the day they toured the Panther programs he hadn't actually asked for any money; when he then heard himself called an extortionist on television, he felt double-crossed. Laviske said he'd like to reopen the Union Avenue store without the pickets. He offered to contribute 500 paper cups and 50 pounds of hamburger meat every week to the breakfast program and to promote Blacks into management positions.

"Me and that guy from McDonald's, after he got the FBI out of the picture, we became pretty good friends," says Ford. In 1973, when the Panthers were promoting sickle-cell anemia testing through the Portland area, Laviske gave them 1,500 courtesy cards to offer to anyone willing to be tested. The cards entitled the bearer to a free hamburger, fries and a beverage. Moreover, Laviske made the fast-food lobby available for blood draws four Saturdays in a row.

Ford's organizing did not advance him personally. In the opinion of Robert Phillips, who now serves as Affirmative Action Officer for Multnomah County, "Kent was willing to sacrifice himself and the opportunities he might have had in the white community in order to promote justice in the Black community."

Ford had dropped the candy operation in the late sixties, "and then I pretty much took on various jobs. Nothing really lucrative, you know, just enough to make a living. I managed apartments for a guy who had over 400 units up on 13th and Killingsworth, but I had to get out of there when the drugs moved in."

His work as manager had involved painting units when tenants moved out. "And so I just started painting. There was a gentleman who was a minority contractor and he had a contract

down at the Arlene Schnitzer [concert hall] when they were remodeling the place. I went to work for him as a painter." Since 1996, Ford has also worked part-time as a weight room attendant at Dishman.

Except for one year when he paid Lumumba's $13,000 tuition at Morehouse out of pocket, Kent Ford never had the resources to send the four kids to college and he is grateful that they were good enough students to merit financial aid. James, his stepson, went through law school at the University of Oregon; Cindy graduated from Spelman College and has a good job in human resources; Sekou graduated from Stanford Medical School and practices sports medicine in San Francisco.

Lumumba Ford took a year off after undergraduate school, then earned a master's from the Paul H. Nitze School of Advanced International Studies, operated by Johns Hopkins in Nanjing. There he met a beautiful Chinese journalist. They married in a traditional Islamic ceremony in Portland; their first child, a son, was born in January, 2001.

Two of Sandra Ford's kids gravitated toward religion. "I took every religion class they ever offered at Spelman," Cindy Britt says. "Judaism made so much sense, but I think the ritual of Catholicism is what drew me." After years of going to Mass by herself, she converted.

Sandra Ford believes Lumumba's conversion had been a long time coming. "When he was a teenager he had started thinking about Islam," she says. "He said that Allah had part of his heart, but the world called louder; he had women and dancing and he drank some.

"Lumumba has a remarkable reputation in the Muslim community for charitable works," his mother says, "picking up people from the airport who are new to the country, helping them get situated, making sure they get clothes and food. The clothing thing is a big deal, so at the end of every season, if I haven't even worn something, I tell him, 'Just take that to give away.'"

For the next number of months or years, Kent Ford plans to shape his life around the struggle to free his son. He goes to meetings, puts up posters, talks to anyone who might possibly take an interest. "This is stuff I should have been doing two years ago," Ford says, "but I was just in a tailspin." In November, 2004, he passed out "Free Lumumba" leaflets at the Coliseum, where 3,000 Portland Muslims were celebrating the end of Ramadan (and in the process, managed to get a citation barring him from the premises for ninety days). "It's

the only thing I know how to do," he says. "The struggle's the only thing I ever did know."

His old Black Panther friends have been his most faithful supporters, but he finds himself missing Chaivoe, who died in 2000, at the age of eighty-eight. "He'd have made this whole thing go away," Ford believes. "My boy wouldn't be in jail if Nick was alive today."

ECHOES

Ford feels his kids cannot understand the Black Panthers unless they understand the conditions in those days. "One time Lumumba asked and I said, 'You guys don't know what had to be done in those times: the times take their actions, you know.'" He has always tried to give them enough information about America's racial past that they aren't taken by surprise, while not filling their heads with the fears he hopes they'll never find justified by society.

In 1971, the Black Panther Party suffered a leadership split, exacerbated by FBI brown mail between Huey Newton, its founder, and Eldridge Cleaver, exiled in Algeria. When the split came, Percy Hampton says, Portland drew back from Oakland headquarters. "With a lot of people going to jail and dying, it just kind of dissolved over the years."

Hampton especially missed the breakfast program, which closed in the mid-seventies. "We were kind of forced away from it," he says. "We had food handlers' cards and everything, but the City of Portland didn't want a breakfast program by the Black Panthers; they started one of their own. I still maintain my friendships with all the Black Panther Party members, but there came a time where we had to figure out what we were doing with our lives."

Kent Ford stayed in a little longer. "Lots of defections in the mid-seventies," he says. "The health clinic and the dental clinic, we ran those up until 1980. But as soon as Reagan got in there, we couldn't sustain the funding anymore.

"The main thing was just harassment. They arrest you by day and harass you by night. I'd go down to Dishman to work out, and no sooner would I leave, they'd go in and talk to the instructor there. And they did that every place we went.

"In the old days me and my friends always judged people by: How much dues have you paid? How many times have you ever been

arrested? How many times have you had your door kicked in? How many times have you been stopped on the street when you were planning to go to the movies and taken downtown instead?"

One of the last times Kent Ford ever wore the Panther black pants and blue shirt was for a funeral. "The police killed a guy out at Rocky Butte who was trying to escape, and we felt he was trying to get free. We marched from Cox Funeral Home to where the *Skanner* [newspaper] used to be, there on Williams, fifteen or twenty of us, and we had a barbecue. There was police and FBI all over; we could see them everywhere. They could have come by to get some barbecue," he adds with a laugh. "That barbecue was good."

Ford's Panther past continues to follow him. "I was at Dishman one morning, in the game room watching CNN," he says, "and in walks this reporter from the *Tribune* and he hands me a stack of papers." It was September, 2002, less than a month before the FBI arrested his son. The *Portland Tribune* had come into possession of the surveillance files that the Portland Police Intelligence Division collected and maintained in the 1960s and 1970s on hundreds of political and religious organizations and individuals, including Kent Ford.

"I said, 'What's this?' And he says, 'This is what they've got on you.' And I said, 'Who?' And he said, 'The City.' And he wanted me to expound on it, but I just told him, 'There's nothing new here. I know all this.'"

In fact, there were some surprises, like the detailed sketch of one of his apartments showing a gun closet that never existed.

Some items were maddening, like the long lists of business people the police interviewed, hoping to find someone who would accuse Ford of extortion because of his solicitations for the children's free breakfast program. Other items were comical, like the police account of the day Ford helped promote African Liberation Day by putting up posters: under "weapons used," the officer had written "paste."

And at least one item was gratifying. Finally, Ford was able to hold in his hand and read what he'd long suspected: one day back in the early seventies, the FBI had broken into his home and taken papers, photographs and his shotgun shells. "I knew it for years, but couldn't confirm it until I saw those files. Lumumba was only this big," he holds out his hands to indicate eighteen inches. "We were coming out of the house and they were parked there underneath the trees."

From Ford's perspective, the FBI used the same COINTELPRO tactics on his son— only now they call it the Patriot Act.

"I think at the time the Panthers thought they'd be the reason for change," says Kay Toran, Director of Affirmative Action under Governor Vic Atiyeh, and now President and CEO of Volunteers of America. "But they didn't see that change happen. They were just young! And a lot of lives were lost."

Yet there are some satisfactions. "I'll be in a store or someplace like that," Ford says, "and some kid will come up to me and say, 'Mr. Ford?' And I'll say, 'Yeah.' 'Remember me? You used to feed us every morning.'"

GRIEF

On November 24, 2003, Lumumba Ford drew eighteen years in federal prison. Kent Ford felt as though he went through the next four months in a daze. He heard that his son's wife spent one entire night weeping and then, from all visible signs, it was over for her. Ford is in awe of her strength. He himself has had a hard time shaking off depression. "It seemed so unreal," he says now of the period immediately following the sentencing. "But I remember Coleman Brown, my old friend in SNCC, always used to say, 'Everything is real.'"

In March, 2004, Ford received a subpoena in the mail: now he was the one being called to testify before the grand jury. "Why are they messing with me?" he asked his family, rhetorically.

His stepdaughter, Cindy, said, "You know."

The subpoena was signed by Judge Robert E. Jones, his old nemesis from the Panther years. What Ford wanted to say now, appearing before Jones in U.S. District court, was, "You've been after my Black ass for years. If you want to put me in jail, you can. It don't make no matter to me."

Instead, he went before the grand jury wearing that T-shirt emblazoned with a blow-up of the mugshot from Lumumba's arrest. The grand jury was pursuing the imam of the Masjed As-Saber mosque, the same imam who had not been forthcoming when Ford went to him to plead for information about the ill-fated China trip. Ford pled the fifth, despite having no pertinent information; he welcomed the chance to act, even if only by refusing to answer questions.

Once, years ago, Ford was shot through the knee and hand in an altercation at a gambling game. He took the .32 pistol off the man who'd lost at dice, walked himself to his car, threw the gun in the Willamette River as he drove across the bridge to the hospital, and insisted to the police in the emergency room that he had accidentally shot himself. In Kent Ford's hierarchy of values, few principles are as sacred as keeping your mouth shut.

Ford keeps replaying a conversation he had with Chaivoe back in 1969, when he was charged with rioting. "They offered me fifteen years, and I just waited, and three or four months went by. Then Chaivoe called and said, 'Kent, this time they offered you eight years.' 'I didn't do anything,' I told him. 'Just prepare the case.' The Friday before the trial he called and told me, 'Kent, they're going to reduce your charge to Disorderly Conduct and give you nine months.' So I said, 'I'm sorry, but I don't even know those guys.' We went to trial and we beat the case."

And he also thinks of another conversation, the one he had with his son when he visited him after the plea bargain. Lumumba asked, "Daddy Kent, you think I made the right deal?"

"What could I say? I couldn't say you should not have gotten yourself in this shit in the first place, messing around with people who couldn't keep their mouth shut. I wouldn't have given those people the time of day."

RESPECT

It's late in the morning on Tuesday, August 31, 2004, and Kent Ford and the other spectators are sitting in a federal courtroom, listening to Judge Jones explain why they were kept waiting an hour and a half: the government wanted the contempt hearing to take place in private because the original grand jury questions involved the mosque where Lumumba used to worship.

The judge reads back part of the proceedings, quoting Lumumba Ford's reasons for refusing to answer the grand jury: "My religion does not permit me to say anything against my brothers which will put them in jeopardy." Jones finds Lumumba guilty because he wouldn't even answer the innocuous questions.

But Kent Ford picks up on something that surprises him: the tone of respect with which the judge addresses his son. Judge Jones says that he finds Lumumba Ford's beliefs to be in good faith, to be

sincere. Speaking directly to the small gathering of listeners, he explains: "He will not be coerced to testify against another Muslim no matter what sanction we impose." Jones gives Lumumba two months, considers the time served, and reminds him that he won't get credit for those two months on his eighteen-year sentence.

When the hearing's over, the defendant rises, the marshal at his side. His father, cap in hand and gray head bowed, leans forward and cries, "Lumumba!" As his son exits the side door, Kent Ford sits back against the courtroom bench, pride and grief warring in his heart.

2023 Note to "A Father's Story"

According to *In the Line of Fire*, the 2006 memoir of former Pakistan President Pervez Musharraf, Al-Saoub was killed in October 2003 along with seven other al-Qaeda terrorists by Pakistani forces. Given that Al-Saoub authored the trip abroad, recruited the others, and was the only defendant who never returned to Portland, this writer has long suspected that he may have been the confidential witness in this case.

Emboldened, the Portland office of the FBI tried prosecuting local constitutional lawyer Brandon Mayfield as the terrorist responsible for the 2004 Madrid train bombing. This was a drastic mistake. They were obliged to drop the case when they realized that Mayfield had never even been to Spain. Mayfield successfully sued the FBI for two million dollars and, furthermore, went on to successfully challenge two provisions of the Patriot Act, convincing the court to have them declared unconstitutional.

On February 22, 2023, National Public Radio reported of the U.S. justice system that "In any given year, 98% of criminal cases in the federal courts end with a plea bargain—a practice that prizes efficiency over fairness and innocence, according to a new report from the American Bar Association." It should be noted that, with a single defendant, the common technique of playing one defendant against another is not available to the prosecution.

Sadly, however, the humiliated FBI chose as their next target a Somali immigrant teenager, and this poor fellow, caught in a classic sting operation, caught thirty-three years.

Patrice Lumumba Ford served out his sentence in seven federal prisons where, variously, he offered tutoring to other prisoners, started a recycling program, studied Spanish, and led a regular prayer service. He was transferred to a federal halfway house in Portland in January 2017, and granted a final release in October 2018.

INVINCIBLE SUMMER

> In the middle of winter
> I at last discovered that there was in me
> an invincible summer.
> —*Albert Camus*

THE MAN IN THE PEW

He was an old man, tall and thin, with bushy white eyebrows, who always sat alone in the second pew on the far left. Somebody said his name was Joe. I might never have met him had I not preached that one Sunday morning during Lent. I was speaking on Matthew's account of the Transfiguration, where Jesus takes Peter, James, and John up to the mountain, and they see him transfigured into a dazzling radiance. These three have been chosen for a glimpse of his divinity. In the Gospel of Matthew, Jesus commands them, "Do not tell anyone of the vision ..."

This was at the Downtown Chapel, a small Catholic parish served by Holy Cross priests in Portland's Skid Road. Fr. Richard Berg, who was then pastor, used to point out that the vehicles parked out front ranged from a Mercedes to a shopping cart. There was no typical parishioner, and many of us came alone. The Downtown Chapel devoted most of its resources and ministries to people living on the street.

After the 8:30 a.m. Mass, I would go up to the second floor to discuss the Sunday Gospel reading over a cup of coffee with a small group of regulars. Among them there were people suffering from all manner of physical, mental, and emotional infirmities, and some of the wild, impassioned non sequiturs I heard in that room would stay with me throughout the week.

During the discussion, there were always two or three people who would get a cup of coffee and sit apart, never saying a word. This man, Joe, was one of them. He looked to be in his mid-seventies, private and intense, a man who tottered when he walked, and whose jacket and tie had seen better days.

On this particular morning, considering the Transfiguration, someone pointed out, "Jesus told the disciples that he would have to

die, and now he was trying to show them about the Resurrection." Consensus was never our expectation; no one argued. "Who was Elijah, anyway?" someone else demanded to know. "When Jesus's garments began to glow," a girl mused, "he looked like the sun."

A volley of disconnected remarks, yes, but then Peter was not clear either, and he witnessed the event.

After the "discussion," Joe made his way over to me and spoke for the first time.

He said, "Have you seen Raphael's *Transfiguration* in Rome?"

"I beg your pardon?" I said.

"Last week I went to the Vatican Museum and I saw Raphael's *Transfiguration*. Have you ever seen it?"

In truth, I had always figured Joe lived in one of the shabby single-room-occupancy hotels nearby, as did so many of our parishioners. I could not imagine any of them traveling to Rome. But I had worked on Skid Road long enough to know that people have many stories, some of them classic symptoms of dementia or schizophrenia—and some of them true.

"I have never been to Europe," I said. I introduced myself.

"Joe Mullaney." He said he'd bring in a photograph of the painting for me to see the following week. Then it was time for me to go downstairs to give my reflection again, for the 10:30 a.m. Mass.

The following Sunday Mr. Mullaney brought an oversized art book upstairs. After the gospel discussion, he opened it to show me a reproduction of the last canvas painted by Raphael before he died in 1520. Commissioned by Cardinal Giuliano de' Medici for the Cathedral of Narbonne, the painting looks to be one picture stacked on top of another. In the upper half, Christ floats above the earth in a bright cloud; in the lower half, a crowd swarms chaotically.

Mr. Mullaney pointed out to me that the lower half illustrates the gospel passage following the Transfiguration: a father holds an epileptic boy in his arms, waiting for Jesus to come down off the mountain, waiting to implore him to, please, heal his son.

From the day he brought the art book, I tried to get to know Mr. Mullaney, but it was not an easy task. At Mass I'd sometimes slide into the pew next to him and get a polite nod, but he still sat outside our discussion circle in silence. I asked him to dinner. He didn't like to be out after dark, he explained, but he'd think about it. We went on like that for the next few years. Once, after I hadn't seen him for a month or two, he told me that he'd been to Berlin.

Then one day, without warning, Mr. Mullaney stopped me after Sunday Mass and told me that if I still wanted to have dinner some night, he would like that. It was November of 1996, three-and-a-half years after I'd first invited him.

"But there's something you should know," he said. "And maybe you won't want to go to dinner when I tell you, and that's all right."

We were standing in the tiny entrance of the Downtown Chapel, amidst a lot of chatting parishioners. Nearby, Fr. Berg was shaking hands.

"I work for the CIA," Mr. Mullaney said. "If you go out with me, you may have your phone tapped or the FBI may create a file on you."

"I'm sure they already have one," I said, only half joking.

He gave me a moment's look. "Okay," he said finally. "What night is good for you?"

We ended up meeting at the 5 p.m. Mass on a weeknight, and afterwards walked a few blocks up Southwest Broadway to the Imperial Hotel. There we sat at a small table for four in the center of the quiet, brightly-lit dining room. I asked him if he wanted a cocktail before dinner and he said, no, he had a heart condition.

It was difficult trying to sustain a conversation:

"Where do you live?"

"Vancouver."

"Do you have family here?"

"No."

"Where were you raised?"

"Pennsylvania."

Not wanting to pry further, I watched him eat. He had salad, then soup, then prime rib and mashed potatoes, then dessert. He ate very slowly. Several times he said how good the food was, but that was all he said.

At long last, dinner was over. Since he had come at my invitation, I paid the check. We got up from the table. He was a little unsteady on his feet. We slowly made our way over to the coatrack, put on our coats and stepped outside. It was about 7:30 in the evening, already cold and dark.

"What are you doing tonight?" he asked me.

"I'm going home," I told him. He would be looking for the number 5 bus, to head back across the river. I said I'd wait with him at the bus stop.

"Would you have the time to have a drink with me?" he asked.

"I thought you didn't drink."

"Not before I eat," he said. "But now that I've got something on my stomach, I could drink a brandy."

I didn't think I could sit through another socially awkward hour of silence. As though he were reading my mind, he said, "We could talk."

I suppressed a laugh. "Very well," I said. "Where would you like to go?"

"The Benson?" he suggested.

The Benson! Long Portland's flagship hotel, it had an elegant wood-paneled lobby bar with deep windows and, sometimes, a jazz pianist. I was startled, but I did not disagree.

And, so we went, heads down against the wind, across the street and north one block to the Benson Hotel, where we sat in the bar, with its potted palms in massive Chinese vases. A waitress brought us two snifters of brandy, resting at a tilt on mugs of hot water.

Mr. Mullaney perched, spine erect, on the edge of a chintz settee. Without taking off his raincoat, he began to talk. "I worked at Los Alamos. I had studied physics at Catholic University of America, and Edward Teller recruited me personally." He said this with evident pride.

A doubt lingered in my mind, and I asked him the one question I could think of that might convince me he had really been at Los Alamos: "Did you ever go to Edith Warner's tea shop at Otowi Crossing?"

I knew from my reading about the American Southwest that this tea shop had been a meeting place for two unlikely cultures—the native peoples of San Ildefonso Pueblo and the nuclear scientists working in secret on "the hill."

Mr. Mullaney didn't hesitate for a moment. Yes, he knew that spot, the original little suspension bridge across the Rio Grande, the cottonwood trees along the riverbank.

I realized then that it wasn't Mr. Mullaney and it certainly wasn't Joe; as a nuclear physicist, he would be Dr. Mullaney. And he would have worked alongside some of the most prominent minds of the century—Oppenheimer, Fermi, Bohr, Feynman, Bethe, Teller.

Except when talking about Edward Teller's high expectations of him, Dr. Mullaney didn't speak with much

excitement of his work. I assumed Los Alamos had weighed heavily on his mind all these years.

Dr. Mullaney said that many of the people who worked there had developed cancer or other health problems, but that he had been lucky. He had already lived longer than he ever expected to. We had a second brandy and he talked for nearly ninety minutes straight. He had never married. He had a sister living in San Diego. He went frequently to Europe. He was fluent in German. He loved classical music and art.

I did not ask questions about the CIA; I knew he would not answer.

When he learned that I was a writer, Dr. Mullaney wanted to talk about Graham Greene, who was his favorite novelist. A few days later, I took three of Greene's novels with me on a trip to Kerala. Dr. Mullaney was often on my mind as I travelled, reading about Greene's characters who struggle, amidst the contradictions of modern life, to maintain their faith.

When we were ready to leave the Benson, Dr. Mullaney insisted on paying for our drinks. I watched him open his wallet and sort through perhaps ten credit cards before choosing one to hand to the waitress. Clearly, he had a life away from Skid Road.

Despite our long conversation and despite the postcards I sent Dr. Mullaney from abroad, our relationship never got any easier. Back in Portland, I invited him to go to brunch with me some Sunday morning after Mass, and he put me off just as he had done before.

A couple of years after that, in 1999, I began attending Mass elsewhere. I still occasionally wrote to Dr. Mullaney—once on a postcard of that little suspension bridge across the Rio Grande at Otowi Crossing—but I never saw him again.

Then, in the fall of 2001, just as I was about to return to India, I met with Fr. Berg for dinner at the Brasserie Montmartre, our favorite place for cheeseburgers and martinis. "I want to hear about Dr. Mullaney," I said. "I had something of a friendship with him."

"He died last year," Fr. Berg told me.

"Oh, no!" Away from the parish, I had no way of knowing.

"He left the University of Portland more than $800,000."

"He didn't even go to school there!"

"I know," Fr. Berg said. "He'd seen my name on a list of people who have remembered the University in their will, and said he wanted to follow my example." Fr. Berg smiled ruefully. "I told him

I hoped he would remember the Downtown Chapel, but he said, no, he wanted it all to go to education."

"He was a brilliant man." I studied Fr. Berg's face for any reaction.

He, too, spoke guardedly: "He had a certain discomfort with his activities during and after the war." He stared a question back at me.

"Yes, I do know about his work," I said.

"He was a man of faith. Maybe you also know he came into town for daily Mass."

I had no idea, as I was rarely downtown for the noon Mass.

"And to confession," my priest friend added, staring down at his cocktail glass. And that was the last he said about Joe.

Even after the death of the penitent, a priest can never reveal the particulars of confession.

Edward Teller once wrote, in a letter to Leo Szilárd, "First of all, let me say that I have no hope of clearing my conscience. The things we are working on are so terrible that no amount of protesting or fiddling with politics will save our souls." And this was in July of 1945, one month before the needless bombings of Hiroshima and Nagasaki.

It was President Truman, and not the scientific community, who insisted the new bomb be used in Japan. Yet Fr. Berg's mention of Dr. Mullaney's daily confession saddened me, since it suggested a wound too deep for him to accept God's forgiveness.

<p style="text-align:center">ℰℭ</p>

When I again returned from India, I began hunting by phone and online for whatever I could find about the life of Joe Mullaney. His sister had published no obituary, but kindly provided me with a few basic details.

Joseph Frederick Mullaney was born April 1, 1917, in Scranton, Pennsylvania, where his father was a switchman for the Delaware, Lackawanna & Western Railroad. He and his sister both went to a parochial school. It was there that Joe learned to play the piano and cultivated his lifelong love of music.

He attended the University of Scranton, then run by the Christian Brothers, on a Pennsylvania State scholarship. "Those were very hard to get," his sister assured me. "He was the only one in town who ever landed one." Later, he left nearly a quarter of a

million dollars to Scranton, tagged for scholarships in math or physics.

In Washington, D.C., he earned an MA and Ph.D in physics at Catholic University of America. Teller was there then, too, invited in 1935 to teach physics at George Washington University, having immigrated to America from Hungary (via Germany, Denmark, and England).

As early as the winter of 1942-43, J. Robert Oppenheimer had asked Teller to start recruiting scientists for the secret lab being established at Los Alamos. Oppenheimer appointed Teller as liaison to the three other Manhattan Project sites (Hanford, Oak Ridge, and Columbia), and Teller continued to recruit accomplished scientists and bright graduate students right up until the end of the war. By mid-1945, nearly 10,000 people lived at Los Alamos.

Teller might have had any number of opportunities to meet young Joe Mullaney in Washington, D.C., through local scientists who attended lectures at the Bureau of Standards or in the Physics Department at Catholic University. Joe's sister recalled the clandestine nature of the recruitment. "Joe met Teller at night and they spoke on the street," she told me.

Joe moved to Los Alamos sometime in the mid-1940s. "It's possible that the FBI will investigate you," Joe told his sister, though she was unclear exactly why. He never told her directly of his work with the CIA.

"From then on, hearing from him was very unusual; I heard more often from the FBI than from him," she told me without humor over the phone.

She insisted that cars and things never mattered to him, and she believed he never married because he was just so absorbed in his work. He went to Europe when he could, particularly enjoying Germany because he knew the language. Otherwise, he stayed buried in his work in New Mexico for more than four decades, moving to Vancouver, Washington, in 1990.

At the Smith Tower apartments, Joe had lived in a ninth-floor studio with a wide view of the Columbia River. According to Jim Johnson, the manager, "A lot of mail came for Dr. Mullaney, but he wasn't one to mix. He'd come down when we had food. He'd come down for Thanksgiving and Christmas." Joe never wanted to have his photo taken. "He would turn his head or put his hand up."

Cheryl Cody, the activities director at Smith Tower, thought there was something of the absentminded professor about him. By

the time she met him, in 1998, he had already passed out on a city bus. "He had a heart condition and needed some kind of surgery," she recalled, "but he was waiting for permission to go under anesthetic." Evidently, that permission never came, and Cheryl didn't understand why not. "He said he had to seek permission to have any procedure done," she said, implying that the CIA, and not the insurance company, was the problem.

Does the CIA require employees to sign an agreement never to go under anesthesia without their approval? Or had he simply been forgotten? One person, at any rate, remembered Dr. Mullaney: President George H.W. Bush phoned him on his birthday on the apartment building phone. The manager was floored, figuring it was an April Fool's prank. Joe was out at the time. When he got the message, he was not surprised and tried to get someone to return the call to the White House for him. (No one did.) The acquaintance may have dated back to 1976, the year that George H.W. Bush served as director of the CIA; the birthday phone call took place in 1992, when Joe turned seventy-five, and President Bush was campaigning for reelection. As we know from the 720-page collection of his letters, President Bush loved to stay in touch.

Joe began having spells of fainting and blacking out and, in March of 2000, was found in the recreation room with breathing problems. He was sent to St. Vincent's Hospital in a cab, and never came home to Smith Tower. Instead, he was picked up from the hospital by Polly Smith and taken to her Country Adult Family Home, where he lived for six more days. "The night before he died," Polly told me, "he asked for a priest. It was about 9 at night."

She called a Catholic priest she knew in Camas, and he arrived early the next morning to anoint him. By 11:00 a.m., Joe Mullaney was gone. He died of end-stage congestive heart failure on March 16, 2000. His ashes were scattered at Evergreen Memorial Gardens in Vancouver.

Joe Mullaney was a puzzle, living as he did in Vancouver for the last decade of his life, in voluntary poverty, without a phone (it broke, he told me, and he just never got it fixed), without a car and, perhaps, preferring not to touch the CIA money. He looked to be just one step from homeless.

He was private, isolated, and essentially unknowable—except for that one occasion, when we sat together on a chintz settee at the Benson Hotel bar, and he honored me with a glimpse of who he really

was. That evening was a humbling reminder of the deep mystery at the center of each of us.

It was only shortly after that evening, on my first trip to India, that I learned the Hindu greeting *Namaste*, which signals to those we encounter that the divine soul in me recognizes the divine in you.

<div align="center">ཡི</div>

Every year during Lent, when the liturgical readings cycle back to the Transfiguration, I think of Dr. Mullaney and that Raphael painting he wanted me to see.

In the upper half, Jesus is suffused with radiant light.

In the lower half, the world chaotically swarms, as though imploring a risen Christ:

Please. Jesus. Heal us.

Heal us.

SU NOMBRE EN UN GRANO DE ARROZ

My spiritual journey begins long before my journey in the Catholic church, which I first seriously encountered in 1983 and joined in 1984. And the journey continues beyond the Church; ten years in, I saw that the teaching of a parish priest will never be as radical as that of Jesus, congregate worship never as intense as private prayer, and parish membership never as demanding as a life lived in Christ. And I also saw that this revelation, though it appeared to me as my own, is well within the Church's broad tradition.

My starting point was my Christian baptism, arranged by my mother (good daughter-in-law that she was) at Jason Lee Methodist in Salem, Oregon, when I was an infant. For my paternal grandmother, it was nonnegotiable; for my mother, although it had little religious meaning, she did apparently believe a baptismal certificate might be used interchangeably with a birth certificate in certain circumstances.

Born toward the end of World War II, while my father was in Europe as a pilot and an officer, I lived with my mother at the home of her in-laws. My paternal grandmother, Jessie Gies, was a major figure in this historic Methodist congregation, where she taught the young married women's Bible study class for nearly fifty years. She taught the daughters of women she'd taught twenty years before. It was she who taught me the stories—of Jacob wrestling with the angel, of Abraham wrestling with his sense of duty, of Job wrestling with an enigmatic God.

It was also to appease Jessie that I continued to be sent to Methodist Sunday school, as were my three younger siblings, Michael, Julia and Toni. Our parents never went to church. On Sunday morning they would argue about who had the least

incapacitating hangover, that is, who would have to get out of bed and drive us kids to town. Generally, Mother gave in first.

When Sunday school let out, we three girls in black patent buckle shoes and starched dresses and Michael with his clip-on bow tie would walk five blocks down Monmouth Street to Taylor's Drug, where our mother sat waiting on a stool at the soda fountain, drinking black coffee with the owner. This charade of keeping us enrolled in Sunday school was played out only for the sake of my grandmother's beliefs; predictably, it was undermined by my parents' lifestyle.

At age thirteen, I attended a single meeting of Methodist Youth Fellowship, where a dozen young teens sat restlessly in folding chairs arranged in front of Pastor Roy Agte in the church basement. The purpose of this gathering was obscure. I raised my hand and asked: "Do you have to believe in God to be in this group?" The pastor looked momentarily taken aback, then answered with an affable, if wary, "No." The equivocation was too much for my adolescent blood and I announced to my parents that I was never going back.

Nevertheless, I fondly remember the Methodist Church of the 1950s as an arena of strongly held ideas about civil rights and social justice. My grandmother kept her own counsel when I quit Sunday school, though I've no doubt she intensified her prayers. When, in 1975, we moved her into a nursing home, she gave me her teaching texts, among them Henry Burton Sharman's *Records of the Life of Jesus*. Published in 1917, Dr. Sharman's was the first facing-page, parallel-column edition of the synoptic gospels, and Jessie's copy is heavily annotated in her own handwriting. At Matthew 6:13, "Lead us not where we are tempted ...") she scribbles in the margin: "We are tempted more where we are strong than where we are weak."

In 1980, Jessie died, senile, vague and uncomprehending. How can God close with such a death a life so full of prayer, charity and service? Is this a childish question? I am serious about it.

According to a story I heard about the making of *The Mission*, Fr. Daniel Berrigan, who served as script consultant in addition to playing a small role in the film, energetically disagreed with the script's ending: originally it had the small community of indigenous believers incinerated in the thatched-roof jungle chapel. That's not how Christians die! Berrigan insisted, as though it were a technical detail known to all the world. So the filmmakers, eager

for theological authenticity and evidently willing to spend the hundreds of thousands of dollars which an on-location script change can represent, filmed a new ending: the faithful are slaughtered, as before, but not trapped in a fiery oven; rather they go singing in procession behind the Blessed Sacrament, as arrows fly above them, around them and, finally, into their midst.

My other question about Jessie's death is more a footnote of regret: it was only three years after her death that I took up the Bible again, looking for new meaning in the old stories. I wish the timing had been different, that she might have lived to see her early teaching bear fruit in me. But maybe, so thorough was her belief in baptism, she did not need to see my life played out; she knew it to be promised at the cross.

<p align="center">₭℞</p>

While I've yet to meet the person who remembers high school with affection, I think my schooling there surely had to be among the most haphazard. As an adolescent, I affected a deadly sophistication and this, along with my parents' relative affluence, so intimidated my teachers that I was frequently awarded A grades automatically and otherwise encouraged to generate some special project, alone and unsupervised in the library, perhaps so that my teachers would not have to meet my skeptical, mocking eyes. Such was my "education." By the time I was sent to college, I had read eclectically and erratically, André Gide, Philip Wylie, Françoise Sagan, Honoré de Balzac, J. D. Salinger, Henry Miller, T. S. Eliot (at the age of sixteen, I memorized "Ash Wednesday"), James Baldwin, Jack Kerouac, and many of the rich and varied fictional portraits created by John O'Hara.

Mysteriously, I had been accepted to Reed College; predictably, within two years I had flunked out. I could not think analytically, had no study habits whatsoever, and knew neither Latin nor Greek. I did know Spanish, and would have continued it in college, but it was not considered worthy of being taught by the foreign language department of this elite institution, which took the position that no great literature had been written in Spanish in the three centuries since *Don Quixote*. (Surely Gabriel García Márquez, winning the Nobel Prize twenty years after I left Reed, must have changed all that.)

In my freshman year I met a student—he twenty-one, I

seventeen—and we fell in love. With him I tried to recreate the relationship my parents had, one I then thought to be normal, but now understand to have been unique, maybe even outlandish. At times hilarious, at times stormy, always intensely sexual, it was a jealous love that brooked no other passions.

Because I loved this man, I thought we would spend the rest of our lives together. But two years later, when he went on to graduate school and a career in the theatre, I could not read the signs. I followed him to San Francisco and persisted in my expectations, but his hunger for "experience" was too formidable a rival.

Yet my love for him became a live coal that burst into flame over the next four decades, as now and again, he came around just long enough to reignite it.

Finally, I heard he was marrying a woman known among friends to be a kleptomaniac: she lifted expensive personal items from the upstairs drawers in homes where she was an invited guest. That news finally broke the trance. I now look back with bafflement on those years of emotional captivity—though my bafflement never quite rises to regret.

There is, of course, a tradition of men seeking experience. Ennobled in literature, they are heroes on a quest. The women in these romances never journey forth: Penelope spins at her loom; Rachel keeps a seven-year watch on her impatience and jealousy; Solveig grows old and blind in her hut, awaiting the return of Peer Gynt. Not for me these tableaus of passive pining: I became my betrayer's restless counterpart. In San Francisco, I studied French and music, then continued to roam, work and study for the next dozen years. I lived in Carmel, Eugene, Montreal, Cape Cod, Seattle, San Francisco, Santa Fe and, again, San Francisco; I studied Chaucer, Sanskrit, art history, pre-Socratic philosophy, photography, the symbology of modern Spanish poetry, anything that struck my fancy; I worked as a masseuse, stage manager, taxi driver, magician's assistant, computer programmer, sheriff's deputy, bookstore clerk, and waitress in a Chinese bar. I ran the asparagus packing plant at Green Villa Farms, and the properties department at the Seattle Repertory Theater.

During these peripatetic years, I believed myself to be an agnostic, an idea I picked up from one of my intellectual Jewish friends. Yet I continued to find God in nature's variety, beauty and uncountable detail; in the feelings of profundity or clarity evoked

by great music, literature and art; in the small resurrections and sacrifices of love and friendship; and especially in the mysterious sensation of always being companioned, even in my most troubled solitude. Today, I would call this the Holy Spirit, the Comforter promised by Christ. But in the days of my itinerant youth, I had only a dim awareness of a spiritual foundation—unarticulated and unexplored.

If it might be said I worshipped in those years, it was at the temple of sexual love. To artists and scholars, refugees and millionaires, to the obscure and the famous, and without any expectations of constancy, I gave myself, fascinated by the outpourings of secrets and dreams called pillow talk. Not entirely tongue-in-cheek do I use the word "worship." There are few greater treasures to pursue than an understanding of the human heart. I heard what the priest hears behind the grate, what mesmerized Shahryar the Sultan over a thousand and one nights, propped on one elbow, listening to Scheherazade.

All during those years, I harbored a fossilized loyalty to my first lover, just as Yeats asserted in a small poem written for Maude Gonne: *"Others because you did not keep / That deep-sworn vow have been friends of mine ..."*

How gentle can be that first push which sets a new life in motion. In my mid-thirties, I read Raymond Carver's story, "So Much Water So Close to Home" and felt a swift shock of recognition. Two months later, I had written my first short story, and four months later I was studying with Carver himself. That same summer, I resigned as director of a filmmakers' organization and, with little concern for financial certainty, dedicated my time to writing.

At the end of 1980, I moved from Portland to Seattle, where I became uncomfortably aware of the reactionary political atmosphere, especially in contrast to Oregon's relative progressiveness. In Seattle, I found an eight-percent sales tax (which, for a time, extended even to bread) and an economy reliant on the machinery of war. It was while trying to comprehend Seattle's political factions, that I discovered the local Catholic Archbishop, conspicuous in his advocacy for the poor; his public denunciations of Kitsap County's first-strike nuclear build-up; his criticism of federal spending priorities, which persuaded him to withhold that fraction of his income taxes that matched the national allotment for "defense."

Insofar as I had ever considered Catholicism, I had dismissed it as politically conservative. Yet as I read the *Seattle Post-Intelligencer* and the *Seattle Times* in order to follow, over months, Archbishop Raymond Hunthausen's career, I reevaluated what Catholicism stood for. Finally, I sent the archbishop a letter of appreciation and gratitude for his political leadership.

Hunthausen's letter of reply explained that all of his actions had their source in the Gospel, as he understood it. He asked me to pray for him and said he would pray for me. This simple letter made me weep. It led me back to the New Testament, which I reread with care. Eventually, through a series of serendipitous—or synchronistic—meetings, it led me to St. Joseph, a parish run by progressive Jesuits.

There, in September of 1983, I began the Rite of Christian Initiation for Adults (RCIA), which consisted of weekly evening classes. RCIA is divided into three parts: inquiry, discernment and catechism. For the weekly fall sessions, several inquirers were returning to the Church after years away; others, like myself, had been baptized into differing Christian faiths, and some were exploring Christianity for the first time. A few longtime parishioners were still showing up, eighteen years after the closure of Vatican II, to gain a better understanding of the changes to which that Council had aspired.

These classes recessed as Advent began, four weeks before Christmas, when participants were expected to spend the time in prayerful discernment about whether or not they felt a calling to join. By that time, I was beginning to see that the meandering path of my life had led me through the critical process that Carl Jung describes as individuation. It is the necessary separation from childhood patterns that permits the development of consciousness and a sense of the Self that each of us is meant to be.

When RCIA resumes after Epiphany, it is invariably a smaller group. Those of us who decide to return would be given instruction in Catholic doctrine, as preparation to be accepted into the Church at Easter. This is an old convention, dating back to Apostolic times, when the acceptance of Christianity was likely to meet resistance, and even death—St. Stephen stoned, St. Paul beheaded.

But in November, just as our sessions adjourned for Advent, the period of formal discernment and prayer, we learned that Archbishop Hunthausen was to be investigated by the Vatican. I

was shocked by the news.

I had to ask myself if I wanted to join any organization that would persecute this holy man who had drawn me to it in the first place. I had not yet heard the expression, attributed to theologian Romano Guardini and often quoted by Dorothy Day: "The Church is the Cross on which Christ is always crucified."

By this time, I had been asked to do some part-time work at the archdiocesan newspaper, and since *The Catholic Progress* was housed next to his office, that put me in a position to observe the archbishop at close hand. I watched for any sign of anger but saw only the face of peace and purpose. Sweet stories circulated about him—how he would spend a Saturday afternoon sorting used clothing at St. Vincent de Paul or be the first to grab a mop and clean up orange juice spilled at a meeting. Journalists invariably described him as "humble."

Why was Hunthausen singled out for this scrutiny? Evidently, for having lived the vision of Vatican II, that love take precedence over law. He had permitted altar girls; endorsed Seattle's first Gay Pride Week; tried to support former priests who still desired to find some way to serve the Church; allowed Dignity, a national Catholic organization of gay men and women, to use St. James Cathedral for the big Mass of their 1983 national convention; and he had failed to point out, in his pastoral letter on women, that women could never be ordained.

A full-blown reactionary crackdown would go on for years. In retrospect, that long persecution looks like an attack on the very aims and accomplishments of Vatican II itself. Hunthausen did not resign, not even when he learned that the coadjutor bishop sent by Rome had been given powers over him. No one even told Hunthausen what those powers were. Institutional secrecy sharpened the knife.

Hunthausen always acted out of love. Even though he had publicly declared himself to be a tax resister on account of our nuclear arsenal, at a peace rally the Sunday before that first Trident sub arrived at Bangor, he surprised 6,000 demonstrators with this statement: "We are all—Navy and peace people—caught up in the same system. We all struggle to do the best we can to live according to our beliefs."

At Easter, I did join the Church, hoping to live the Catholicism I witnessed in Archbishop Hunthausen. He had not let a broken Church detach him from the guidance he found in the

Gospel, nor alter his respect for all persons, his admiration for the aims of Vatican II, his trust in his own conscience, and his hope, work and prayers for world peace.

From inside the Church, I continue to find God where I always have: in nature, art, human encounters and in the mystery of solitude. Catholicism has not replaced these experiences, but organized them. While taking care not to confuse church with a relationship with God, one may find much that is true and nourishing within it.

From holy communion, I experience direct grace. We eat, we drink, we share, we are changed: this is the most profound among our several bodily worship practices. We also rise, we sit, we file forward; we are signed with water, with oil, with ashes; we chant, we respond, we sing; we drop, astonished and grateful, to our knees.

Admittedly, among the jungled curlicue patterns of Catholic tradition, there are some arabesques I'd rather not follow, conspicuously entire centuries of exclusivism and power mongering. Yet other vines bear fruit and flowers—of architecture, music, scholarship, and the rich rantings of mystics and the examples of saints. Standing back far enough to perceive the whole design, I can still trace, along this twisting course, the line back to the teachings of Jesus, and that connection redeems the whole. That teaching insists that our hands enact our faith and that we share Jesus's stubborn and notorious love of the poor.

ॐ

In 1985 my youngest sister, Toni, was diagnosed with metastatic breast cancer. By the end of 1987, when it became clear that the disease was fourth-stage, incurable, I moved home to Oregon to be near her.

Toni was not the first in our family: in 1964, Father had died unexpectedly, leaving a beautiful, suicidal forty-one-year-old widow and four stunned children.

Since his death, my siblings had each grappled with religious faith. Toni, at age seventeen, converted to a fundamentalist Christianity originally so abrasive that she startled and alienated the rest of us. However, over the years, as she married and began raising her two children, and especially as she faced the

finality of the cancer, her faith matured and came to be a beacon to the rest of us.

In 1970, Julia, then twenty, had joined a Rinzai Zen community where she lived monastically, sitting zazen five hours a day (or sixteen, during the intensive periods of sesshin). Though she left the zendo after seven years, she continues to consider herself a Buddhist.

Our brother, Michael, began sitting zazen in his twenties and became an early member of the Zen Community of Oregon, living for two years in the original Portland "zen house" with group leader John Tesshin Sanderson. Michael's practice eventually evolved into teaching Tai Chi classes.

By the time I joined St. Joseph, in 1984, all three of my siblings had long before affiliated with their respective religious traditions.

<center>ဆဝ</center>

Back in Portland, I vigilled with my family for three years as Toni, always with great faith and courage, struggled with the cancer. Continuing to praise God, she refused to make demands for her health. To be in her presence was to be in the refiner's fire: the beliefs of those around her lost their dross. It was the most vivid spiritual experience of my life.

During that first year back in Portland, while Toni's relationship with God was making such a profound impression on me, I was without a worship community. Spoiled, I suppose, by St. Joseph, I was looking to replicate that simple combination: a contemplative liturgy with a social justice agenda. Former Catholics laughed at me: "Let me know when you find it," many teased. Instead, where I found a contemplative liturgy, I found the vestibule stacked with copies of a notoriously conservative newspaper; where I found a peace-and-justice agenda, I found scant gravitas in the liturgy.

In 1989, I heard Fr. Richard Berg, CSC, give a moving talk about spiritual healing. Later that same year, his Holy Cross order took over the Downtown Chapel, an historic Skid Road parish. I joined Fr. Berg and a handful of parishioners to write a first mission statement and to help build up a small faith community. That became my home for twenty-two years. There Fr. Berg encouraged me, as he did other lay people, to preach and to lead study groups.

I gave my first "reflection" on the twelfth anniversary of the assassination of Archbishop Oscar Romero, and went on to preach on a variety of subjects, including Jewish prayer, the life of Dorothy Day, and jail ministry.

While "jail ministry" made a nice homily, I eventually found it to be the great fiasco of my life in the Church. In 1991, the Multnomah County Jail chaplaincy staff, which consisted of three full-time paid chaplains, contacted our little parish hoping to recruit a volunteer who might bring communion to inmates who requested it. Fr. Berg appointed a young priest, Fr. Jeff Liddell, to this task and then asked me to accompany him.

The six weeks "training" that the Sheriff's Office provided consisted almost entirely of security precautions which, for me, were known practices, given that I had worked as a sheriff's deputy years before. I found it odd that little was offered by way of ministry; we were simply warned to never get involved with the lives of the inmates. Why? Because it was against the rules.

Fr. Jeff and I began by visiting together both the men's and the women's blocks at the big Multnomah County Detention Center (MCDC) downtown. Within a couple of months, however, we saw the wisdom in visiting alone the inmates of our own gender, thereby disentangling ministry from the sexual projections of inmates.

Inside, I encountered the wreckage unloaded by fundamentalist volunteer chaplains who'd worked the cellblocks before me: hell was the most distinct image these women had of Christianity. I could never seem to develop a dialogue outside the stale jargon of "saved" and "damned." When I once tried to persuade a woman that her little rose tattoo was not a decisive factor in her salvation, I could see that neither the inmates nor the chaplaincy staff regarded me as a "real" Christian.

I floundered in this environment for three years, making my once or twice-weekly visits and attempting to establish mine as a listening ministry. Together, in defiance of all the rules, Fr. Jeff and I spent more and more time making housing arrangements and buying clothing for women about to be released.

In my efforts to help women change, or even stabilize their lives, I was a perfect failure. Without exception, every woman I befriended returned to prostitution, drugs, jail, or all three. One young woman, of whom I was especially fond, returned to MCDC

on five separate sentences, each time regarding me with a greater contempt, by way of concealing her own embarrassment, I'm sure.

In this "ministry" my lone support was Fr. Jeff. After a visit to MCDC, we sometimes went for a beer, describing "cases" to each other and trying to dream up fresh strategies to help inmates make positive changes. Jeff had begun talking with some of the professional counseling staff and came to be more and more convinced that family-of-origin work was an important tool. Eventually, he left Holy Cross to earn an MSW, then took a job as a social worker, where he brought a pastoral approach to helping clients.

Finally, a friend's murder ended my jail ministry. I had met Marvin Rohman in the late eighties when I worked on contract with a private nonprofit agency helping to transition people out of homelessness. Widely known and loved, Marvin was periodically dismantled by cyclical and violent bouts of depression and alcoholism. When he was healthy, he was eager to help any of the social workers, whether or not he'd ever been their client. He was just a very friendly, soulful guy. So it stunned the Skid Road community when his body was found under the Ross Island Bridge, beaten and stabbed to death.

After the murder, *Oregonian* reporter Steve Woodward interviewed me for a feature he was writing about Marvin. Like everyone who knew him, I had great Marvin stories—about his generosity and resourcefulness, his tenderness and savvy.

After Steve and I finished our coffee and chat, I walked a few blocks from the café to MCDC for my regular "shift." In one of the sixth-floor women's modules a corrections officer, clearly distraught, asked me if I would please talk with an inmate who'd been acting deranged all day. This woman—Mary, I'll call her—bombarded me for two hours with a blow-by-blow description of Marvin's murder, which she had witnessed. Which, perhaps, she had abetted. She was haunted and raving. That afternoon would be the grand finale of my "listening ministry." Every word raked my heart, and it was clear I could not console her. I could not console myself.

Convinced that a little idealism is a dangerous thing, I resigned with the excuse of too little time. From this fiasco I did learn one thing: my only meaningful "ministry" is teaching creative writing, which I do with competence and insight and love.

In those years, I took inspiration and consolation from the

Latin American Church. In 1992, while spending a month in Chiapas, I made an appointment with Bishop Samuel Ruiz. He talked intimately and candidly with me about his own "conversion" (a term Archbishop Hunthausen also used) during thirty-two years among the indigenous poor, and about the efforts of his lay catechists to meet the spiritual and material needs of the Mayan villagers who lived across the wide and jungled reaches of his archdiocese. Don Samuel, as the bishop was fondly known, told me that his personal visits to these villages, contrary to his expectations, had resulted in his own sense of renewal. The indigenous Mayan poor, with their reverence for nature and their gifts of generosity and hospitality, had evangelized him.

The following summer, I spent six weeks in Oaxaca, where I lived at the Divine Word Seminary (it being August and the seminarians away on a mission to the Chol). Under the aegis of Call and Response, a maverick Maryknoll program, I worked on various community projects in the barrio. Toward the end of my stay, it happened that Archbishop Bartolomé Carrasco Briseño, another great fighter for the rights of the indigenous, was celebrating his 75th birthday, and I had the opportunity to go to the celebration and to hear him preach. With these words he ended his birthday homily in the Cathedral on August 18, 1993: "Si Dios Padre y Madre me lo permiten, en este surco oaxaqueno quiero vivir y morir como abono del Reino. Asi sea." ["If God the Father and Mother allow me, in this Oaxacan furrow I want to live and die as fertilizer of the Kingdom. So be it."]

Carrasco, too, had been touched by the ideals, conduct and faith of the indigenous of Oaxaca, where Pope Paul VI had sent him seventeen years before. I remember seeing dozens of Indians—Zapotec, Mixtec—filing into the Cathedral, their arms laden with flowers they had carried down the mountain for the birthday of this humble man.

Back in Portland, I learned that a young assistant pastor had fallen off the wagon and nearly killed himself when he wrecked his car. He was quietly whisked off to a treatment center somewhere in the Midwest. Since Fr. Berg was under stress and shorthanded, I tried to show my support by relieving him of scheduling the lectors and eucharistic ministers, one of the many tasks abandoned by the relapsed priest. Since the young priest had disappeared without public explanation, I began to receive phone calls and notes from the parishioners I was scheduling, all asking

me, "Where is Father Tim?" I was uncomfortable with the secrecy, which I took for policy. Truth does not fracture community, it strengthens it. Secrecy can be damaging, maybe fatal to community.

It was also in the spring that a pastoral decision was reached at the Downtown Chapel to eliminate, in the Prayers of the Faithful, spoken intercessions from the pews. This went into effect without pastoral comment to the congregation, though I guessed it was intended to eliminate the shrieked schizophrenic utterances that sometimes passed as prayer at the Downtown Chapel, where many parishioners were wounded in one way or another. Again, I disagreed, but the decision was already a fait accompli. I experienced this as a real loss: public prayer had always been simple and heartfelt at the Chapel, and on those few occasions when a desperate prayer turned unintelligible, my heart was ready to embrace the voice as an essential part of our community. I found this "small" change, this silencing, had a huge symbolic significance for me.

Again, I was recentered in Latin America: in 1994, I first traveled to Guatemala with Bob and Cristina Hentzen on a mission trip with the Christian Foundation for Children and Aging, which Bob had founded with one of his brothers and a Jesuit friend. In the western highlands around Lake Atitlán we visited hospitals, schools, orphanages and community development projects organized by native Guatemalan religious sisters and brothers, often helped by Christian Brothers or Maryknollers. These trips to Mexico, Honduras, Chile, Bolivia, all taken while Bob was still alive, were always restorative and nourishing for me.

<p style="text-align:center">⁊Ɔ</p>

All but that last line of this account was written sitting under the portales on the Veracruz zócalo in the summer of 1994 heat, after I returned from Guatemala. Looking back over these words, I think of Albert Schweitzer's observation that every biography of Jesus (he had undertaken his first one in 1906) would always turn out to be autobiography. Now I wonder if the reverse may hold true as well: isn't autobiography often a narrative of the suffering, dying and emerging Christ within?

In front of me a small boy hurries across the zócalo, carrying the work that he will soon set up in the shade of the

municipal palace: a wooden crate on which is printed in large letters, SU NOMBRE EN UN GRANO DE ARROZ (Your name on a grain of rice). His sign makes me laugh. Millions of grains of rice, and all of us eager to see our name microscopically emblazoned and floating, magnified, in oil inside the transparent plastic cartridge of a cheap ballpoint pen.

<center>ℰ)(ℛ</center>

My gratitude extends not only to my grandmother Jessie, who insisted on my infant baptism, but also to the great spiritual leaders of the twentieth century—Gandhi, Day, Merton, King, Romero—and to the great writers and their characters who live in my imagination as teachers and friends.

I am grateful for all those personal crises—my first sweetheart, whom I carried in my heart for so many years, my mother's alcoholism and the sense of abandonment it engendered, even the death of my precious kid sister. All of these have driven me from complacency and into the heart of God.

Questions do linger, many of them already touched on here, about how I may be of service, how to relate to the Church in a way that enhances rather than confounds my spiritual life, and how I may move toward a better integration of my writing and my life. I think about suffering and see it all around me, as the cold rain drips into the thousands of tents pitched throughout this city, this nation. How can we yank back the vast sums spent on war and use it to house and to console those whom we have abandoned?

I hope for a deeper immersion in the sacramental life of the Church. I regret that, in preparation for my confirmation, I was neither invited nor expected to offer a general confession. Now, decades later, I would not know where to begin. When once I mentioned this oversight to a priest, he dismissed it, explaining that my baptism was equivalent to a general confession. Evidently, he had not listened: my baptism predated my conversion by forty years. In this I am a "revert" to Methodism: I take my guilt and anxiety directly to God.

I hope that the life remaining to me may be navigated by ever-deeper prayer, and that it may create in me a pure heart and, even as my days diminish me, a renewed and steadfast spirit.

<div align="right">7 September, 1994, Veracruz
3 January, 2023, Portland</div>

PARADISE REFUSED

The phone call came a week before I was to fly. It was María, a young Mixtec woman whom I knew in Portland, Oregon, where I live. She wanted to know when I was next leaving for Mexico.

Viernes de la semana que viene, I told her. My ticket was for Friday, June 16, 2000.

¡Tan pronto!

Precisamente, I told her.

And then María startled me by asking if I would please take her aging parents home?

When I pointed out that was only eight days away, she wrote down my flight numbers, said good-bye and hung up. She had no time to waste.

The next day she phoned me back to say my flight still had seats.

<center>℘℘</center>

In the late 1980s, María's family started coming across the border to find work. Her sister Natalia, then nineteen, came first. Eventually, one by one, siblings followed—her brother, then María, and then another sister. Finally, only the oldest sister remained in Mexico but she, too, had left their rural Oaxaca home to find a job in Mexico City. With all five of their hijos gone, the aging parents were alone in the remote and hilly Mixteca Baja.

I knew all of this because I had met María four years earlier, when I wrote the narration for a documentary film about a farmworker strike during strawberry harvest, here in the Willamette Valley. María was the girlfriend of our protagonist, a young Chicano labor leader. After they split up, she and I stayed in touch.

El problema es que ahora los papás son grandes, María had explained to me the year before. So the four adult children in Portland had persuaded the parents to join them, and in November Natalia had flown to Mexico to bring them across.

It had been a costly affair. Arriving at the Mexico City airport, Natalia had traveled to the family ranchito, which was an hour's walk from San Jerónimo Taviche Ocotlán. From there she escorted her parents back to Mexico City by bus, paid three airfares to Hermosillo and, from there, bus tickets to Agua Prieta, on the Mexican border across from Douglas, Arizona. She found and hired a *coyote* to bring all three of them across the border and as far as Phoenix, where they were handed off to the second *coyote*, who drove them to Los Angeles. Her husband met them in L.A. and drove them up to Portland.

When I worked the math in my head, counting airfare, buses, the coyote partners, gas, meals, and lost wages, I came up with $6,000.

But once installed in Southeast Portland, the parents felt lonely and useless sitting around the house all day while their sons and daughters worked. Eufemia, the mother, found the sidewalks and thoroughfares around María's rented apartment barren, dirty, and loud. Eight months of access to cell phones, microwaves, and cable television had failed to entrance them; they yearned for the clean mountain air and the starry nights of the sierra.

<div align="center">෨෬</div>

I planned to be in Mexico for two weeks of research in Guanajuato, where I hoped to get a fix on how people felt about presidential candidate Vicente Fox in his home state. The general election was scheduled for the first Sunday in July. Since volunteering as a foreign election observer in the previous race, when Ernesto Zedillo won on the PRI ticket, I kept an eye on Mexican elections.

By sending the parents with me, María could get them home for a fraction of the price she and her siblings had paid to bring them here: $750 would buy two one-way tickets to Mexico City. My job was to help them through the maze of terminals at LAX, where we would have to switch planes. Once in Mexico, we would be met by the eldest daughter, Josefina.

Yes, of course, I would be happy to help.

Well, then, everything was settled.

During the night I woke with a terrible thought: they had come across the border illegally.

What rigmarole might I face trying to get them back across the other way? At 5:30 in the morning, I dialed the 800 number for United Airlines. Kermit, a ticket clerk in Denver, informed me that they would need the photo ID routinely required to get on any flight; since it was an international flight they would also need proof of citizenship, either a valid passport, expired passport, or original birth certificate, not a copy.

But the Portland flight is only going to L.A., I pointed out.

It doesn't matter, he said. Since it's a connecting flight, the paperwork will be handled in Portland.

And then, I suppose because I hesitated, he sniffed: They're not *illegal* are they?

Such officiousness brings out the worst in me, and I was tempted to say, of course they were *legal*; they'd simply left their passports in Palm Springs.

Later that morning, I phoned a travel agent who specializes in Latin America and after that I phoned the Mexican Consulate. In between, I phoned the daughters several times. By the end of the morning, I had collected a lot of information. What the parents needed, I learned, was a matrícula consular, that is, an official photo ID card issued by Mexican consular offices, proving that the bearer is of Mexican nationality and living outside of Mexico.

For this, they would need birth certificates. Doubtful, I phoned Natalia who, at thirty, was the eldest of the three sisters living in Portland. With eleven years in the U.S., she was also the most savvy.

Improbably, the parents had with them their original birth certificates. Now she simply needed to take them down to the Mexican Consulate to apply for those cards.

That night, a friend asked me: If the *coyote* sneaks people across the border in the night, which animal returns them safely to the other side in broad daylight?

Whatever its name, I was about to be that animal.

<p style="text-align:center">ဢ)ᏮᎡ</p>

Tendrá que visitarnos, Natalia had advised when she called to say they had their ID cards and airline tickets. No puede conocerles por primera vez en el aeropuerto.

True, I could not meet the parents just before flight time, which was 6:10 a.m. So late one afternoon I borrowed a car and met them at Natalia's home, an address so deep into Southeast Portland that I traveled the last three blocks on a rutted gravel road. Three trucks stuffed with yard debris, garden tools hanging off the rails, were parked in front of the green, fifties-vintage house.

In a spotless living room, I sat with the family, squeezed together on a sectional sofa.

Erasmo, the father, tiny and stoop-shouldered, appeared older than his sixty-eight years; Eufemia, sixty-three, also had leathery skin, but her long hair was glossy and black and she moved with agility. María was not there: she worked as a motel maid, and Natalia was watching her young son Omar, who toddled around the living room in pursuit of a wary tabby cat and a twitching white rabbit.

Eufemia sat by me and many times expressed her thanks for my willingness to get her back to her ranchito. She left the room and returned with a small plastic baggie from which she extracted the national photo ID cards issued by the consulate the day before. She asked that I inspect them: the size of a driver's license, they had the seal of Mexico on the reverse and were laminated in plastic.

I drank a tall glass of water, ate a couple of cookies, and followed the family outdoors, where I was shown how the backyard had been transformed into a small ranchito, with a producing henhouse and a few sheep penned behind a fence. Here, the daughters had suggested their mother tend the animals and gather eggs, but it wasn't enough: Eufemia still wanted to go home.

I shook hands with los grandes, with Natalia, her husband, and mother-in-law, even with little Omar. We agreed to meet at the airport Friday morning at 4:10 a.m., the recommended two hours before the flight. Eufemia hugged me and we all shook hands again. Then I made my way around to the front of the house, past the three green trucks to the car I'd borrowed and started back to my apartment.

✖✖✖

In 2000, when I made this trip, approximately three million unauthorized Mexican immigrants lived in the United States, according to estimates made by the U.S. Immigration and Naturalization Service (INS, as we then called it).

Although many Americans think illegal immigration is merely a symptom of ineffective border control, immigration analysts—and probably the average Mexican—understand that the lack of jobs in Mexico is responsible for the never-ending migrant flow. By 2014, that number, according to Pew Research Center estimates, had reached 5.8 million.

When I was a girl growing up in Oregon, I saw the smooth functioning of the Mexican Farm Labor Agreement that allowed Mexican workers, called *braceros* (from brazo, the arm with which one works) to live in the USA, usually on short-term labor contracts. They crossed over into Texas to harvest citrus and cotton, and traveled north up the labor route through California, Oregon, Washington, and Idaho. The Bracero Program, which began in 1942 to address shortages of agricultural workers during World War II, was administered by the U.S. government. Here on the West Coast, it ensured that workers arrived in time to harvest the tomatoes, lettuce, asparagus, apples, and potatoes. Throughout the country, 275 important crop areas used braceros.

In Mexico, some families were resigned to the absence of a father who supported his wife and children from afar and typically came home for two or three months over Christmas; in other families, young braceros adventured north for a season before settling down to get married, just as Oregon boys might spend a summer or two fishing in Alaska.

Enshrined in the Mexico home of my friend Leonor Maldonado sits a Singer sewing machine, a souvenir of her father's bracero summer years ago in Chicago, where he earned enough to buy this lavish gift for his bride-to-be. After that one trip, he built a small grocery business in Monterrey, Nuevo León, and raised eleven children without ever again leaving home.

In 1964, the Bracero Program was revoked, theoretically because the labor shortage created by World War II was no longer a problem. But because growers still needed farmworkers willing to do stoop labor, people continued to stream across the border, though without the peace of mind or the civil rights that bracero status had given them.

After two decades of haphazard INS prosecution of unauthorized workers, a general amnesty was extended to people who could prove they had been working here regularly for a specified amount of time. In 1986, the U.S. government legalized one million

Mexican workers under this amnesty, evidently with the expectation that this would take care of "the problem of undocumented workers."

In 1994, the year the North American Free Trade Agreement (NAFTA) went into effect, the Mexican peso fell drastically, going from 3.5 to 5.5 on the dollar in December, and then to more than 7 at the beginning of 1995. (By the end of 2016, the peso had fallen to a dismal 21:1.)

As it became harder and harder to make a living in rural Mexico, people fled their ranchitos for Mexico City. But with an uncountable population—a best guess puts it upwards of twenty-one million—the city offered little more than shantytown poverty for most newcomers. Thousands fled north, to the very edge of the country, where border sweatshops beckoned.

And tens of thousands more crossed the border to fan out across the USA, willing to do the dishwashing, fieldwork, and hard labor that so many North Americans no longer wish to do.

Their desperation supports lucrative rackets in forged green cards and "borrowed" (often from the dead) social security numbers, and flourishing business for the coyotes who (if reliable) steer immigrants through the blazing deserts and steep canyons of the most remote borderlands, or (if unreliable) may abandon them to die in the desert. They come because, according to a 2014 Oxfam estimate, nearly half (46.2%) of Mexico's 120 million people live in poverty. Mexico's poverty rate is increasing every year.

In 1999, these workers sent an estimated seven billion dollars back to Mexico, making money-sent-home Mexico's third largest source of legal income, behind oil and tourism.

In 2015, according to a report from Mexico's central bank, Mexicans overseas sent home nearly $24.8 billion, these remittances overtaking oil revenues for the first time as a source of foreign income.

If, as it is generally reckoned, most of the illegal immigrants are poor unskilled farmworkers, many of them indigenous, then Mexico's economy is dramatically bolstered by the poorest of the poor. They are, to put it bluntly, keeping their countrymen at home alive.

☙❧

On that Saturday morning in June, when I arrived at the Portland airport, Erasmo and Eufemia had not yet arrived. At 4:40 a.m. I

moved swiftly to the counter and, by the time I'd checked my bags a line had grown behind me; another seventy-five people had arrived all at once. Just as I began to grow worried, I saw the diminutive Erasmo in jeans, green flannel shirt and a white cowboy hat, and beside him Eufemia, her long black hair tucked under a blue baseball cap lettered NIKE. Six other family members—the four adult siblings, along with one spouse and one granddaughter—were with them, all laboring to drag forward to the airline counter four tall cardboard cartons tied with rope.

Natalia, the daughter who is generally in charge, was doing a good job of ignoring the United Airlines employee who was insisting that they wait, like everyone else, in line.

The four cartons, which comprised their only luggage, became a sore point between the family and the airline. The cartons were hoisted onto the baggage scales and wrangled off again. Minutes later the ropes lay slack on the floor, the boxes were open, and the family was sorting through mounds of clothing that they'd acquired to take into Mexico, for themselves and for neighbors, paring it down to what was most essential.

I greeted the family and went to wait in the lobby, anxiously watching the clock. Finally Natalia consented to have the four overweight cartons shipped separately as freight, and I moved the nine of us through security (permitted before 9/11) and out along the concourse.

But as I trotted ahead to the gate, they fell behind. The plane was already boarding, and I had to speed back through the crowd to pull my two dazed charges out of the arms of the family. As we trekked down the jetway, Erasmo wiped his cheek with the back of his hand. And then we were in the plane, strapped into our seats and lifting into the air.

At LAX the transfer was easier than usual: we hiked along a corridor, made a couple of turns and were at our departure gate. Neither Erasmo nor Eufemia was perturbed by the news that we had two hours to wait. They refused my offer of lunch and were content to sit, dignified and motionless, within view of our next gate. We sat together, they absorbed in their quiet waiting, I restless and sleepy at the same time. I had been up since 3 a.m. and I imagined, given the heft of their four boxes, that my charges had not even been to bed.

I took this opportunity to ask Eufemia, who sat between me and Erasmo: ¿Qué le gustó más de Oregon?

She liked the opportunity to be with her hijos.

Y el ranchito, ¿de allá qué más le hace falta?

She missed her animals and worried they were not being well cared for by the neighbor left in charge of the task. With pleasure, she named them: cuatro toros (I could see in her eyes that the four bulls were her favorites), además burros, pigs, goats, sheep, chickens, de todo.

¿Y cómo fue la experiencia de cruzar la frontera?

Not bad, Eufemia told me. Natalia had picked her month: by traveling in November they weren't subjected to the terrible heat of the Sonoran desert in summer. (On this June day, as we sat in Los Angeles, it was 112° F in Hermosillo.) Along with a family of seven, they'd come across the border along a rude path that took only two-and-a-half hours on foot.

¿Cuando cruzaron, traían con ustedes las actas de nacimiento o se las mandó su hija?

No, Josefina had not mailed the birth certificates; they'd actually brought them with them. According to the common wisdom, people crossing the border illegally should not carry ID. That way, should they get caught, they can't be identified; the next night they just try again. Natalia must have been very certain of her coyotes to have permitted her parents to carry papers.

Throughout our conversation, Erasmo sat smiling quietly to himself, clearly eavesdropping, but with his gaze directed toward his own boots. I was curious about his native language, which I knew was not Spanish, but one of the indigenous dialects.

¿Tiene usted otra lengua además del español, no? I asked him.

The furrow of his smile deepened, but he didn't answer.

His wife spoke for him: Él habla cholcholteco.

Don Erasmo, I asked, using the respectful form of address, ¿Me diría algo en cholcholteco, por favor?

He lifted his head and pronounced a few mysterious words.

He said, 'Good morning. How are you?' Eufemia explained to me in Spanish, her eyes and smile on her husband. I can understand Cholcholteco, but I don't speak it, she added.

Soon her husband would be back in the Mixteca, where all his friends and neighbors understood.

৯৩

Mexico City lies 1,555 miles from Los Angeles; the flight takes three-and-a-half hours. Once we lifted off, I was content knowing that

Erasmo and Eufemia had made it: the plane was not going to turn around now. Those simple matrículas consulares had been the solution.

As we gained altitude, I thought about that word *coyote.* Originally a Nahuatl word, it describes a nocturnal animal that can run forty miles per hour across the desert.

And my friend's question about what animal returns people across the border? As we flew north to south, the word loon came to mind. It's a heavy-bodied bird that can't fly without a running start but, once airborne, it's been clocked at ninety miles per hour in a shallow dive. I wondered idly whether loony derives from loon or from *luna.*

Then I dozed.

I woke to find Erasmo standing in the aisle beside me, his customs declaration in hand. The copy they gave him was in Spanish, but neither he nor his wife could read. I suggested that he have his meal and that we'd fill it out after lunch. He nodded solemnly and returned to his seat.

After the food trays had been cleared away, I filled out my own declaration, laughing at the question that asks if you're bringing in over $10,000 in cash. Who even has $10,000? But the moment I'd asked myself that question, I realized: if anyone on this plane had that kind of cash it was likely to be precisely the inconspicuous indigenous couple in my charge.

Within half an hour we were on the ground. Judging from the puddles on the runway, it had been raining in Mexico City. Now, at 5:30 in the afternoon, the sky was overcast, though in that dirty cloud of unchecked pollution, it is perpetually overcast.

We came through immigration in two groups: I alone through the visitor's line, and the old couple through the line for Mexican nationals. We met up again on the other side of customs, where the oldest daughter, Josefina, and her four children swarmed around us, all pleading that I come and eat a meal.

Sadly, I had to turn them down. I had already made Saturday night plans before I first got María's phone call. And in the morning, I had to catch an early bus to Guanajuato.

We exchanged hugs and one of Josefina's daughters took pictures of the three travelers. I remember the airport crowd parted around us, as though aware of one of life's significant moments.

I sensed I would never see this old couple again, that I had been presented a brief opportunity to accompany two people who

were and would remain strangers. People, who valued a life close to the earth, filled with the peace that Mexico, even then, was in its last days of offering.

Those four big cartons might have caught up with them eventually, stuffed with tennis shoes and T-shirts, blue jeans and baseball caps, wool socks and windbreakers—all things we take for granted north of the border. For Don Erasmo and Eufemia, the fortunate among many unfortunate, the baggage would be just a bonus, for which they had not traded their entire lives to buy.

WHERE PABLO NERUDA FIRST SAW THE SEA

Estábamos rodeados de montañas vírgenes,
pero yo quería conocer el mar.
—Pablo Neruda, *Confieso que he vivido*

Under the spell of Pablo Neruda's memoirs, I travel from my home in Oregon to Temuco, Chile, in order to retrace a life-changing journey the poet made as a boy.

Arriving in early 2000, I find Temuco, capital of Araucanía, to be an inland city of a quarter-million people, with few signs remaining of the dusty frontier village Neruda would have known in the early 1900s. The coast, eighty-five kilometers to the west, was out of a schoolboy's reach. Yet Neruda dreamed of the rumored sea, sensing its vast motion and untamed power. He pestered his father, who worked as a conductor on a ballast train delivering gravel to the mountain tracks, to organize an expedition. When Neruda was fifteen, his father finally acquiesced.

In January, the sunniest month in the region, the father loaded mattresses, dishes, and clothing onto a baggage car and shepherded the family—himself and the boy, his second wife and his two other children—onto a railway coach. They traveled those first fifty-three kilometers by train, generally following the course of the Cautín, a river so impressive that the Spanish conquistador, Pedro de Valdivia, writing home to King Charles I in the sixteenth century, had described it in words of awe.

In 1920, the locomotive steamed through dense forests, coming into settled clearings at Labranza, Boroa and Nueva Imperial, where the Cholchol River, flowing down from the north, adds its waters to the Cautín. At that convergence, thus swollen in size, the Cautín suffers a name change, becoming the Imperial.

At Carahue, still thirty-five kilometers east of the coast, all the family's belongings were piled into an oxcart and delivered to a steam-powered paddle wheeler, tied up at the dock.

Writing his memoirs more than fifty years later, Neruda would remember the feathery beauty of the mimosas on the shore, and the wild, soul-piercing notes of a lonely accordion played by a man on the deck: "Nothing can flood a fifteen-year-old's heart with feeling like a voyage down a strange, wide river, between steep banks, on the way to the mysterious sea." He rode the entire way on deck, so as not to miss a thing; it was from his seat near the bow that he first saw the dark and restless Pacific and thereby began a lifetime of contemplating the sea.

<div align="center">℘⚭</div>

By the time I arrive, this train is no longer running. Of Chilean rail service only the spine running north and south is left; the east-west ribs are gone. Also, large craft no longer ply the Imperial River, which was rendered unnavigable when the great maremoto of 1960 reconfigured its depth and width. To retrace Neruda's journey, both rail and river, I have to find a bus.

On Avenida Balmaceda, across from the vegetable market, I locate Temuco's rural bus station, a lively depot for the local Mapuche Indians and other small farmers heading to rural places where the long-distance buses don't go. Here passengers are more likely to carry a live chicken than a suitcase, and the air is filled with the odors of diesel, dust, and frying *empanadas*.

I take a window seat up front, watching passengers stream on board. Pulling out for his ten in the morning run, the driver is waved into traffic by a man posted at the sidewalk. We briefly follow the Pan American Highway south, then turn west onto a narrow two-lane highway which runs through open fields. Dense patches of bachelor buttons create a blue fringe at the edge of the road. We pass stockyards, then small farms, a stud mill, and a diminutive old cemetery. From the window of the bus, I see copihue, the waxy bell-like flowers of red, rose, and white that grow throughout Chile, along with eucalyptus, birch, radiata pine, wild mustard, Queen Anne's lace, blackberries, and the pretty yellow gumweed that sickens cattle.

<div align="center">℘⚭</div>

The first small town—on Neruda's route and mine—is Labranza, now embellished with concrete sidewalks, a library, and an evangelical church. We pass through it quickly and are again moving past tilled fields. Behind woven willow fences lie gardens, guinea hens, cows, and wooden, single-story houses with roofs of tin.

For the town of Boroa, which consists of a few blocks, the bus does not even bother to slow down. An elderly Mapuche woman treks along the grassy strip just off the pavement, her heavy black poncho falling over a long black skirt, a white kerchief on her head.

All of this was Mapuche country, a people who never surrendered to the racism and rapacity of their Spanish invaders. To this day, they continue to wage a fight for the return of stolen lands, through both the courts and the national assembly. As for Pedro de Valdivia, he was killed in a Mapuche uprising in 1553. All versions of his execution agree on one point: when he offered to back off from the settlements he had established on their territory, the Indians understood it would be a mistake to believe him.

We come to Nueva Imperial, which boasts a traffic light, Shell station, Lions Club, funeral parlor, orthodontist, and five black taxicabs parked in a line. Now the road begins to climb into the gentle coastal range. The dense, imposing forests of Neruda's boyhood are gone now; instead, great open vistas of green fields lie in the rich valley below.

The bus brakes to a stop, and I look up from my note-taking to see an adolescent girl and her small brother herding four cows and a calf across the road.

At Carahue, where Neruda's family switched from train to boat, I leave the bus to explore. The town is constructed on three terraces, and the highway enters on the high ridge, where a single row of commercial buildings flanks the main street. Twenty rusty steam engines are strung out along a green meridian. Neruda loved these old locomotives and managed to transport an elegant green and black one with huge red wheels to the yard of his home at Isla Negra, where it sits today. From this Museo de Vapor, footpaths wind downhill, among houses whose backsides are supported by stilts. On the lowest shelf, a white pontoon boat is tied up on the river.

Carahue means "site of a city" in the Mapuche language, referring to the original city which Valdivia founded in 1552. Today, there's not a trace of it to be seen; enslaved Indians rose up at the end of the 16th century and reduced it to a pile of stones. Indeed, it's hard

to believe that here once stood a hospital, nine or ten churches, and the oldest seminary in the Americas.

<center>ℬℭ</center>

I catch the next westbound bus and we leave Carahue, crossing the Imperial over a graceful white suspension bridge. The river is a wide, quiet presence now, giving off mist and fog as it flows through fields of gladiola and potato. Willows fold nearly prostrate over the low bank, the odd canoe or rowboat tucked beneath their branches. Egrets stand in a field where horses are pastured, and yellow buttercups overspill the ditches.

Half an hour down the road, the river widens to estuary, treeless and flat. Shallow irrigation ditches crisscross a meadow dotted with clumps of bunch grass and Canadian thistle. The foggy landscape is moody, fertile, portentous.

Looking closely, I realize that the water flows backward now; within a kilometer, it will stand still, flat, glossy, and subdued between the forward flow off the mountains and the thrust of invading tide.

"... y luego te vi entregarte al mar ..." runs a Neruda line from "Los Ríos Acuden." "... and then I saw you give yourself to the sea ..."

This is the spot.

Beyond the sandbar, which renders the Imperial useless as a port, Neruda first glimpsed the brimming divinity, and it preoccupied him for half a century. He would spend a lifetime describing the ocean's moods, not because any one poem failed but because he understood that seas have many moods, stinging cold or steamy, booming or muffled, pensive or possessive. The sea is of every color, not only all the blues of an artist's palette—cerulean, cobalt, manganese, turquoise, ultramarine—but lilac and gray and sun-gold. The changes invite engagement, and Neruda kept that engagement for the rest of his creative life.

"... una a una las olas repitieron ..." Neruda writes in "Mareas," remarking the implacable crash of waves. "... one after another the waves repeated / that which I sensed fluttering inside / until I was formed by salt and foam."

<center>ℬℭ</center>

Neruda's cult of the sea can be seen at any of his three houses, and I visited each of them. Originally sacked by the military after the 1973 coup that ended the presidency and life of Salvador Allende, they have been lovingly restored as museums by the Neruda Foundation.

His Valparaíso house sits high on Cerro Florida, with a dramatic view of the harbor and Pacific Ocean below.

At La Chascona, Neruda's home in Santiago, he had a large garden wall painted blue because that city has the misfortune of being inland, with no ocean view of its own.

And at Isla Negra, where he kept up a sea watch for the last years of his life, everything here—the improbable long horn of a narwhale, the blue glass bottles positioned on the ledges of the seaward windows, the ship's lumber used to frame and finish the house, the collection of prow figureheads, brooding maidens with painted eyes cast westward—refers to and celebrates the neighboring sea.

∞

I, too, arrive at the mouth of the Imperial River on a January summer day. Stepping down from the bus, I pull my coat tight and walk across the sand. But while the adolescent Neruda was emotionally overcome at this very spot, I experience a different version of the unexpected. Here at Puerto Saavedra the Pacific is exactly as I have often seen it at home in Oregon—churning, foreboding, the color of pewter.

Standing in a cold wind at the edge of the surf, I consider what a journey we sometimes make of it, to reach that which we have always known.

WHO DO YOU SAY I AM: THE INTERVIEW

After Oregon State University Press published my book, *Up All Night*, there was a flurry of interviews and readings, and then the entire enterprise died down and I got back to work on other projects. Most of the people I profiled in the book came to one of those readings, but within a few years—with two exceptions—we had dropped out of each other's lives.

I continued to think often of those two people. As the Portland Police Association—the so-called "union" for the Police Bureau—appeared more and more in the news, aggressively defending trigger-happy officers whose violence was most often directed at people of color and the mentally ill, I kept wishing that Sgt. Robert Voepel, whom I interviewed for the book, could somehow teach, mentor, or convert the whole darned force. I have some experience of policing, having worked as a deputy sheriff for a year (another hairpin turn in my search for right livelihood) and I recognized Voepel as a good cop. After the book came out, we had coffee a couple of times and he explained to me that, having once worked for Safeway, he felt the customer-is-always-right ethic would be a better way for law enforcement to approach their work. While I agree with him that courtesy and a sense of service are important, I also saw, in just one night riding along with Voepel, that he did not fear the public he was hired to protect. It is clear to me that racism is not the only problem besetting many police departments; a lot of cops are simply walking around terrified.

I thought, too, of Mike McCoy, especially as HUD began promoting a shell game called "The Ten-Year Plan to End Homelessness," and the numbers of homeless on Portland streets skyrocketed. It was Mike who had described his life outdoors, picking up discarded dirty needles and using them to draw water from mud

puddles, preparing to shoot up his drugs. When I first met him, he had come in from the cold. But had he managed to stay clean?

A decade after the book came out I went looking for him, but by the time I found him, he was working a job so constrained by confidentiality issues that it would have been problematic to publish. Nevertheless, Mike did agree to another interview.

I invited him to my apartment, where we sat on counter stools across from each other in the kitchen. He is a compact man with alert eyes and a warm smile, a good-looking guy, Irish and Scottish on his dad's side, Filipino and Spanish on his mom's. He had just turned sixty-three.

I positioned my little Sony cassette recorder on the counter between us and from time to time cast a surreptitious glance at the tape counter to make sure it was still running. We each had a glass of water in front of us. I asked questions. The quiet winter afternoon grew gray at the window as Mike spoke.

His story began where I last saw him, at the Peniel Mission on Southeast Grand, shortly after it had been taken over by CityTeam Ministries. At the time, he was working at Portland Fasteners for Tom Baker, one of those admirable Christians who take a chance on hiring men who are trying to make a new life.

<p style="text-align:center">☙☞☘</p>

So, then, Portland Fasteners?

In 2001, when I was hired full-time at CityTeam, I quit Tom, and I moved out. That's a matter of self-care. People need that, especially in that kind of place where everybody's needy and everybody's coming to see you about this and that. I moved to the Rex Arms on SE Morrison and I was there for a few years.

I met up with an old friend from Cleveland High School, and in 2006, we got married. We bought a house together, out by Happy Valley, but we were only married like a couple of years. One day we just looked at each other and said, you know, we're a lot better as friends than as a couple. Every once in a while, I see her. We're still friends.

Already divorced from Liz, and financially I was struggling to begin with, and then I lost my income at CityTeam. And that just kind of pushed me over the edge.

You were fired from the mission?

Yes. I'd been working there for almost ten years at that point, when they gave me the left foot of fellowship. Was I scared to death? I filed bankruptcy, gave up the home, sent the car back. I'd lost everything. It was a tough year.

So, you would have been 58 at that point?

Yes, and with no job, I was having trouble even finding a place to rent. I was still holed up in the house, but I didn't want to be one of those guys who hangs around until the Sheriff's Office comes in.

 The good thing was that I had kind of a reputation around the counseling community, as being a good guy and good at working with people. I got a phone call from Hooper Detox. 'I hear you're looking for work,' they said. 'Well, we're looking for counselors.'

 I went over there and interviewed and, you know, it's been fantastic ever since. God, I love these people. They hired me on the condition that I work toward my accreditation which took about a year. Meanwhile I could do my practicum right there at Hooper, under my supervisor. Goddamn, you get your practicum in no time in a place like that, so it was all good. I got along with them and I got through all my reviews.

You were hired when?

2010, November.

And housing?

A woman helped me find an apartment out by Southeast 130th and Division. 'It's gangland,' she told me, 'but it beats the streets.'

Was it actually dangerous?

Lots of drugs, lots of shootings. Like one year they probably had, within 500 yards of that apartment, three shootings, easily.

What's the ethnic concentration out there?

Black, Russian, Hispanic. The shootings were gang-related, mostly Black gangs. But it was pretty cool on Division Street in the summertime, where the apartments were mostly Hispanic. To dry their clothes, they'd just drape them over the bushes. I thought that was kind of cool.

And certifying for Alcohol and Drug Counselor, how was that?

Pharmacology was the hardest. You've got to really study on that.

I liked the counseling. They'd shove us in a room, and one guy would play the patient and the other would play a counselor. And they'd have us videotaped, which let them see what kind of skills we retained.

There was one teacher I remember who told me, 'You know what, Mike? It's not about getting your credentials and stuff, as much as it is about the rapport you have with the people. That's what counts.'

At the mission, I was struck by your empathy for the men who came through there.

At Hooper, our patients are mostly heroin addicts and alcoholics. Though anymore, so many people have co-occurring disorders. Maybe the guy that has schizophrenia, hears a lot of voices, might want a drink to squelch some of those voices. I see that more and more with people.

We also get the cocaine and the meth addicts, but the medical detox piece isn't that rough for them; it's mostly the cravings.

All of them have that one component for sure, the craving piece, the psychological piece. But the alcoholics, when they detox, it's extremely dangerous; they can go into seizure and die. The heroin addicts, they just wish that somebody would help them—they feel like they're going to die.

I talk to people who are traumatized by a lot of things in their lives, and they kind of seem lost in there. Some significant trauma, molestations, and things like that. We also get our fair share of veterans. We get people that have witnessed domestic violence, their parents were drug dealers and fighting all the time. They abandon the kids, so the kids go to live with the uncle who molests them. It's an infinite journey of trauma.

Mike, is it possible for a homeless person to get clean?

Yes, but you need wraparound services, you need the support. At Hooper, we get them medically detoxed, that's that first step, send them to ten days, usually, and from there we try to get them treatment. If a guy lives on the streets and goes back out, chances are very slim that he's going to get recovery.

He would need support housing with the treatment. Because people need that basic resource, a place to land every night, to clean up, that kind of thing.

Do you see middle class people self-referring to Hooper?

I see that a lot. People that still have a home, a wife, and kids. We get a fair share of people that are just beginning to lose these things. The wife has said, 'I'm done with you unless you go and get sobered up.' The ultimatums are motivators. It's kind of a negative way, but it's a motivator, for sure.

Mandates from the courts actually work pretty good. When the judge says, 'You know what? I'll throw you in jail.'

I get some guys who'll say, 'I feel good, I'm detoxed, I really don't need treatment, I can figure it out on my own.' But, typically, they can't. They need help. So, I ask them, 'What do you have left when you sober up a drunken horse thief?'

And they kind of look at me. I say, 'Well, what you got left is a sober horse thief.'

Just because the guy's detoxed or abstinent, doesn't mean he's in recovery or getting the skills that he needs to cope with daily activities.

What drugs are you seeing?

It's probably heroin first, 'cause they got that pipeline, and it's cheap. Black tar heroin, from Mexico. It just shoots straight up I-5.

Another big problem is pharmaceuticals. Lots of oxycodone, OxyContin, Vicodin stuff. There is some diversion from the streets, but usually it starts out as prescriptions. A lot of the heroin users that I work with start out there. I always ask them, 'So when did you stop using the pills and why?' And nine times out of ten, the 'why' is: it's too expensive to maintain the pill thing. The heroin's cheaper, so

they just go there automatically. Plus, it's stronger. They were using Vicodin; they can go to heroin.

I look at it like, this is an addict, addicts are smart people. They'll figure out a way to get loaded.

When I first cracked open this huge book on pharmacology, there in this one little sentence—I loved it. It read: *Man has always wanted to alter his conscious state.* What a great statement. Isn't that the truth!

Do you believe the AA model, Once an alcoholic, always an alcoholic?

That's kind of a medical model. They are now so good with brain imaging that they see how the brain remembers things. So when people take drugs and alcohol, and the dopamine is flushing through, the brain says, that was nice! We need to do that again. I don't think the mind forgets that, though it's more controlled over time.

But in recovery, there is a stage called termination. I learned the stages of change in the counseling classes, but I notice that the newer books took out the term 'termination.'

Do you think some people might not need AA or NA anymore?

I look at AA and NA as a means to an end. When I talk with a patient, they'll say, 'Well, what do you suggest?' And I'll say, 'Well, I know the best rehab in the world is the one YOU get recovered in. It's really about you.'

If a guy says, 'Mike, I've been clean and sober for twenty years,' and I ask, 'How'd you do it?' and they say, 'I've been standing on my head in the corner and gargling peanut butter every day,' I say, 'Keep doing it, brother.' Whatever it takes.

For me, personally, I view AA and NA as a kind of organized religion. Am I against it? No, because it works for some people, and I wouldn't put it down just because it's not for me. Different head sizes, different hat sizes. It's that easy.

Did you never relapse?

No, I never looked back.

How many years did you use? Your drug was speed, right?

Yeah, the last few years was speed and I did it almost daily. And I'd done it off and on since I was fifteen.

Success in recovery, I think, is all pretty simple. I think it's gratitude, a willingness to help those who still struggle, and just a joy for life again. You know, just that zest for it, regardless of the ups and downs. 'Cause you're still going to have your struggles. Now it's a matter of dealing with them, just pushing through and looking at those difficulties and saying, What did I learn? 'Cause life goes on.

It's funny, but I think of this often: I am still very humbled by having that one creaky, little, military bed with the funny springs that they offered me when I first went into the Peniel mission. When I first got there and went on program.

You went to the mission to be in the program, didn't you? You weren't just looking for a night at a shelter; you came in from the cold, basically. Am I right?

Yeah. As a matter of fact, there was somebody that washed out from the program and I just got to talking to this guy, and he sensed that I was lost. He told me, 'Hey, try this place.'

What brought you to the point that you would even consider giving up the drugs and the life?

Well, from a spiritual sense, I do think that led from God, that kind of push. And then the realization that, This isn't really me. It's almost like astral travel: you get out of yourself, look back and go, wow, time to change. I felt it wasn't who I really am. And that was tough because I'd lost my identity over the years.

What's life like today?

I've got a one-bedroom apartment downtown; my income qualified for a subsidized unit. I work ten-hour days at Hooper, get off work at 6:30. I get home, feed my cat. We look at each other and I go to bed.

And how do you take care of yourself?

I've got my little NutriBullet blender, and I stuff it full of kale. I ordered some cool probiotics. I do Tai Chi in my living room. At first,

I picked up a booklet out at Barnes & Noble, with a little DVD. I went to Northwest Fighting Arts on Southeast Morrison for a while. That's relaxing. I need that kind of thing.

I don't understand why CityTeam ever fired you.

Well, first of all, when they hired me, I'd signed a statement of faith. But over time, I had started looking into scripture a little bit more, and I found this funny thing in there: 1 Timothy 4:10. Paul is talking and he says: 'For it is for this we labor and strive, because we have fixed our hope on the living God, who is the Savior of all men, especially of believers.' Especially of believers! And I said, What? Wait a minute! There's something here! The savior of *all* men!

And then I started thinking, Wow! That makes sense. I went downstairs to Julie. I don't know if you ever met Julie Stephenson— she was the director. I went to Julie. It was almost time for her to go home, and I said, 'Look, my core beliefs are kind of changing.' It wasn't that I wasn't on board, but I didn't fit the evangelical mold.

It scared them. At one point, Julie said, 'You can't come back on the property, Mike.'

It wasn't like I'd turned into Charlie Manson, or anything.

You can't come back on the property!

They didn't allow me to come back.

I just saw *the salvation of all.* It's a bit more complex than that, but that's what I started to see. And then I thought, Well, what about all the fear of Hell and all this stuff? And I started reading about that and found out that really, in fact, Hades is just really Sheol, the place of the dead. And Hell, I think it came from the German *hel,* to cover. That's where we get helmet, made sense, to cover! I felt kind of betrayed.

I had just gone in and laid it out: 'Here's where I'm at.'

It was hard because I knew there would have to be some sacrifice in there. I didn't know it would be that bad, but I knew that there would be ramifications to my belief.

When I was living in my little townhouse up there off Happy Valley, I used to have this walking path that I'd do. And I'd just be praying, 'I need to know, God. I need to know. Because this is going to cost me.' I prayed and I didn't get an answer, so that was the answer: 'Yeah, you're okay. Just keep going.'

[The kitchen was almost dark now, and I couldn't see if the Sony was still spooling. We were both silent for a spell, and then I spoke first.]
Can you pray for all your patients?

Not necessarily on a daily basis. But I'll tell you, Martha, sometimes when you are sitting there and you talk to a person for forty-five minutes and their life has just been struggle, torment, and anguish— it's no wonder they take drugs. And every kind of drug. I mean it's like, 'You're kidding me!' It's horrible! And it just reconfirms the very fact that some people don't have a fighting chance.

Sometimes I have to stop and decompress. After we're done, I'll leave and go out and just say, 'You know what, Lord, I hope that when you die them, you heal them, and bring something to their life.' The God I know is both mercy and love. And that's the way it is. We do reap what we sow, in a sense. But in the big picture, God will make it all right, nothing will be lost.

You're happy now, aren't you?

Yeah. Probably.

I don't think I shared this when you interviewed me for the book, but my brother Kevin was shot and killed in front of his family by the police. He was shot on his front lawn in front of three of his children. It was a big to-do here. June 10, 1990.

It was a real tough thing, and the family basically just kind of imploded at that point.

For the first time, I saw my dad not as a man but as a broken person. And Mom was just beside herself. The grieving mom. And then Kevin's widow!

We took the guy to federal court and tried to sue him on a civil rights thing, which they denied. And we took it to appeals and lost all that in court. And that was the next year and a half, two years.

As time went on, there was a lot of hatred. A lot of resentment, a lot of hurt, lot of disillusionment. My mother had been so resentful. She had a triple bypass; it just eventually ran her down to the ground. She died in 2005.

I'm so sorry, Mike.

Well, but then I was at this little church function and I heard some guy say, 'My dad was killed by his old business partner.' He said, 'I wasn't going to let that stop me: I needed to just resolve that with this guy.'

He made amends with this guy who killed his dad!

I thought about it and chewed on it for about a month, and I thought, You know what? I need to do what's right. So I called him.

You called the cop who shot your brother?

Yeah. He'd moved on from the police department. At that time, he was working for the district attorney as an investigator.

This cop knew me, used to see me when I was living on the streets, 'cause he was a supervisor out in Southeast Precinct.

I called him up and I said, 'Hey, John, this is Mike McCoy. Do you remember me?'

He said, 'Yeah, what can I do for you?'

And I said, 'I'd like to see you.'

And he was kind of like, 'Uh, I don't think that's possible.'

I said, 'John, I just need to talk to you. I want to ask for your forgiveness for taking you to court, for hating you all these years.'

I wanted to make my amends; I wasn't expecting anything. He didn't owe me anything, and he could have hung up.

He said, 'You know what, Mike? I think about it every day. I wish things could have been better. But they weren't. And here we are.'

Then he started asking about Kevin's widow and asking, 'How are the kids? What are they up to?' That kind of stuff. He just opened up like that.

Did you two get together?

No. It was all on the phone. You know, you can get a lot said in ten minutes. He said, 'Mike, do you remember those times when you'd be on the street and we'd be shaking you down, and I'd call off the stop?'

I said, 'I remember seeing you.'

'If it wasn't a felon stop, I told those guys to let you go. Because I knew the grief you were in.'

I said, 'Wow!'

We had this huge closure, you know, between the two of us. I hung up and I wept.

You must have helped him a lot.

You know what? We helped each other. It was a great movement of healing, in both of our lives. Not that I'm a great person, but I think that it's probably the biggest thing that I've done.

[It was completely dark now, but by the light coming through the window, I could still see Mike's face. He reached for his glass and drained his water, was silent for a moment, and then explained to me.]

It was God's work in my life.

<div align="center">℠ʢ</div>

When I think about the reversals in the life of Mike McCoy, I am reminded of an interview I was granted with Bishop Samuel Ruiz in San Cristóbal de las Casas (where he was known simply and affectionately as Don Samuel). This was in the summer of 1992, before the world press knew him as chief mediator between the Zapatistas and the Mexican federal government.

I was in Chiapas looking to meet a Jesuit priest who had led three-hundred indigenous people, in the spring of that year, on a long trek to Mexico City to protest human rights abuses. I'd read about him in an unbylined three-inch piece in the *National Catholic Reporter.*

Don Samuel could not tell me where to find Fr. Jerónimo Hernández, but he did steer me to the Jesuits in residence nearby and they, in turn, advised me to inquire up at Bachajón, a Tzeltal Maya village maybe two hours away, heading northwest into the hills.

Meanwhile, the bishop generously gave me an hour of his time, as he explained the issues and hardships facing the faithful of the diocese. Big ranchers had several devious ways of cheating the indigenous out of their land, including "fences that move in the night."

The bishop also told me how he had come to love and defend the poor. He had arrived three decades before from the diocese of León, where he had been teaching sacred scripture to seminarians. He described himself as a conservative but said that many years of visiting people in far-flung villages throughout Chiapas had opened

his heart to their plight. He said the faith of those villagers had converted him. "I did not evangelize them," he insisted. "They evangelized me."

The life of abundance, I have learned from both Don Samuel and Mike McCoy, is a life of continual conversion. And to hear their stories, I see that transformation can happen over a day's mule ride into the Maya highlands, or over ten minutes with one's "enemy" on the phone.

THE JUDICIOUS BEAUTY OF MEMORY LOSS

From Marcel Proust we learned to differentiate between the memory that envelops us unbidden and the memory that we pursue. The latter is like a cat we try to grab and pet; she darts beneath the davenport, and only after we have immersed ourselves in a book will she reappear to rub against our trousers.

An artist friend of mine, still elegant at seventy-six, tells me about a gallery opening: "So in through the door walked ... damn it! What is happening to me?" Later, in the middle of a conversation about Ingmar Bergman, she shouts out the single word, "Serena!" and I realize she has been only half attentive for the last thirty minutes.

Or a guest, having concluded a flowery and relevant digression, falls silent with a look of helpless annoyance. "I'm sorry. I don't know where I was going with this!"

In pursuit of the smooth ride, it is no use grinding the gears.

I have known these lapses. Accepting them without frustration is not always easy with so much media stirring up the common brooding. A few articles are meant to reassure, advising readers to offset symptoms of aging with daily walks, good sleep, and leafy green vegetables, but plenty of others stoke the fear. "Alzheimer's Isn't Inevitable" reads a bold red subhead in America's highest circulation magazine, a title neither phrased nor typeset to calm the reader. In *The New Yorker*, Patricia Marx evaluates brain training games, of which there are more than a dozen on the market. It is a lucrative industry now, though it does strike me as odd that most of them, like Lumosity, require a computer, the very apparatus that we have used for decades to replace memory.

Even more dismaying is the 2011 survey cited by Marx that finds baby boomers more afraid of losing their memory than of death!

Wouldn't it be more helpful to treat ourselves with patience and kindness, to cultivate affectionate indulgence for ourselves and for others? This would do more to calm the general fear than all those articles meant to acquaint us with the lexicon of the human brain: prefrontal cortex, neurons, synapses, hippocampus. Nor is it helpful to read about the competing theories of beta-amyloid buildup versus tau protein tangles, as brain scientists try to demystify Alzheimer's. Too grisly, yes, but also too complicated.

In a spirit of helpfulness, I have developed my own brain model, one simple enough for anyone to understand: the brain's pathways are like micro-cannelloni, and since the word we can't remember is almost always a proper name, the capital letters are getting stuck in these delicate narrow tubes. The force exerted as we strain to remember eventually thrusts the word forward with a pop—Dubrovnik! Heraclitus!—their lowercase letters dangling loosely behind them like a kite string.

Thurberesque science aside, maybe a certain amount of cognitive decline is natural. Just as leaves, grass, and the pages of old books yellow with age, so do teeth and fingernails. Maybe we can learn to recognize that the yellow light of aging memory, like a September that glows golden, can be beautiful.

Besides, what is it we have forgotten? Whether the light was left on in the basement? How in the hell the grocery list never made it as far as the purse? If today's breakfast was cold cereal or one of the big yolkers from the neighbor's coop? Nothing truly precious has been lost—though this simple truth may be a hard sell for boomers who still identify with old SAT scores.

Perhaps we should listen to Rumi, the thirteenth-century Persian Sufi mystic—and America's best-selling poet—when he advises, "Sell your cleverness and buy bewilderment."

Released from the obligation to instantly summon Jalaluddin or Cochabamba, I find my mind visited by details that I had forgotten once lodged in the heart, as though memory itself had taken over, judiciously choosing the beautiful over the dull utilitarian.

For instance, the Prologue to *The Canterbury Tales* comes back to me after all these years: *"Whan that Aprill with his shoures soote / The droghte of March hath perced to the roote ..."*

Dear old Mrs. Harrington. She insisted we learn to recite it in eleventh grade. I see her eyeglasses, attached to a delicate chain and resting on the shelf of her ample breast, and I even recall that her daughters were named Prudence and Patience.

Our twelve-line assignment builds to the familiar restlessness of spring: *"Thanne longen folk to goon on pilgrimages."*

These days I find that every trip I take is a pilgrimage, including memory itself.

<div align="center">ഇരു</div>

Like that elusive cat, the unbidden memory overtakes us at so unsuspecting a prompt as the soft surprise of sponge cake on the tongue. Our passivity is so complete that we might be said to suffer remembrance.

The landscape of my Willamette Valley childhood lay beyond the big front windows of the house that once belonged to my grandfather. In the foreground, two birches formally framed a lawn kept trimmed and green; beyond, on the other side of the county road, all the flatness of wheat stretched clear to the coastal foothills, their ragged outline stuttering across the horizon like an electrocardiogram monitoring the heart.

Upstairs, my bedroom gave the same western view, though I best remember that room from my bed, where, nestled below the level of the French windows and toy balcony, I could make out, by the light of passing cars, the pretty piazze of Italy on my wallpaper.

Now in my Portland bedroom, where a quiet avenue runs beneath second-story windows, I sometimes wake with the sensation that I am back in the bed of my childhood, and I expect the next set of headlights to reveal those corner fountains and flowering terracotta pots that I have not seen in fifty years.

<div align="center">ഇരു</div>

We stand on a high footbridge, this boy and I, where we have wandered on a cold afternoon off campus. With his arm lightly across my shoulder, he feels me shiver and offers his handsome new sheepskin coat, which I refuse. He tears it off and insists, standing there in his thin cotton shirt. Fierce, he holds the jacket out over the bridge rail. "No!" I cry out, but I raise my arm too late to stop him. He flings the coat from us, where it continues to hang suspended, above the raging winter creek. And I am still in love.

<div align="center">ഇരു</div>

The poet Rafael Alberti wrote of aging as being subject to the "inexorable, advancing invasion of that remembered lost grove of youth." That grove, for this great poet driven out of his homeland at the onset of the Spanish Civil War, was both literal and figurative: the home to which he safely returned, after Franco's death and his own four-decade exile, was no longer the Andalusia of his childhood.

It is Alberti's sense of being *invaded* by memories that I recognize: my own midnight visit to the zoo, where the bull elephant ate apples by moonlight, snaking them up one at a time and rearing his head back to devour all twenty in one dramatic swallow; my first glimpse of the exuberant Chodos brothers whose masculine beauty so disturbed me that I stopped transfixed on the concert hall's upper stair; the thousands of stars above the Andes suggesting a white blaze just behind the perforated midnight sky; the afternoon I bent among dense ferns to ladle clear, bubbling spring water into my pail and discovered the pink pearlescent shock of a large abalone shell left by a recent guest; the bacon fat spitting inside my mother's oven when she cooked wild duck; the cold caress of champagne as Alain overfilled my cup, gazing steadily over the punch bowl and bathing my hand.

<center>℘℘℘</center>

It is January when I arrive in Montreal by train, and so cold that I reverse my steps and drink tea for an hour in the warmth of the station. For weeks, I cannot get warm. My immigration papers do not come through, my money dwindles, I know no one, and, despite my boots and good coat, I am always cold. One day, as I make my way carefully down the icy street, a voice calls out behind me, "Louise!" Repeatedly, insistently, until I turn. A young man hurries forward, then stops, disconcerted. *"Non, je ne suis pas Louise,"* I acknowledge with my clumsy accent and a smile. *"Mais vous n'avez pas de cache-col!"* he observes. He pulls a long strip of Black Watch plaid from his own collar, wraps the warm wool around my neck, gives it a satisfied pat, and hurries, still embarrassed, down the street. Tears brimming, I see that Montreal will be possible.

<center>℘℘℘</center>

And if, someday, our cognitive impairment turns out to be the very worst?

There is one wise elder whom I have kept in my heart for thirty years. Though I never had the opportunity to meet Bishop Topel of Spokane, I still have a newspaper article about him, now yellowed with age. He forsook the bishop's mansion to live in a simple cottage where he grew vegetables for his table and to give to the poor, and he looked forward to being released from his diocesan duties because he had many local good works planned. But a few days after announcing his retirement, he was diagnosed with Alzheimer's. He accepted it calmly. He told a newspaper reporter, "I've given God my life and my work, and if He now wants my mind, it is His to take."

The bishop's acceptance speaks of his belief in a self beyond the tether of memory. For the rest of us, who may never achieve such wholehearted grace, we can at least look forward to Mnemosyne's sweet invasions.

From the docks, a sailor comes into the city on an evening in late spring. He wears the classic peacoat and watch cap, his skin the black of ebony (a young African prince, I decide, gone, as fairy-tale princes must, out into the wide world in disguise). He is the only customer, and he speaks to me in English: "Do you have the *Meditations of Marcus Aurelius?*" We have three editions, and he chooses the one in Modern Greek. Somewhere in mid-ocean, Marcus Aurelius will remind him: *"To reverence and honour thy own mind will make thee content with thyself, and in harmony with society, and in agreement with the gods."*

As his ship carries him across the Atlantic, so I also carry him with me down through the years.

ACKNOWLEDGMENTS

My gratitude goes out to my writer friends who read drafts of individual essays and offered valuable insights: Benjamin Chambers, Molly Gloss, Rebecca Koffman, Marilyn Krueger, Jason Maurer, Jon Ross, Michael Royce, Robin Schauffler, Wayne Scott, Geronimo Tagatac and Rajesh Varma. Special thanks to Jane Salisbury, who helped select the essays and edited the collection, and to Melissa Marsland, Laura Moulton, and Theresa Lois Tate, who read the assembled manuscript.

I am grateful for my writing teachers of the eighties, when I first determined to take my writing beyond journalism. I was in Raymond Carver's workshop the two summers he taught at Port Townsend and I studied with María Irene Fornés the summer she brought her workshop to Seattle's New City Theater.

I also learned from independent filmmaker Jill Godmilow, who startled me with her invitation to collaborate on an adaptation of twelve Raymond Carver stories. Jill's exacting standards were a bracing refreshment for me, and she has remained, over the years, a dear friend. Although I never aspired to write for the movies, I also learned valuable lessons from screenwriters Tom Rickman and Gill Dennis at Squaw Valley, and from a slew of brilliant mentors at Sundance, including Richard Price.

I received a life-changing gift from the late Jon Sinclair, who first invited me to teach creative writing at Marylhurst College. Peculiar as his idea sounded at first, it turned into a calling that has immensely enriched my life and my work. I also had the pleasure of teaching human rights and creative writing for the graduate writing program that poet Kim Stafford created for Lewis & Clark College. And right here belongs the name of Diane McDevitt, the hands and feet of Kim's Northwest Writing Institute, who treated like visiting royalty all of us part-timers who came and went.

In respect to those essays that have been published, I thank editors who worked with me, their contributions ranging from a trusting "hands off" to a significant investment of time and ideas for improving the piece at hand. I remember fondly one particular 90-minute phone call with *Gettysburg Review's* editor Mark Drew, where we fussed over delicate tweaks while sharing our mutual regard for the writing of Nelson Algren. A single ingenious

suggestion made by Andrew Snee enabled me to snap an essay into shape for *The Sun,* and Mackenzie Branson's enthusiasm for "Paradise Refused" suffused every email she sent me from *JuxtaProse Literary Magazine.* And I can never forget Russ Rymer, briefly the editor at *Portland Monthly,* whose talent and courage I admired so much.

Thanks to Oregon Literary Arts for a grant back in the mid-nineties, and to Regional Arts & Culture Council for three grants supporting my work in the early aughts. Three consecutive years of residencies at The Rice Place were crucial for the long view that only nature can lend to those of us hemmed in by cities, and I thank Charlotte Rubin and her fellow board members whose dedication keeps it going. Thanks, also, to Peter Kehler, who mows the meadow, watches over the guests, and so loves the land.

I was especially fortunate to meet my publisher, Jill McCabe Johnson, at the Seattle AWP. The respect and kindness she extends to authors is a lovely thing, and this same courtesy shows up in her editorial team who helped with this book, in my case, Gail Folkins and Andrew Shattuck McBride. I am also grateful to Martin Stabler and my friend of many years, Susan Emmons, both of whom kindly provided photography.

Finally, I thank my partner, photo archivist Thomas Robinson. His attentive care and zany sense of humor make daily life with him a joy. I wish you all could meet him.

These essays were originally published in the following journals and magazines:

Arroyo Literary Review: "Old Fashioneds"

Cream City Review: "The Skin of the World" and reprinted in *20ᵗʰ Anniversary Anthology: The Best of Cream City Review*

Gettysburg Review: "Driving Blind" and "The Judicious Beauty of Memory Loss"

JuxtaProse Literary Magazine: "Paradise Refused"

New Rag Rising: "Where Pablo Neruda First Saw the Sea"

Notre Dame Review: "October Song"

Oregon English Journal: "Teacher: A Memoir of Raymond Carver" and reprinted by *Writers NW* and, in translation, at *La Palabra y el Hombre* (Xalapa, Veracruz, Mexico)

Portland Magazine: "The Man in the Pew"

Portland Monthly: "A Father's Story"

Second Opinion: "Heart of Wisdom"

The Sun: "Judgments"

Timberline Review: "Camping Practice"

And these essays first appeared in books:

"Substitution Trunk" Seal Press anthology *Drive: Women's True Stories from the Open Road*, edited by Jennie Goode

"The Mission at Night" reprinted from *Up All Night* (Oregon State University Press)

Printed in the USA
CPSIA information can be obtained
at www.ICGtesting.com
CBHW050751130924
14476CB00040B/565